IMAGES
of America

CATHOLICS ALONG THE RIO GRANDE

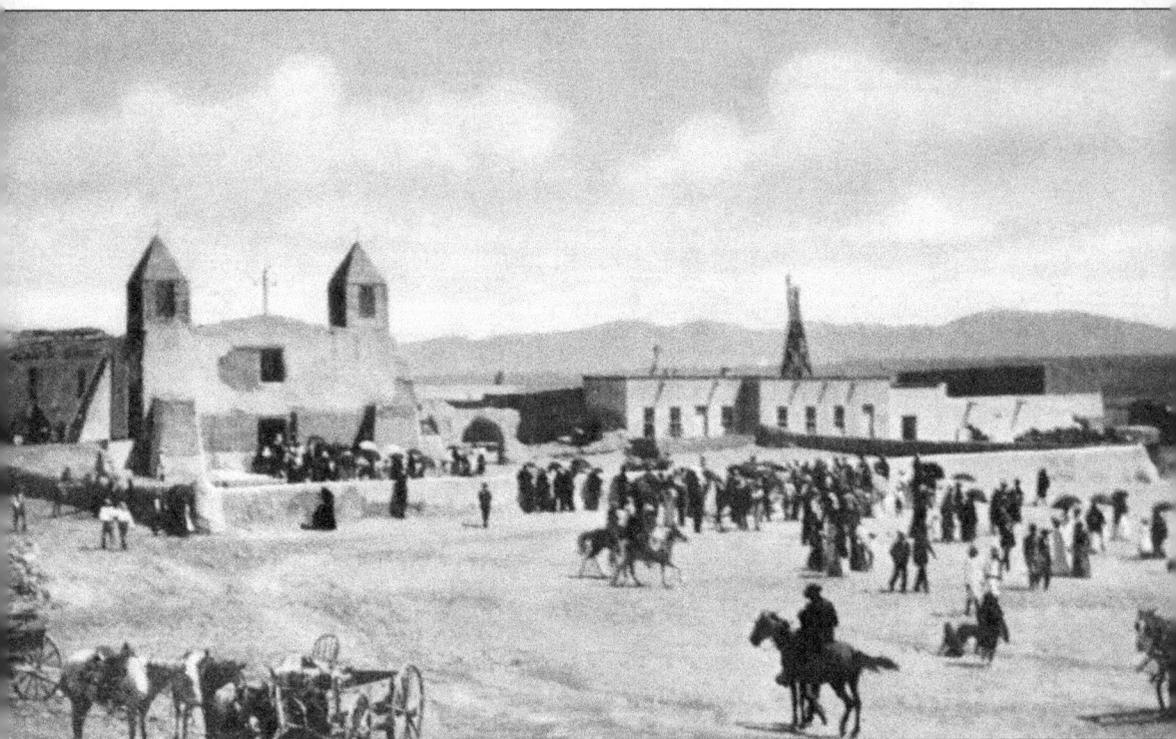

Above is the church of San Agustín de Isleta in the late 19th century. This church, one of the oldest in New Mexico, was first build by Franciscan missionaries between 1613 and 1617. (Museum of New Mexico, 177756.)

IMAGES
of America

CATHOLICS ALONG THE RIO GRANDE

John Taylor
Foreword by Richard Melzer

ARCADIA
PUBLISHING

Published by Arcadia Publishing
Charleston, South Carolina

Library of Congress Control Number: 2010935616

For all general information, please contact Arcadia Publishing:
Telephone 843-853-2070
Fax 843-853-0044
E-mail sales@arcadiapublishing.com
For customer service and orders:
Toll-Free 1-888-313-2665

Visit us on the Internet at www.arcadiapublishing.com

This book is dedicated to my lovely wife, Lynn—without her encouragement and patience, it would not have been possible.

CONTENTS

FOREWORD

Much attention has been given to the history, culture, and religions of the northern region of the Rio Grande Valley, commonly known as the Río Arriba. Many of New Mexico's most famous novels, from Willa Cather's *Death Comes for the Archbishop* (1927) to John Nichols's *Milagro Beanfield War* (1976), have been set in that locale. Artists such as Joseph Henry Sharp in Taos and Georgia O'Keeffe in Abiquiu have focused on northern subjects. Many regional painters have captured the San Francisco de Asis church in Ranchos de Taos and the famous Santuario at Chimayo at least once in their careers. Cultural anthropologists have studied Native American pueblos and Hispanic villages of the area. Volumes have been written about the Brotherhood of Our Father Jesus, or Penitentes, mostly in isolated northern villages.

Far less attention has been given to the history, culture, and especially the religion of the Río Abajo valley region that extends south of Albuquerque to Truth or Consequences. Many assume that what was true of the Río Arriba must be true of the Río Abajo. Though some realize the vast differences, few have attempted to understand them, much less depict them in art, literature, or academic studies.

While most historians have simply bemoaned this neglect of the Río Abajo, John Taylor has done much to fill the void. His award-winning previous books have considered the Civil War battles at Valverde (*Bloody Valverde*, 1995) and Glorieta Pass (*The Battle of Glorieta Pass*, 1998), as well as the history of Our Lady of Guadalupe Parish in Peralta (*Dejad a los Niños Venir a Mi*, 2005).

Now Taylor has done much more. *Catholics Along the Rio Grande* documents the history of the Catholic parishes in the Río Abajo from the Spanish conquest of the 16th century to the present. Like the industrious Franciscans who built the first churches in the Río Abajo, Taylor has labored for years to collect valuable photographs and accurate data about the parishes and their leaders. To the Río Abajo's great benefit, he has laid an enduring, solid foundation for the study of the Catholic religion in the valley.

—Richard Melzer

ACKNOWLEDGMENTS

Many individuals and organizations have provided assistance in the completion of this project. I owe particular debts of gratitude to Dr. Richard Melzer, Paul Harden, Dr. Maggie MacDonald, and Felipe Mirabal for their reviews and thoughtful insights on various versions of the manuscript. Marina Ochoa, archivist of the Archdiocese of Santa Fe, provided me access to a number of archdiocesan files to help document the evolution of various parishes and missions. B. G. Burr and Patty Guggino of the Los Lunas Museum of Heritage and Arts provided invaluable assistance in accessing photographic documentation. This work would not have been possible without the assistance and cooperation of the various parishes—in particular, Viola Armijo from Our Lady of Perpetual Help in Truth or Consequences, Connie Flores of San Clemente in Los Lunas, and the administrative staffs at Our Lady of Belén, Holy Child in Tijeras, Our Lady of Sorrows in La Joya, San Miguel in Socorro, and at the Diocese of Gallup. Cati Aragon (deceased), Celso Armijo, Ramon Baca, Emily Brito, Gil Duncan, Maria Fedewa, Emma Gabaldon (deceased), Tony Gallegos, Sid Gariss, Margene Harris, Marlene Monteith, Ben Otero (deceased), Columba Reid, Anita Saiz, and Joe Stewart provided some of the unique photographs. Special thanks also go to José Aragon, Patricia Gallegos, and Johanna Hartenberg for their paintings and pencil sketches. All images come from the author's collection unless otherwise noted.

INTRODUCTION

Bending over his wooden hoe, the young man broke the soft, sandy earth atop the mesa. Then, as his ancestors had for centuries, he carefully pulled the green shoots from around the broadleaf squash and poured some of the precious water from his gourd at the base of the plant, chanting a prayer to bring the moisture that would mean a healthy crop again this year. The river was low, the cisterns were starting to deplete, and the sky was almost cloudless—there would be no rain today, but perhaps tomorrow.

Suddenly the young man straightened. He had been trained to be acutely aware of changes in his surroundings from the time he was old enough to toddle through the fields with his parents and siblings. An abrupt movement could be a rabbit, meat to enrich the stew of maize and squash, or it could be a rattlesnake, death to the unwary child that crossed its path, but good luck if it were allowed to pass unharmed. This was different, though—a glint to the north that was unlike the morning sun reflecting from the river. This one came and went almost rhythmically.

The young man stared at the source of the signal for several seconds. Yes, there was definitely something different along the trail that ran north from the pueblo. A small cloud of dust was now visible and something that he had never seen before—a dog the size of five men with a back of silver that caught the morning sun. There were several of these unusual apparitions and behind them, men marched with long sticks and strange silvery heads. Strange sightings had been reported to the south and west—men that rode astride great beasts and carried sticks that flashed and roared and killed men far away. If they were now coming toward his home, the elders must be told. He dropped his hoe and started down the mesa at a dog trot, heading for the village.

What the young man did not see were the tonsured men that moved in company with the soldiers. They wore sandals and coarse, blue-grey robes and carried long walking sticks. These men, much more than those with the weapons of wood and steel, would change the rhythms of the young man's village in ways he could not even imagine—Catholicism was coming to the central Rio Grande Valley.

This book follows the evolution of Catholicism in central New Mexico in an area that is sometimes referred to as the Río Abajo. (In the strictest sense, *Río Abajo*, a phrase meaning lower river, was a Spanish jurisdictional demarcation for that part of the colony south of the escarpment between Albuquerque and Santa Fe. In current times, it is informally used to designate the area south of Albuquerque.) The missions and parishes in this region form a historical lineage that can be traced to the earliest days of the Spanish colonial period.

The first European to enter what is now New Mexico was probably Alvar Nuñez Cabeza de Vaca (above), a shipwrecked Spaniard who wandered from the Texas coast to the west coast of Mexico in 1536. However, this trek was well to the south of the Río Abajo. Francisco Vásquez de Coronado (below) traveled north in 1540, spurred on by tales of the Seven Cities of Cíbola and the gold of Quivira. Finding harsh conditions, native resistance, and lack of gold, he returned to Mexico in disgrace in 1542. Three Franciscans who had remained behind were soon killed by Native Americans. It would be almost 40 years before explorers would once again come to the land of the pueblos. (Both, Museum of New Mexico, 071390, 20206.)

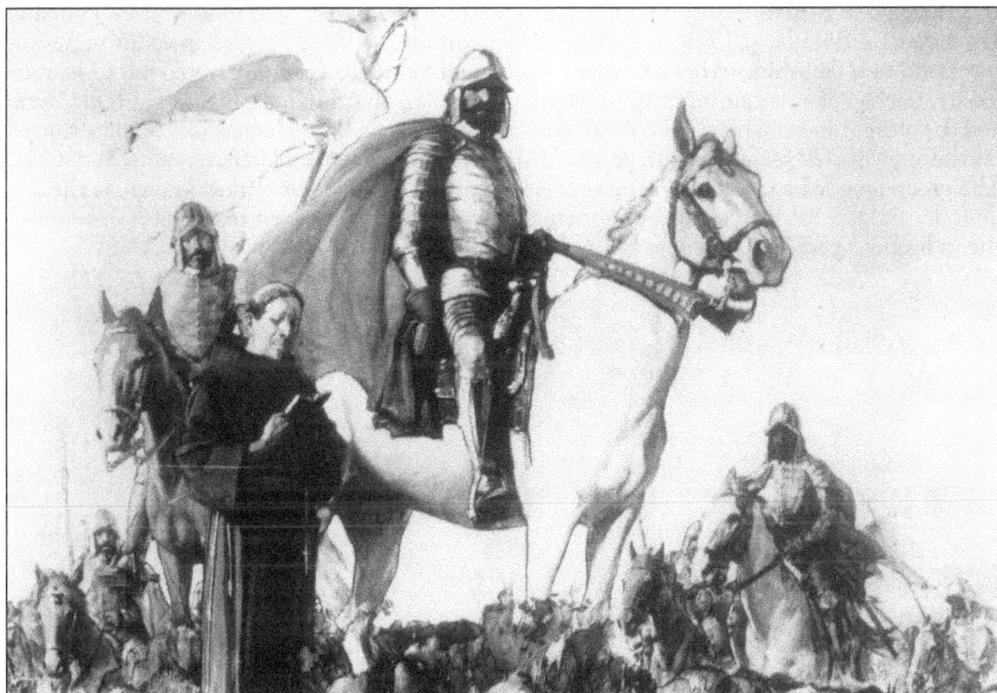

Almost 40 years after Coronado, explorers again came north along the Rio Grande—Chamuscado and Rodríguez in 1581, Espejo in 1582, Castaño de Sosa in 1590, and Gutiérrez de Humaña and Leyva de Bonilla in 1593. Each of these expeditions included Franciscans, but none was successful in establishing either a religious or colonial foothold. That task would fall to Juan de Oñate, the son of a Basque mining family, whose wife was the granddaughter of Hernán Cortés and the great-granddaughter of the Aztec emperor Moctezuma II. In January 1598, Oñate started northward with 129 soldiers and an unrecorded number of women, children, servants, and slaves. The group founded a colony near the confluence of the Río del Norte (now known as the Rio Grande) and the Río de Chama. From there the Franciscans fanned out to establish missions to the indigenous people. (Geronimo Springs Museum.)

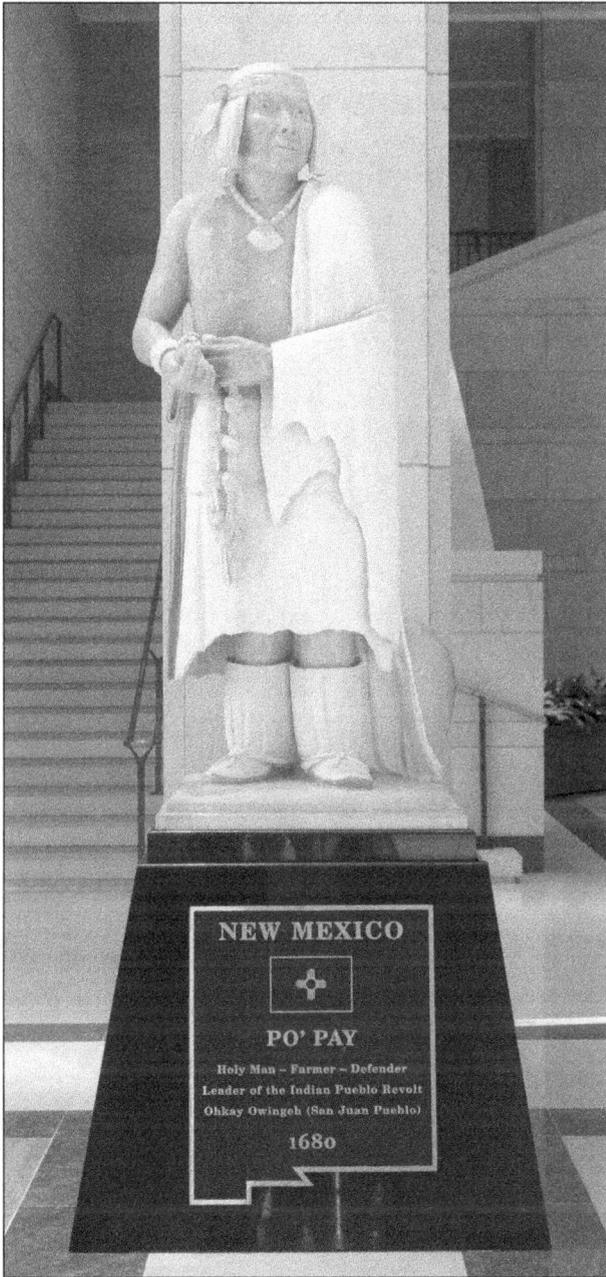

In 1680, after nearly a century of oppression and attacks on their traditions and beliefs by the colonists and the Franciscans, the Pueblo Indians united under a San Juan religious leader named Po'pay and drove the Spaniards out of the territory. This event, known as the Pueblo Revolt, was a wrenching development in the progress of Catholicism in the Río Abajo. Haciendas were abandoned, in some cases with much attendant violence, and the churches at Isleta, Socorro, La Joya, Alamillo, and Senecú were captured and were desecrated and severely damaged. The Native Americans managed to keep the Spanish out of their colony for 12 years, but the successful alliance among the Pueblos eventually succumbed to previous rivalries. (Sculpture by Cliff Fragua; National Statuary Hall Collection, U.S. Capitol Building.)

11

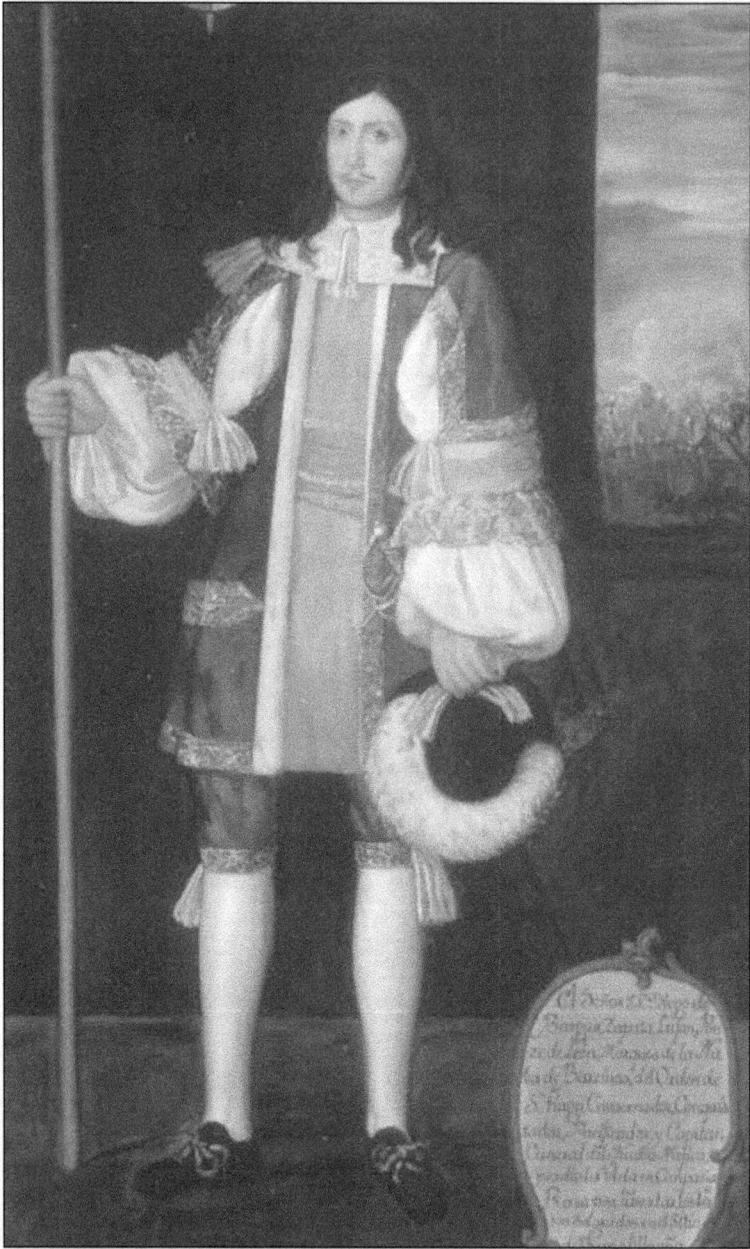

In August 1692, Don Diego de Vargas Zapata Lujan Ponce de Leon and an army of 200 men mounted a major expedition to recapture north-central New Mexico. Learning from unsuccessful attempts in 1681, 1687, and 1688, this expedition was adequately staffed and provisioned. De Vargas moved north along the Rio Grande, passing burned haciendas and desecrated chapels, but encountering no Native American opposition. On December 20, 1692, De Vargas reported to Mexico City that he had successfully restored Spanish sovereignty in the upstart colony without the loss of a single soldier. However, in December 1693, he returned with colonists who had to fight to regain Santa Fe. Although the days of Native American strife, resentment, and outright conflict were far from over, this time Europeans were in New Mexico to stay. (Museum of New Mexico, 11409.)

One

ISLETA,
THE MOTHER CHURCH

Isleta Pueblo was a few hundred years old when Oñate arrived. It was the largest of a group of Southern Tiwa villages that bracketed the Rio Grande about 80 miles south of Santa Fe. The original church at Isleta, dedicated to San Antonio (St. Anthony), was constructed between 1613 and 1617. During the 1680 Pueblo Revolt, this church was desecrated and nearly destroyed. The church was rebuilt and rededicated to San Agustín (St. Augustine) in 1720, although the reason for the change in patronage is lost to memory.

San Agustín has had its share of mystery and controversy. For example, the coffin containing a priest who had been killed by Native Americans was buried beneath the floor of the church in 1756. It has repeatedly "surfaced" inside the sanctuary. In addition, there was a report that a huge pounding and commotion came from the grave site when some residents danced inside the church in defiance of the priest's orders. The priest was reinterred beneath the altar (hopefully for the last time) following the 1962 renovation.

In 1965, disagreements between the residents and the priest (whom the Isletans accused of "gross disrespect for the Indian way of life") came to a head, and the governor of the pueblo led the priest off the reservation in handcuffs. In retribution, Archbishop James Peter Davis promptly closed the parish. The church was not reopened until 1974.

Since the original establishment of Isleta, more than 84 priests from the parish have served 15 missions, *visitas* (infrequently visited local chapels), or *oratorios* (small chapels), covering an area as far west as Zuni and as far south as Sabinal, bringing the Word of God to the Catholics of the Río Abajo. Today the Church of San Agustín continues to serve the residents of Isleta and northern Valencia County and stands proudly as the Mother Church of the Río Abajo.

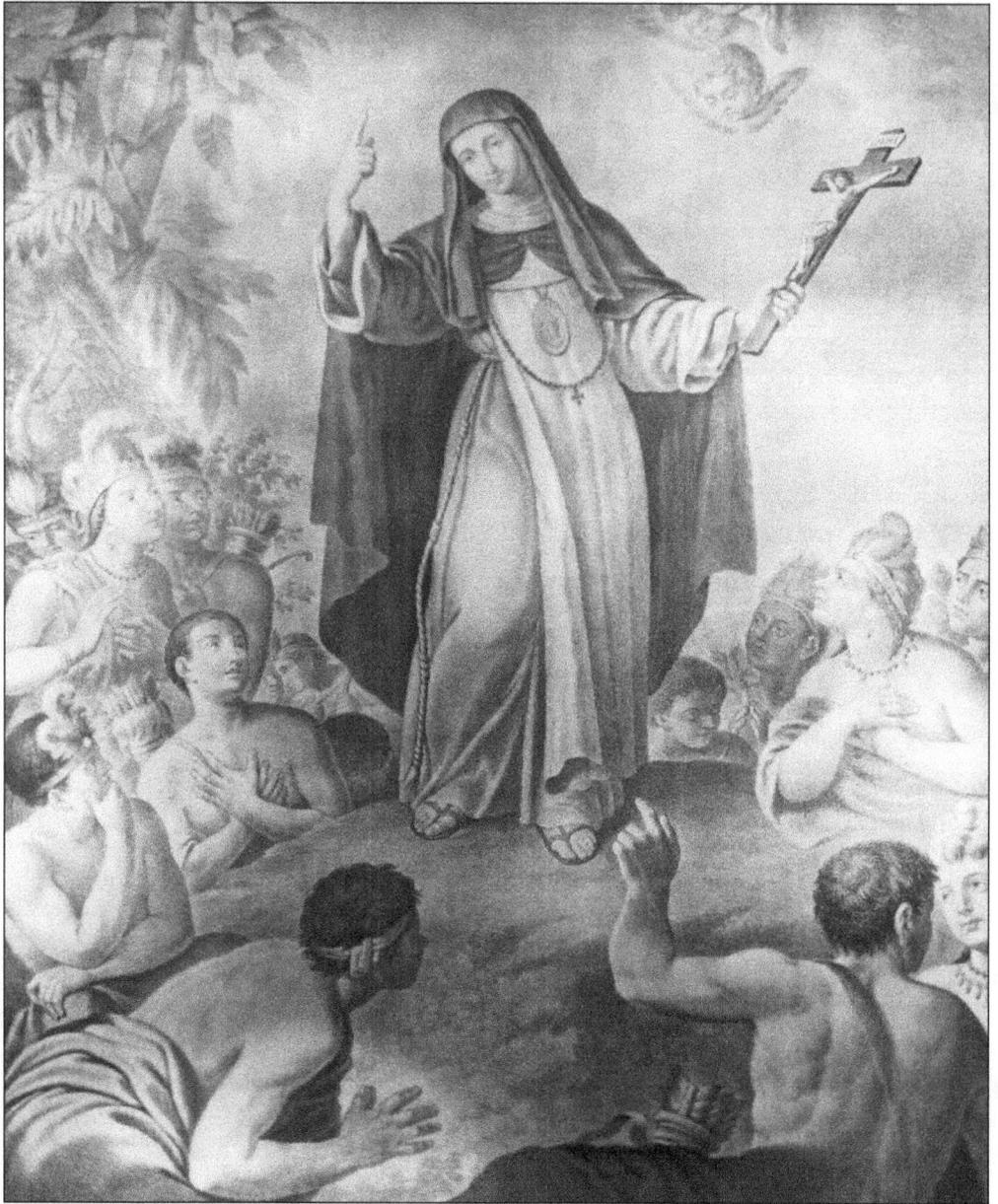

Fray Benavides, one of the early Franciscan friars to work in the Río Abajo, reported to his superiors that when he arrived at Isleta, "fifty Indians came to him and requested baptism for thousands of their people." When he inquired how they knew of the sacraments, they reported that the "Lady in Blue" had previously visited them and given a sermon in their own language. The Blue Lady was reputed to be Sister María de Jesús de Agreda, a Franciscan nun from the Poor Clares' Convent of the Immaculate Conception in Agreda, Spain. She was said to have mystically flown to New Mexico over 500 times between 1620 and 1631. It was reported that she would go into an ecstatic trance in her convent and then appear in the New World, where she introduced the Native Americans to the fundamentals of the Christian faith. She is depicted here in an 1865 lithograph by Vicente Aznar of Valencia. (Marilyn Fedewa.)

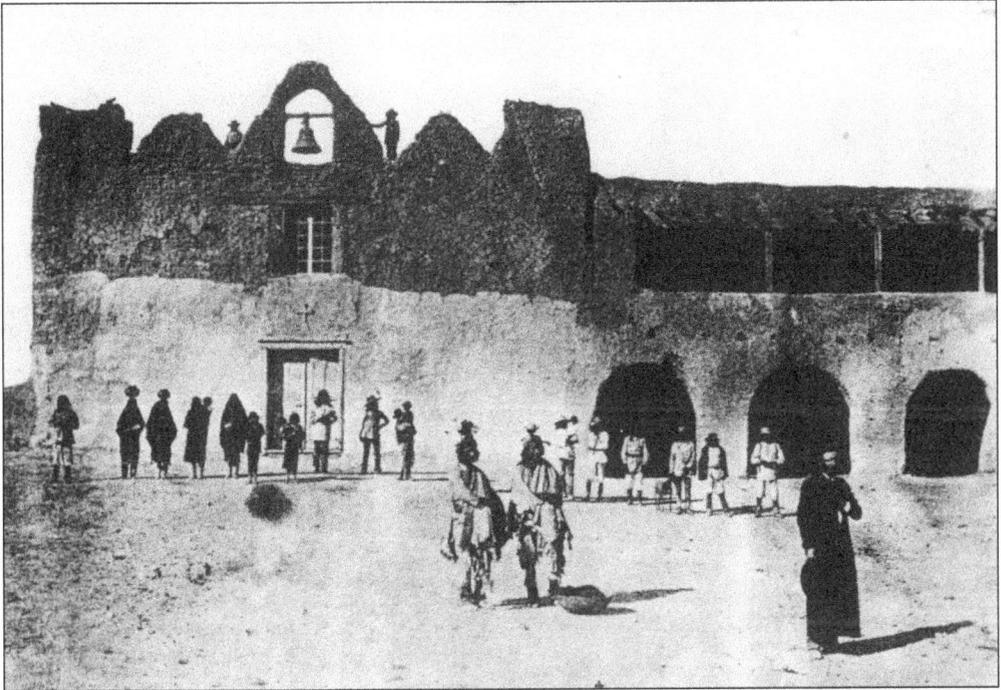

Fray Francisco Atanasio Domínguez conducted a general inspection of all New Mexico missions and churches in 1776. The friar provided a lengthy and very favorable description of the Isleta church that lists characteristics similar to those shown in a photograph of the structure taken in 1867. Note in particular the *companario* (an opening in the church facade, usually for a bell) configuration (above). The conflict between Mexico and the United States from 1846 to 1848, the change of oversight authority from the Diocese of Durango to the Diocese of Santa Fe in 1853, and the American Civil War in the 1860s had little impact on Isleta. The interior of the church (right) is similar to others of the time, with a few benches on the side, but no pews. Worshippers either stood or knelt. (Both, Museum of New Mexico, 12321, 015590.)

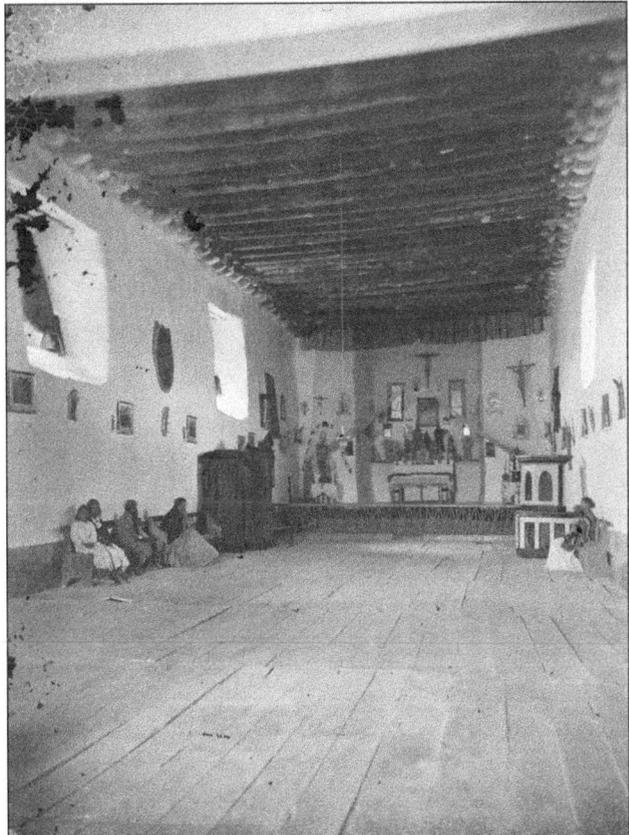

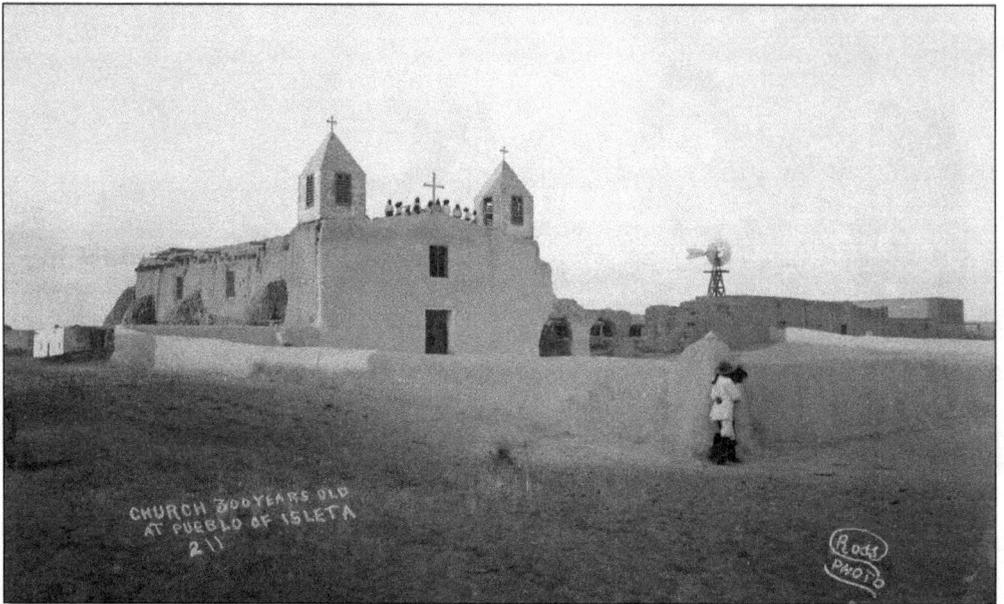

CHURCH 300 YEARS OLD
AT PUEBLO OF ISLETA
211

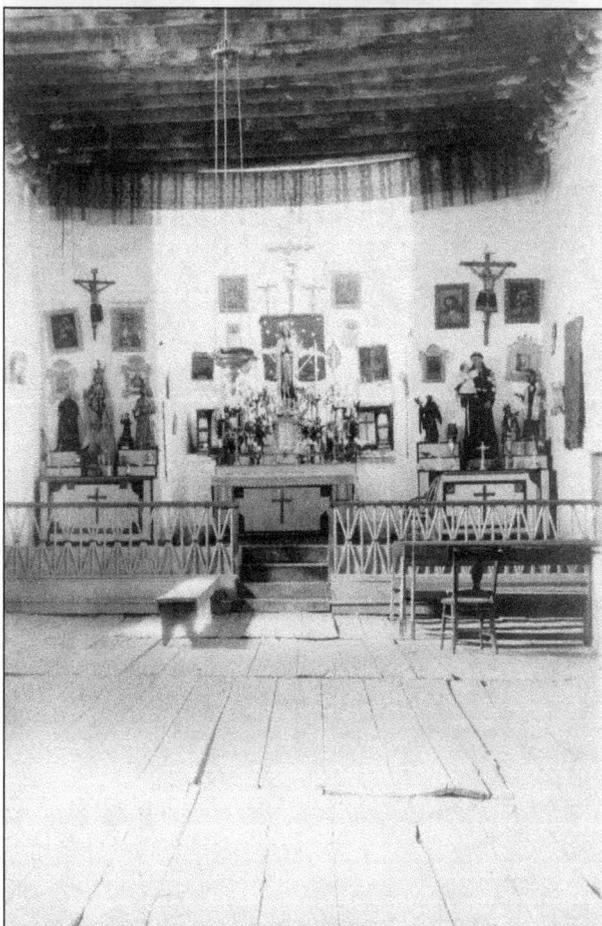

By the latter part of the 19th century, the exterior of the Isleta church had been significantly remodeled. The three-arch structure with its distinctive central bell tower was gone, and the two towers that bracketed the center had been refurbished and capped. The arched walkway to the *convento* (priest residence) remained, but the second level had been removed. Internally the sanctuary remained much the same, as seen in the 1915 image at left, although pews had been added (at least in the front of the nave). Numerous statues and paintings still adorned the altar and transept of the church. In this image, the sanctuary appears to have been decorated for a special celebration, perhaps one of the Advent Masses or the fiesta Mass of their patron, St. Augustine, which is celebrated on August 28. (Both, Museum of New Mexico, 012330, 146501.)

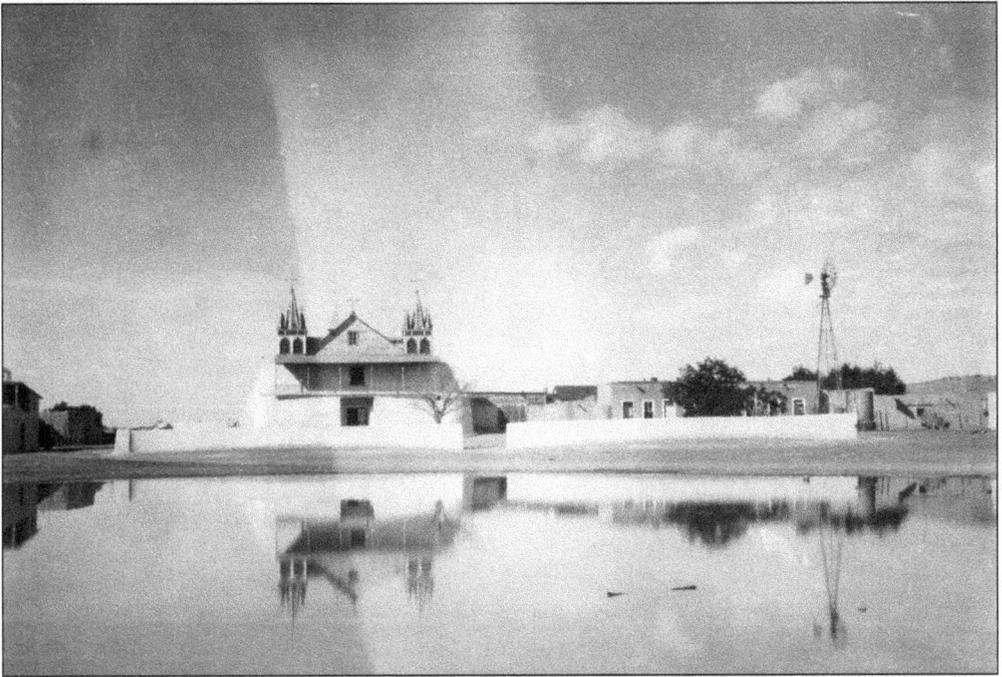

Under a series of priests beginning with Fr. Antoine Docher in the 1920s, the external appearance of San Agustín was changed to the point that most of its historic architectural characteristics were either lost or disguised. A pitched roof replaced the flat roof, and a third steeple was added on the north end of the church. The steeples were redesigned to include large Gothic openings and smaller, ornamented steeples, although the internal configuration of the church remained essentially the same. The ornamentation was removed over the next 30 years. Note the flooding in front of the church in the image above. (Both, Museum of New Mexico, 09095, 057078.)

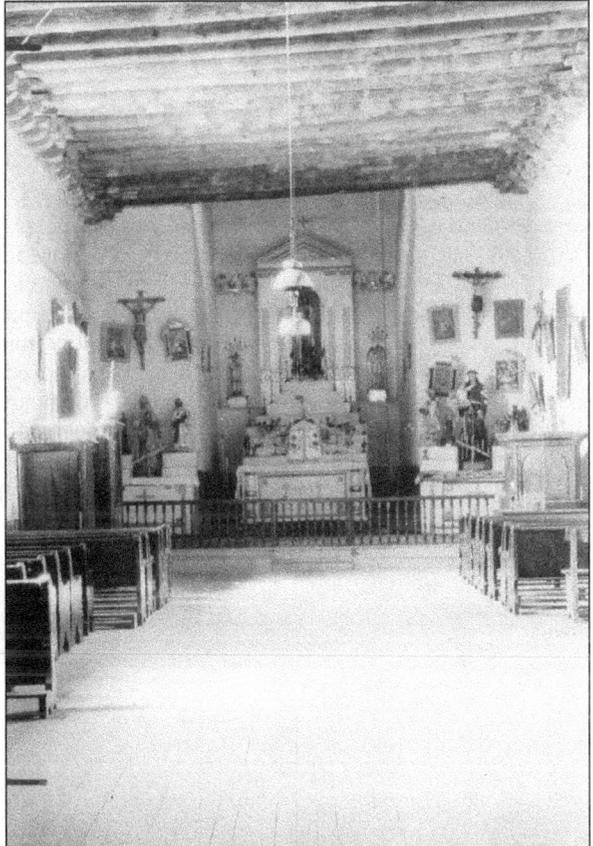

Although some of the ornamentation had been removed between 1920 and the late 1950s, Fr. Fred Stadtmueller, a German priest who had been assigned to Isleta in 1955, would lead a remodeling campaign from 1959 until 1962. During that time the remainder of the ornamentation was removed, and the church was externally reconfigured to look much like it did during the 19th century. The flat roof was restored and the north steeple removed, capped bell towers replaced the ornate steeples with their Gothic panels, and a central companario bell tower similar to the larger one shown in the 1867 photograph was added. Although Father Stadtmueller subsequently ran afoul of the Pueblo leadership for some of his other projects and ideas, his restoration of San Augustín de Isleta to its more authentic configuration was much appreciated. (National Archives.)

The village of Los Padillas was settled in 1705 on the northern edge of the Lo de Padilla land grant. The northern part of the Lo de Padilla grant was sold to Clemente Gutiérrez, husband of Apolonia Baca of Pajarito, in 1768. Most of the southern part of the grant was sold to Isleta Pueblo in 1908. From the outset, the Los Padillas area was dedicated to San Andrés, although the chapel was referred to as San José in the Catholic directories from 1860 until it was noted as San Andrés in 1880. In fact, the original land grant is sometimes referred to as San Andrés de Los Padillas, so there was almost certainly a small chapel in the area, probably at the Padilla hacienda. (Joe Stewart.)

19

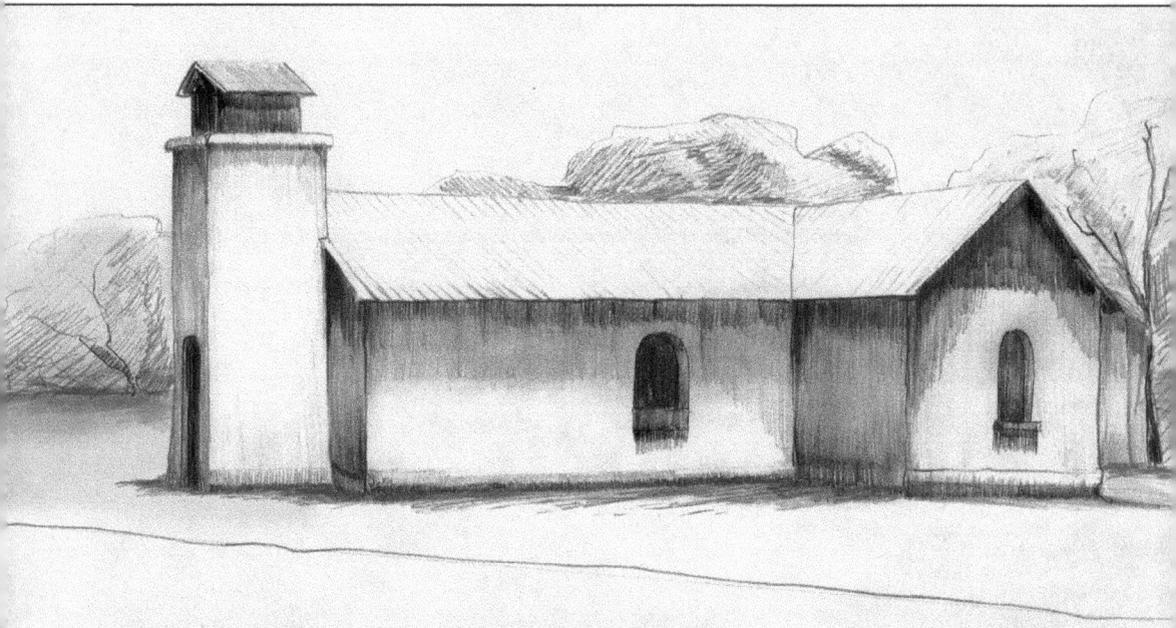

The first mention of an official chapel in Los Padillas occurs in 1826, when the license for the church of San Andrés was renewed. The chapel was served by priests from Isleta and was listed as a mission of that parish in Bishop Jean-Baptiste Lamy's first inventory of churches in 1852. The Los Padillas area was an important agricultural part of the greater Albuquerque area. From the 1950s onward, it became another of the many suburban neighborhoods of the growing Albuquerque metroplex. The church was closed in 1965 when Archbishop Davis shut down Isleta parish. This event coincided with the erection of the nearby parish of the Ascension of the Lord. The Los Padillas chapel building was used as a Boy's Club in the South Valley for about a year, but the structure collapsed and burned in 1966. (Johanna Hartenberg.)

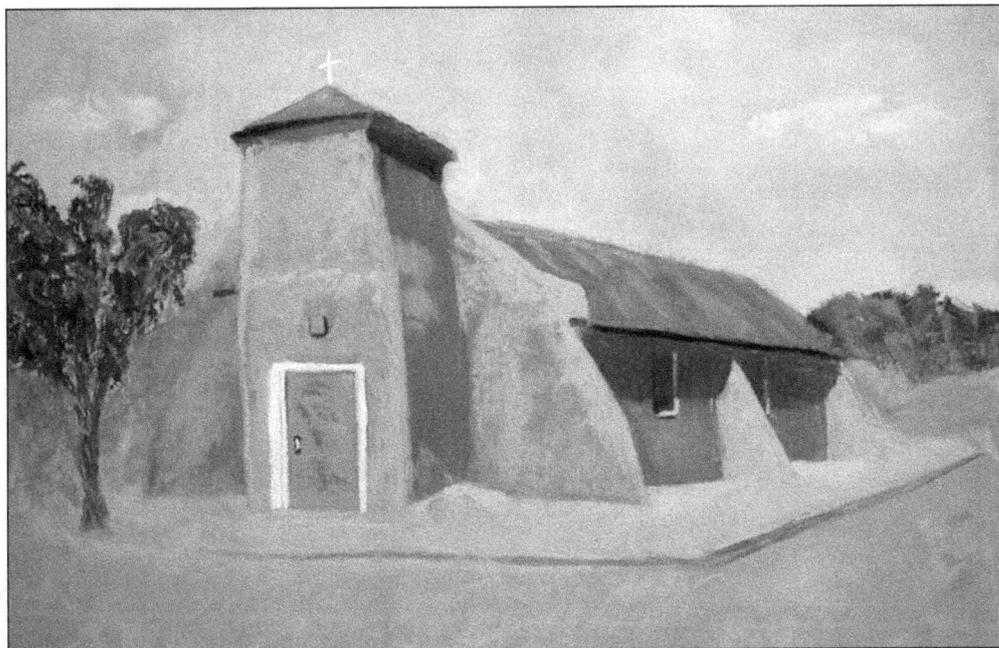

Plaza de San Ysidro de Pajarito, just north of Los Padillas, was settled in 1699. Pajarito (Spanish for "little bird," "small campground," or "stopping place") became a separate entity when one of the sons of Diego de Padilla sold approximately 28,700 acres to Clemente Gutiérrez. The center of the community seems to have been the Baca hacienda with a small chapel, which was mentioned as a beneficiary in Gutiérrez's will. Over the years, the dedications of the chapel (above) have included Our Lady of Sorrows, San Isidro (pictured below *c.* 1982), and San Rafael. The church was eventually deconsecrated and sold to a Protestant group. It is now used as a senior center. (Above, Patty Gallegos; below, Bernalillo County Archives.)

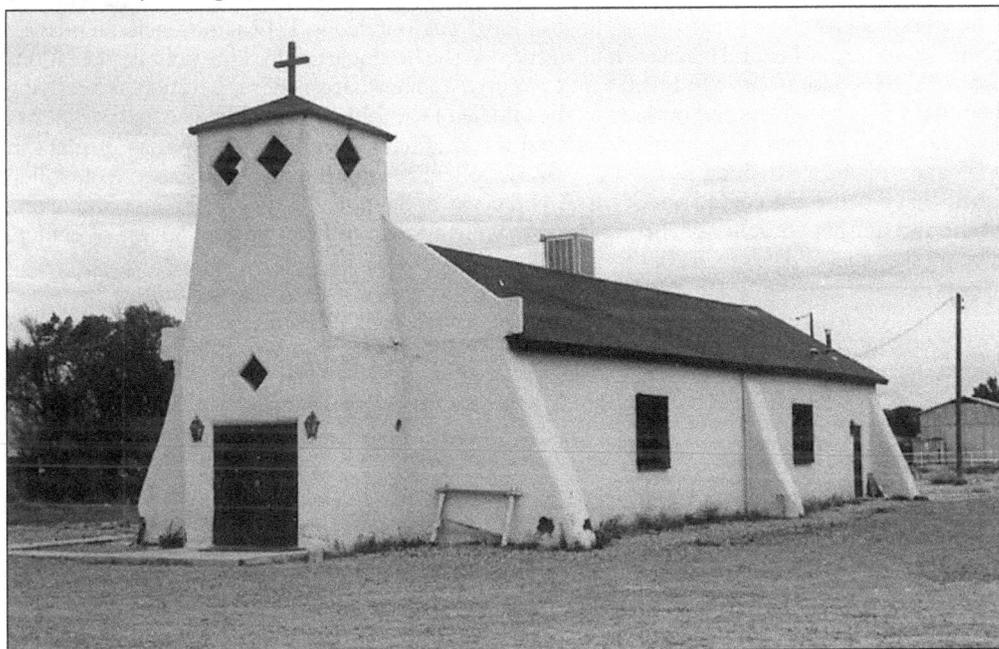

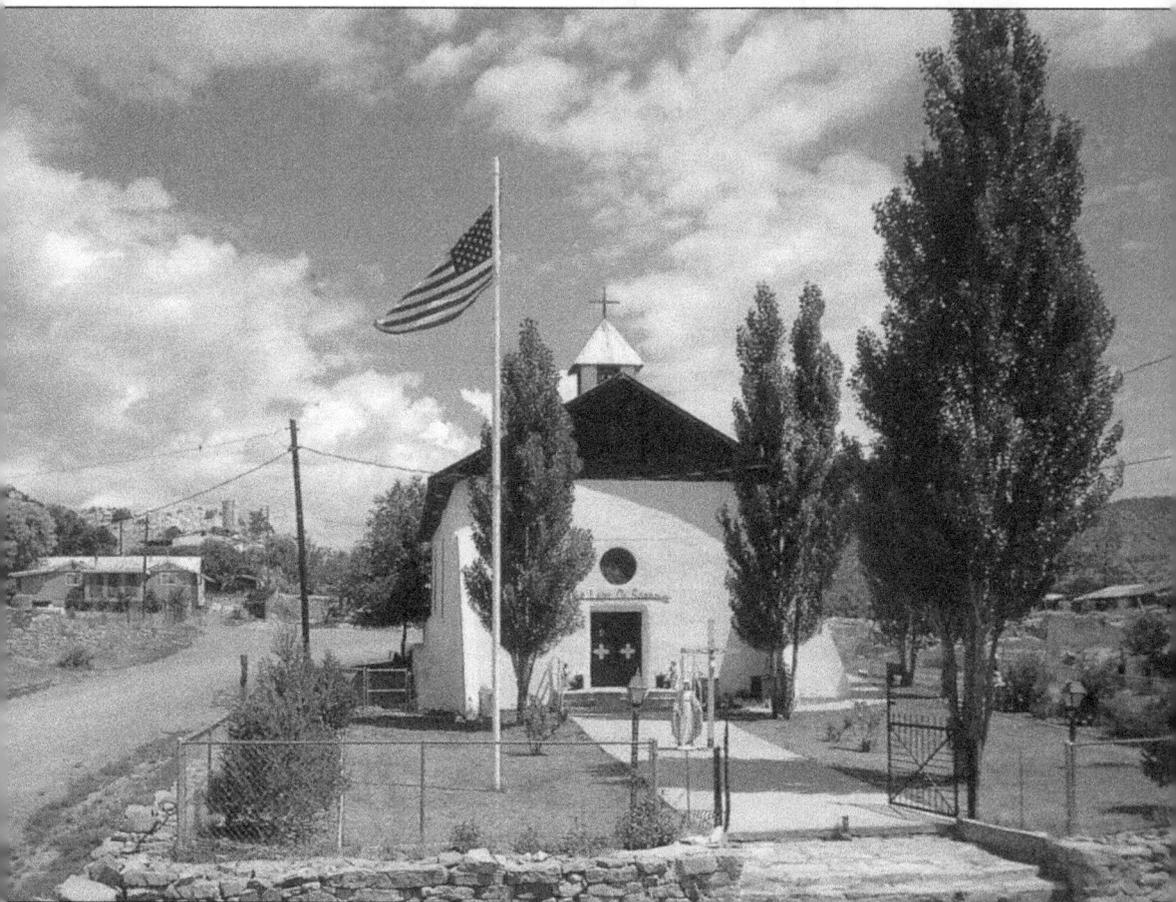

The village of Cebolleta (Spanish for "little onion") was founded in 1749 as a Franciscan mission to the western Apaches and Navajos. It also served as the headquarters for U.S. military operations against the Navajos from 1846 to 1858 and acquired a somewhat sinister reputation as a rallying point for Mexican slavers and outlaws in the middle of the 19th century. The chapel of Nuestra Señora de Los Dolores (Our Lady of Sorrows) was originally assigned to the parish of Isleta in 1855 and became a parish on its own in 1857. Cebolleta became a part of the Diocese of Gallup when that diocese was carved out of the Archdiocese of Santa Fe in 1939. Cebolleta is now one of the two mother churches of the parish of Cebolleta and San Fidel in the Diocese of Gallup. The present chapel dates to 1820. (Tony Gallegos.)

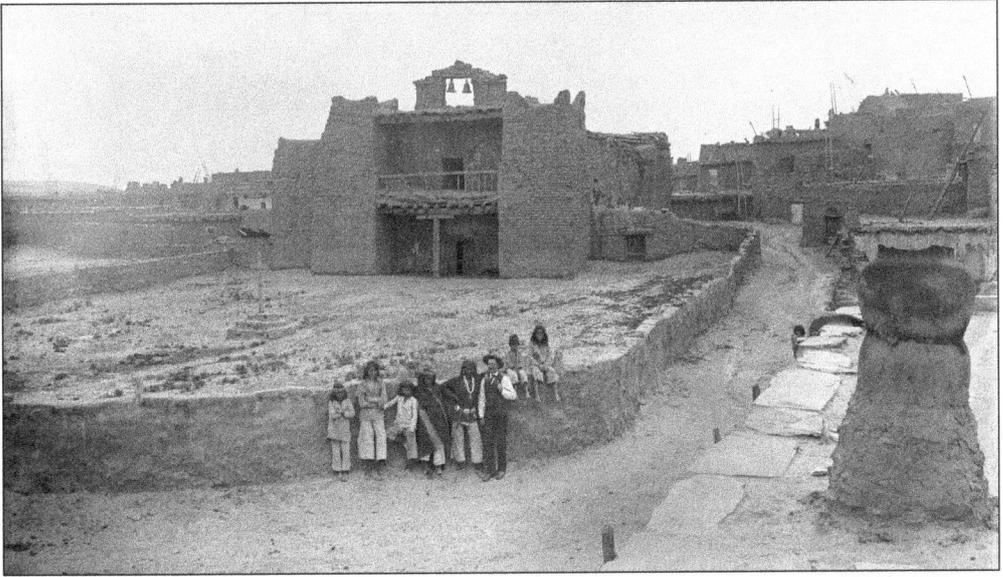

The pueblos of Zuni and Ácoma were the first to encounter Coronado in 1540; however, it would be 1629 before the mission church was built in Zuni. This church (above) was dedicated to Our Lady of Guadalupe during the Isleta period. The church of San Esteban Rey (Stephen I, the 11th-century king and patron saint of Hungary) was completed at Ácoma in 1640 (below). These churches were severely damaged during the 1680 Pueblo Revolt and again during a failed Native American uprising in 1696. After the clergy crisis in the late 1820s when the number of available priests sharply declined, and specifically from 1854 to 1857, these churches were served from Isleta. In 1857, they were reassigned to the newly formed parish of Cebolleta. (Above, Diocese of Gallup; below, Museum of New Mexico, 165882.)

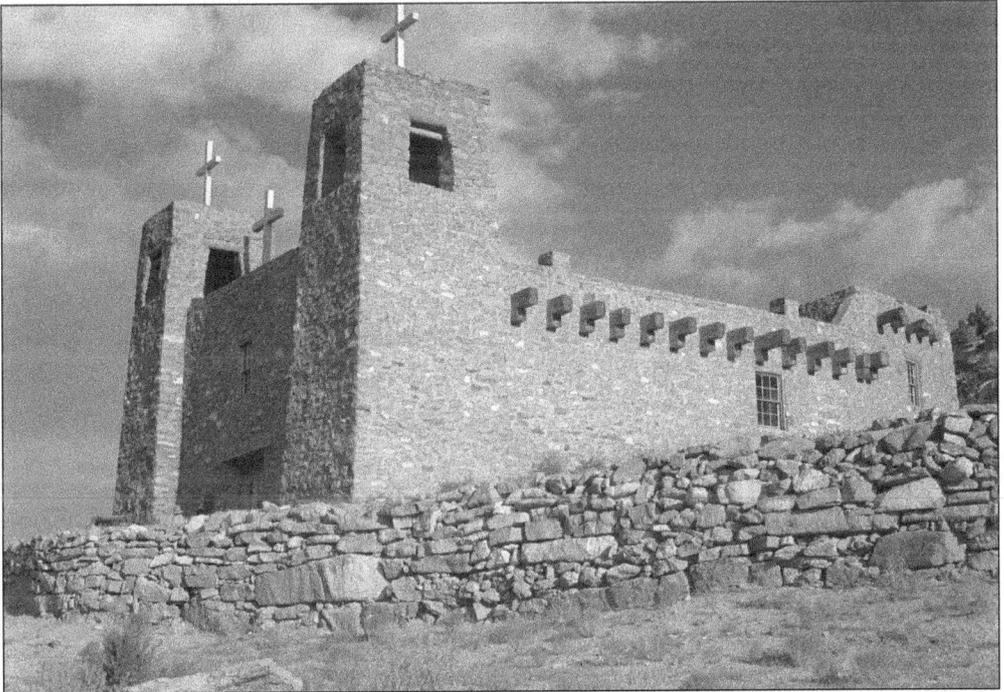

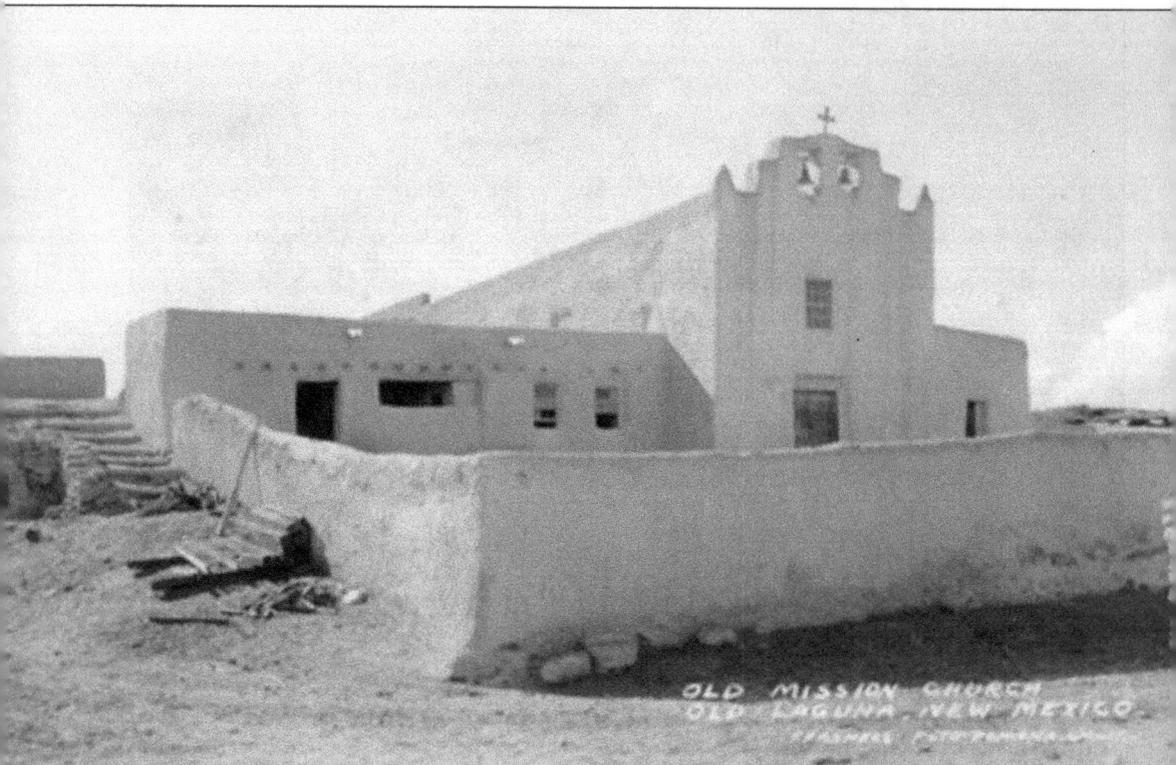

A church dedicated to San José (St. Joseph, the patron saint of New Spain) was built at Laguna in 1699 shortly after the De Vargas reconquest. This image is of the church after its 1935 restoration. It was also served from Isleta from 1854 to 1857, but not by Franciscans. The last Franciscan priest at Isleta had left by 1840, and diocesan priests from the Diocese of Durango, Mexico, were serving Isleta as well as most of the other Río Abajo parishes. Note the similarities to the front of the Isleta church in 1867—there are two small vertical structures and a central bell tower with two bells instead of one. The church is enclosed in a large courtyard that was used for dances during special festivities. In 1857, San José at Laguna was reassigned to the newly formed parish of Cebolleta. (Frashers Fotos Collection.)

Two

TOMÉ AND ITS MISSIONS

About 1660, Tomé Domínguez de Mendoza received a grant to the area southwest of the hill now known as El Cerro de Tomé. During the Pueblo Revolt, 38 members of his family were killed, and the remainder fled south, never to return. Even after the reconquest, the area continued to be victimized by raiding natives, so no large-scale resettlement was attempted. However, in 1739, the alcalde (chief administration officer) of Albuquerque granted permission for a group of residents to settle the area they referred to as *lo de Tomé*, or Tomé's place.

The first church at Tomé was completed in 1750, and dedicated to Nuestra Señora de la Concepción (Our Lady of the Immaculate Conception). A visitor in 1760 noted " a decent church already built . . . with a transept and three altars . . . dedicated to the Immaculate Conception. There is a house for the parish priest who is from Alburquerque [sic]." Immaculate Conception was erected as a separate parish in 1821.

During its more than 250 years of service, the Parish of the Immaculate Conception in Tomé has served the spiritual needs of the people of the Río Abajo. During that time, the parish's reach extended to 14 missions or visitas—east as far as Manzano and Tajique, south to Casa Colorada, and north to Bosque de Los Pinos and Isleta, a sprawling area encompassing nearly 600 square miles. In addition to the missions presented in this chapter, Tomé served the missions of Our Lady of Sorrows in Manzano, San Antonio at Tajique, St. Anthony and the Holy Family at Torreón, and St. Vincent de Paul at Punta de Agua (all recounted in chapter eight); a chapel dedicated to St. Ann located on the grounds of the Sánchez hacienda near the present-day intersection of Jerome and La Ladera Roads in Valencia; a chapel dedicated to San Lorenzo at Adelino; and several local oratorios and visitas.

Franciscan Province of the Holy Gospel 1535-1729

↓

Custody of the Conversion of Saint Paul 1616-1847

↓

Archdiocese of Durango 1729-1850

↓

Vicarite Apostolic of New Mexico under the Archdiocese of Saint Louis 1850-1853

↓

Diocese of Santa Fe 1853-1875

↓

Archdiocese of Santa Fe 1875-

↓ ↓

Diocese of Gallup 1939-

Diocese of Las Cruces 1982-

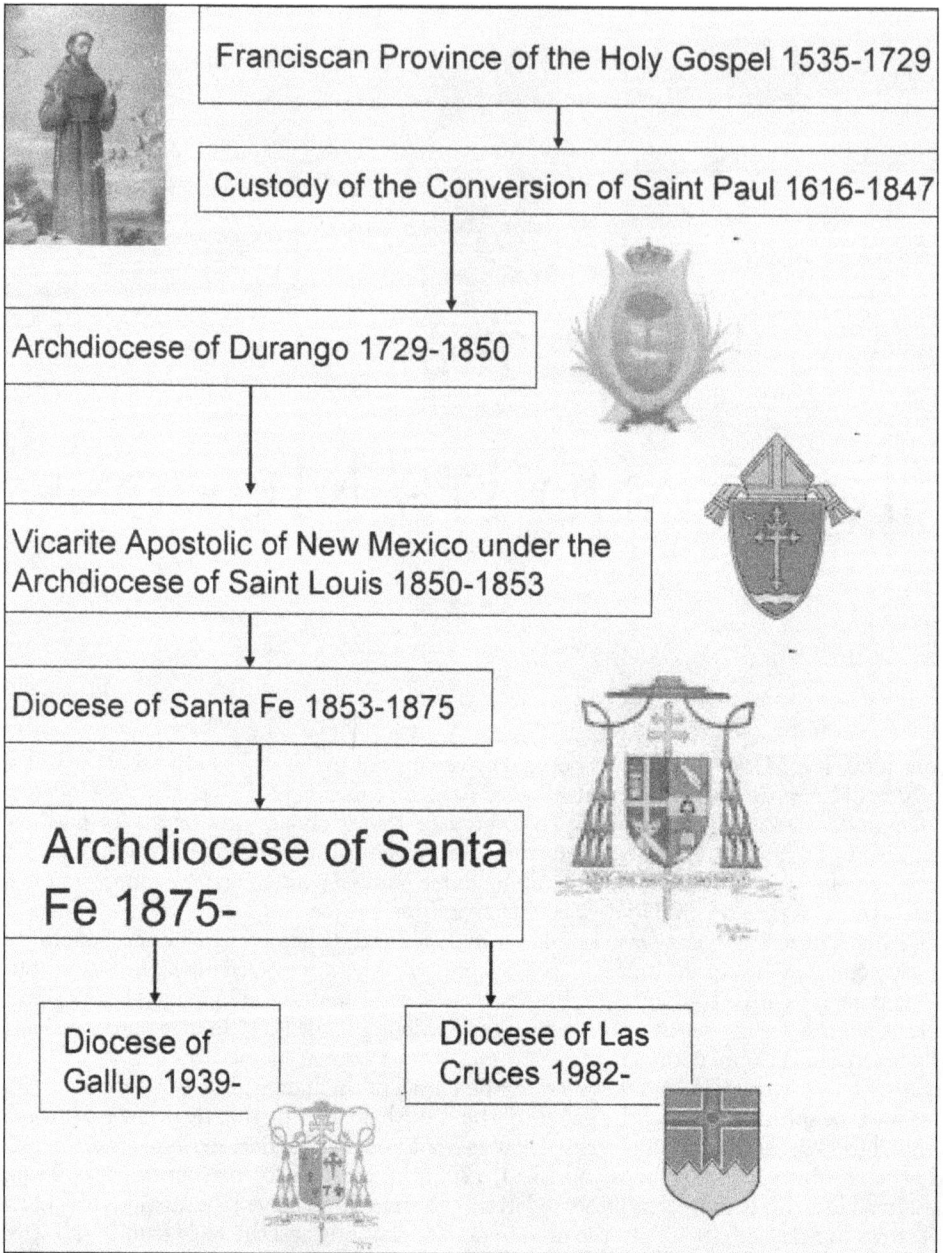

Ecclesiastical oversight for New Mexico's Catholics began with the Franciscan Province of the Holy Gospel, which had been established in 1535, five years before Coronado's expedition. In 1616, the Franciscans organized the Custody of the Conversion of St. Paul (a custody is a Franciscan administrative subunit of a province) to oversee their activities in the new colony. The missions and churches in New Mexico were officially annexed to the Archdiocese of Durango, Mexico, in 1729. As the population of the colony continued to grow and demand more priests, the Franciscans were pushed to the outlying areas. There they found themselves ministering almost exclusively at the pueblos, while diocesan priests served the Hispanic populations in the towns and villages. In the 20th century, the western portion of the Archdiocese of Santa Fe would be separated as the Diocese of Gallup, and the southern portion would be separated as the Diocese of Las Cruces.

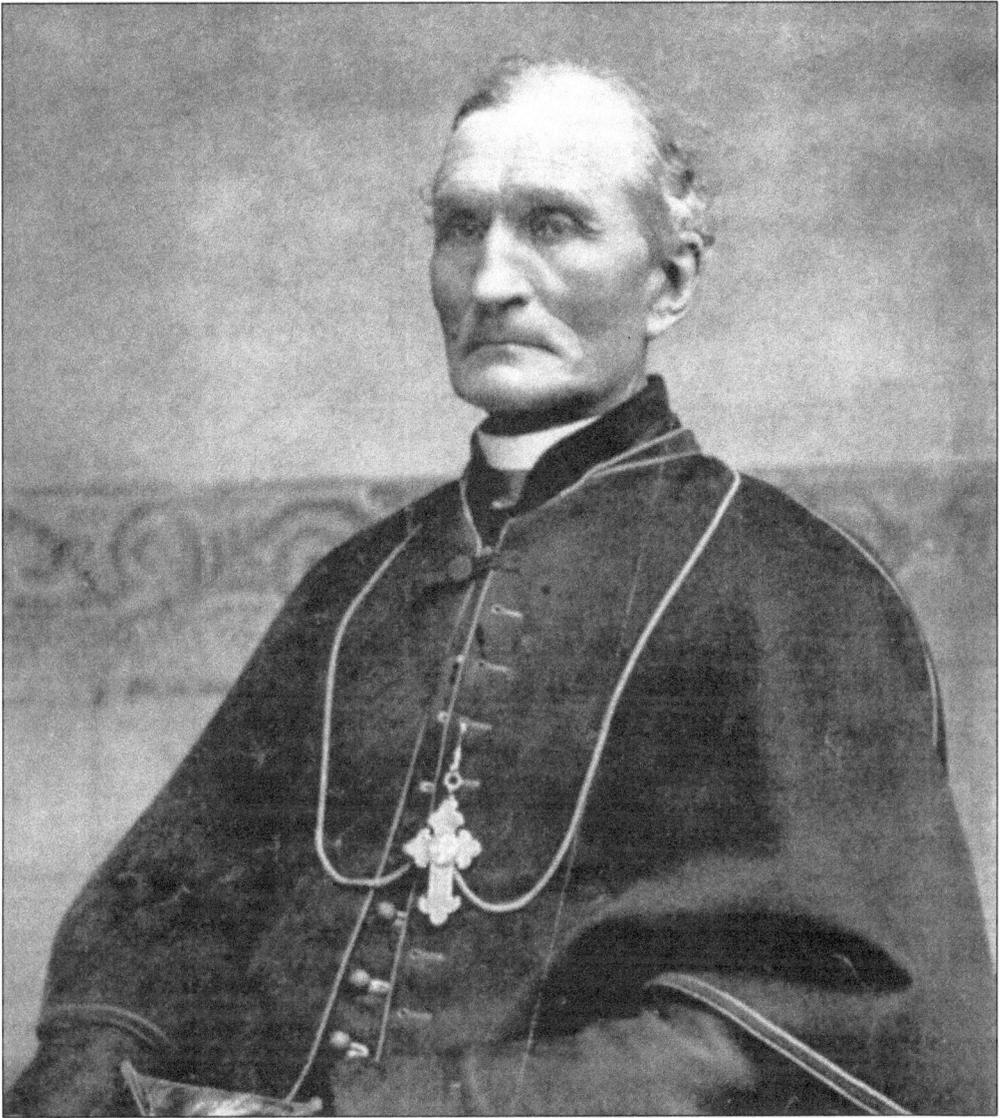

In 1850, Pope Pius IX designated part of the territory acquired from Mexico as the Vicarite Apostolic of New Mexico and assigned it to the westernmost diocese in the United States—the Archdiocese of St. Louis. He appointed Jean-Baptiste Lamy, a French-born priest then serving in Kentucky, as bishop. In 1853, the area was detached from St. Louis and designated as the Diocese of Santa Fe. The diocese was elevated to archdiocese in 1875, and Lamy continued on as archbishop. Lamy's influence on the new diocese was profound but in some cases clashed with the 250 years of extant tradition and practice to which the priests from Mexico were accustomed. Lamy was a local bishop, stationed "just up the road" in Santa Fe, as distinct from being nearly 1,000 miles away in Durango, Mexico. Many of the priests in the new diocese were not used to this degree of oversight. (Archdiocese of Santa Fe.)

San Felipe de Neri, 1790
New Mexico Adobe Style
The church has been in continuous use
since its construction. Both interior
and exterior show fine examples of
New Mexico folk art.

The venerable church of San Agustín at Isleta served as the mother church for Tomé off and on prior to the establishment of Immaculate Conception Parish in 1821. From 1858 to 1859, Isleta was designated as a mission of Tomé, with Fr. Jean Baptiste Rallière providing priestly service. The church in Tomé and the missions that came to be associated with it were also served by Franciscans from Belén and San Felipe Neri in Albuquerque (San Felipe is illustrated in the image above). In March 1793, a parish was established in Belén, and its new pastor, Fray Cayetano Ignacio Bernal, declared that he was also responsible for serving people from "Valencia to Tomé." On July 6, 1821, Fray José Pedro Rubí, the Franciscan *custos* (superior) in Belén, instructed Isleta pastor Fray José Ignacio Sánchez to turn responsibility for Immaculate Conception over to Padre Francisco Ignacio de Madariaga, Tomé's first parish priest. (Museum of New Mexico, 3-45lt.)

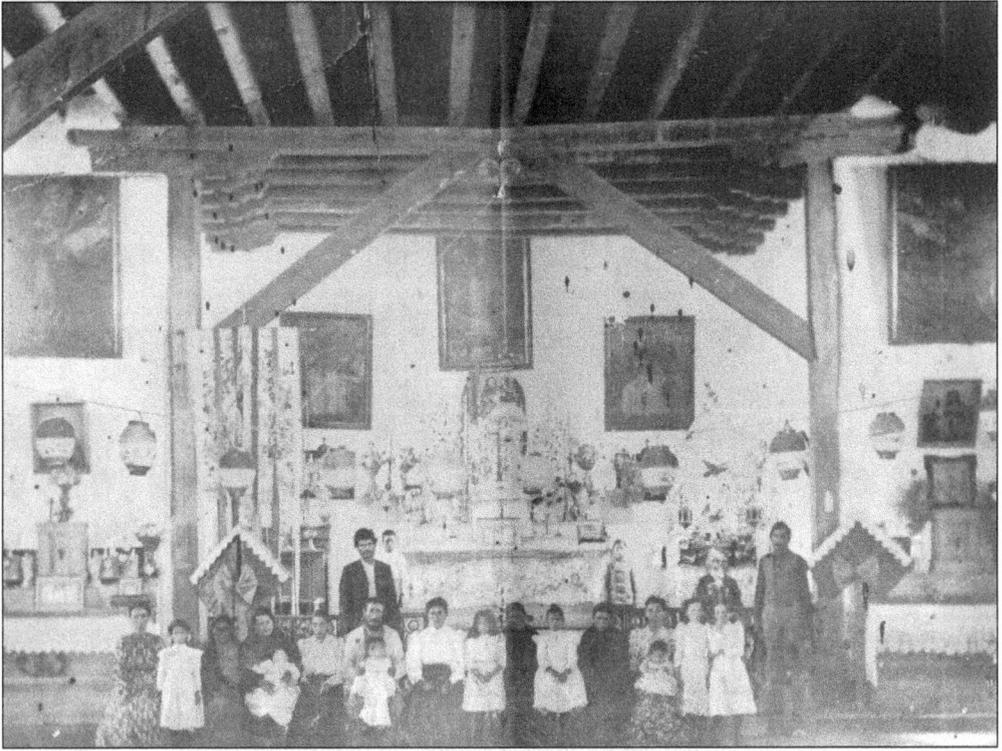

Through the years, floods inflicted significant damage in Tomé. The inundation of 1884 was particularly severe, leaving the church standing in 5 feet of water. The building was repaired, remodeled, and renovated several times, including the addition of towers. The photograph above dates from the late 19th century and shows the inside of the Tomé church. Note the extensive statuary and paintings on the altar. Judging from the formal dresses worn by the children, it probably reflects a First Holy Communion celebration. The 1915 image below shows a set of towers installed in the late 19th century, which had begun to deteriorate. (Above, Roberto de La Vega; below, Museum of New Mexico, 163771.)

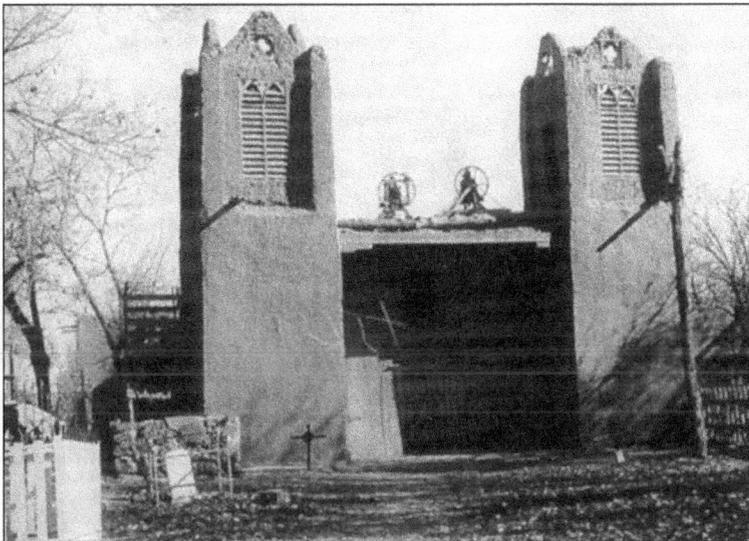

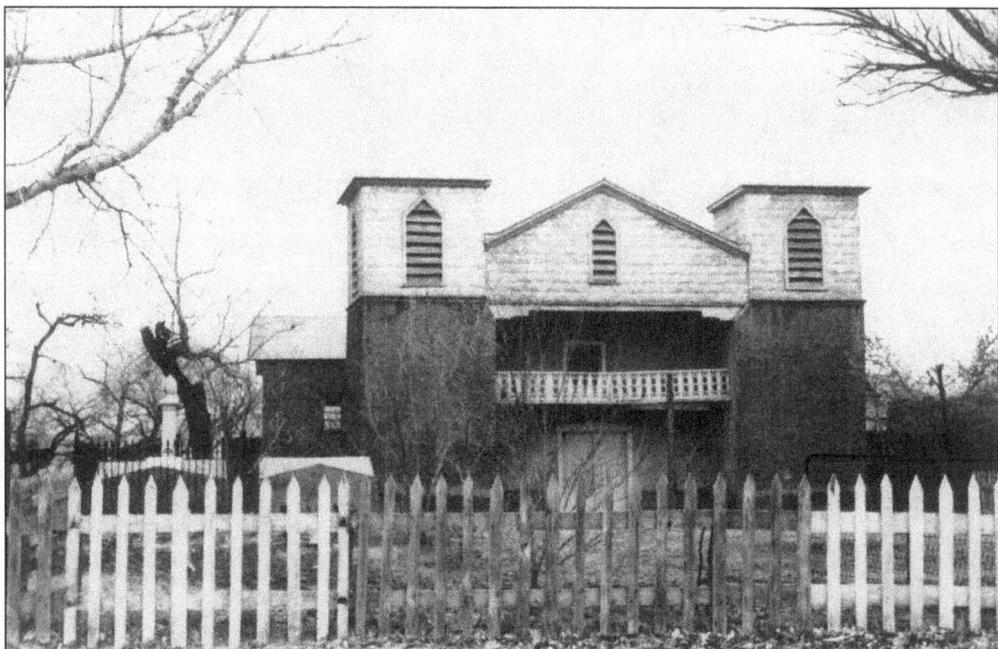

In the mid-20th century, the adobe towers that had suffered the ravages of wind, rain, and New Mexico winters were torn down, and the caps were replaced with slatted wooden tops with Gothic panes. A pitched roof was installed, and niceties such as electricity and gas heat were added. The towers were completely removed during another renovation in the 20th century. Though much of the ornate altar decoration has been removed in keeping with guidance from the Vatican and the archdiocese, the internal layout and essential character of the Tomé church has remained the same. (Above, Museum of New Mexico, 86712; below, Tomé Parish.)

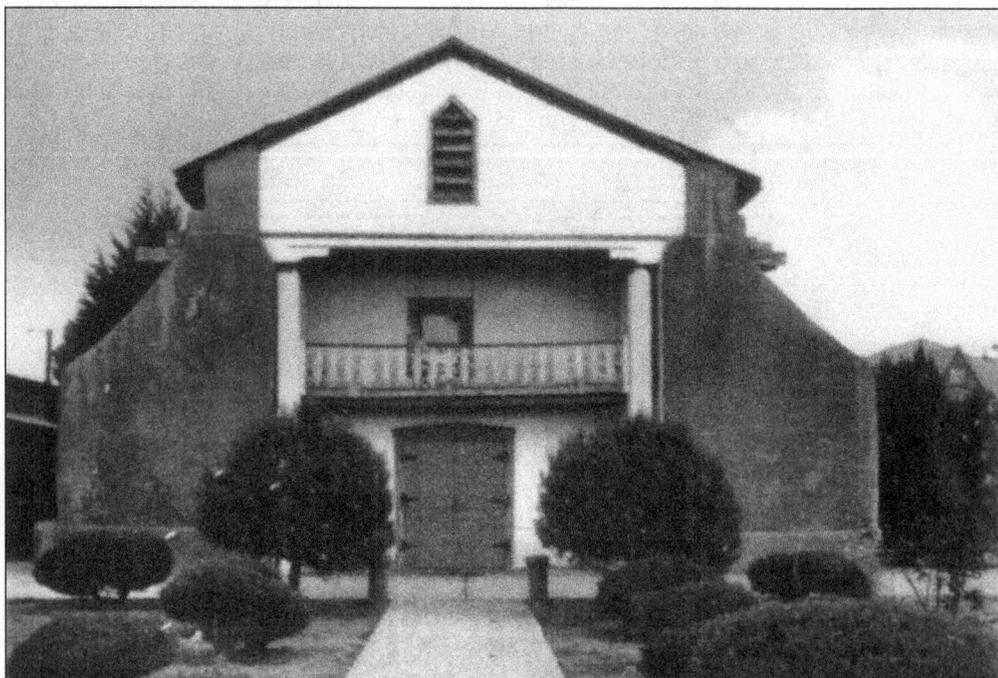

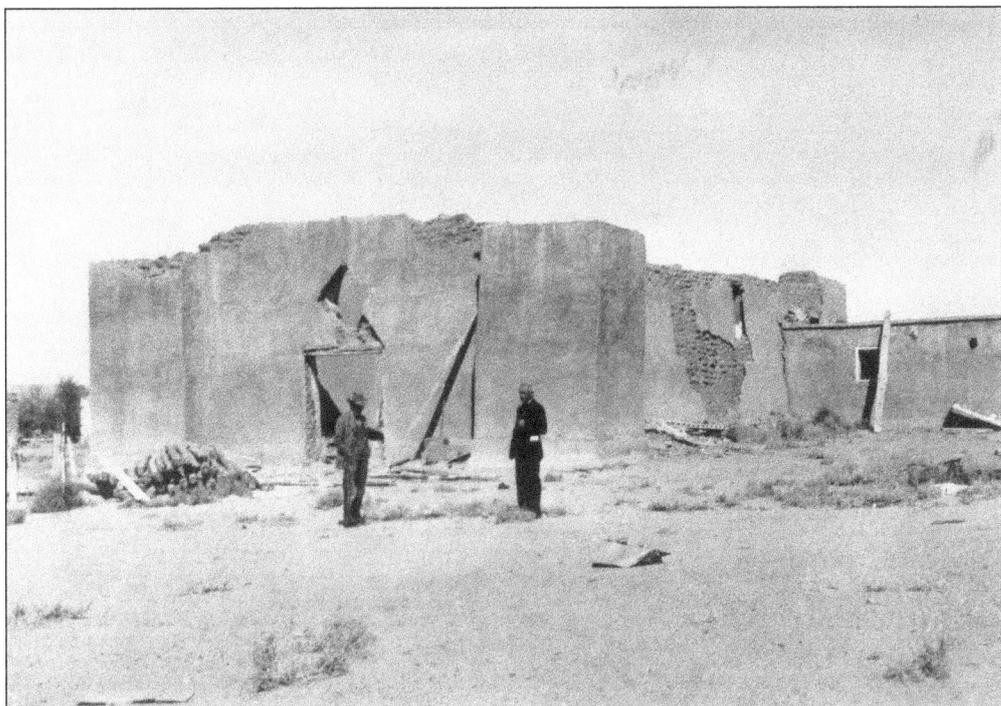

The Casa Colorada (Spanish for "red house") area, initially part of the Spanish land grant of Belén, was probably occupied in the late 18th century, since there are references to the location in several Spanish documents. Following the dictates of an 1823 decree from the Provincial Deputation of New Mexico for residents of outlying areas to consolidate for their mutual benefit and protection, 42 families from Manzano applied for a Mexican grant that was to be carved out of the eastern portion of the Belén grant. This Casa Colorada grant was approved on September 19, 1823. Permission to construct a church dedicated to the Immaculate Conception in the area had been granted two years earlier. The original flat-roofed structure was a mission of Tomé from the outset. By the 1930s, the original adobe structure was in ruins. (Both, Ben Otero.)

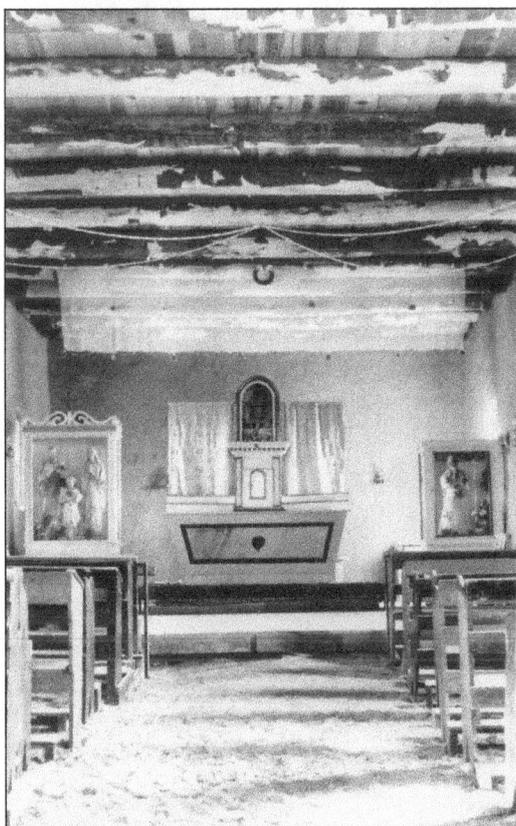

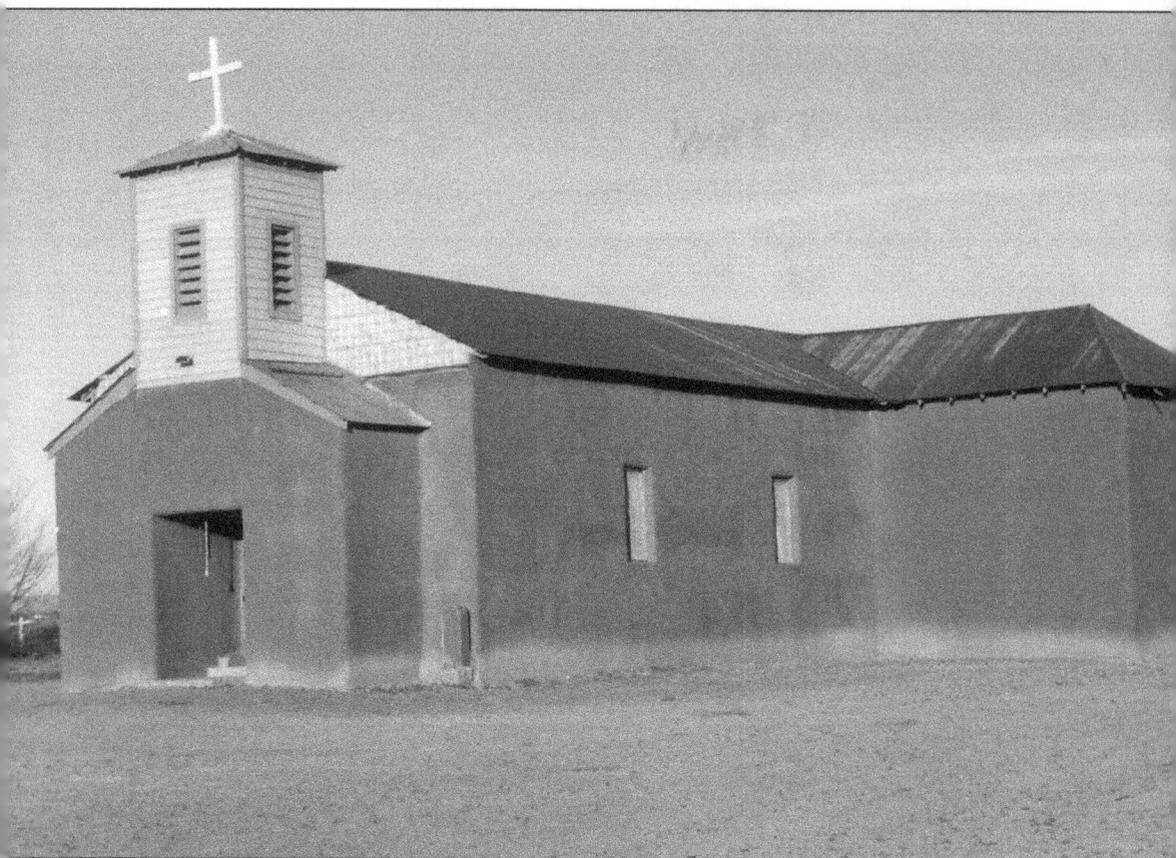

In light of the condition of the old mission and recognizing the attachment that the farmers and ranchers in the area had to their church, Fr. Joseph Assenmacher of Tomé had the old Casa Colorada mission razed and rebuilt in 1949. Although the structure was modernized and reflects many of the architectural features that characterized simple mission churches of the time (pitched roof, attached bell tower with a tall rectangular central section, standard nave-transept design), the new chapel was built on the footprint of the original structure. Although Tomé at one time had 14 missions or visitas stretching over 600 square miles, Immaculate Conception in Casa Colorada remains the sole mission of Tomé. The chapel, lovingly cared for by its assigned *mayordomos* (parishioners responsible for maintaining the church), is used primarily by the local residents for weddings, funerals, and other special devotions. (Ramon Baca.)

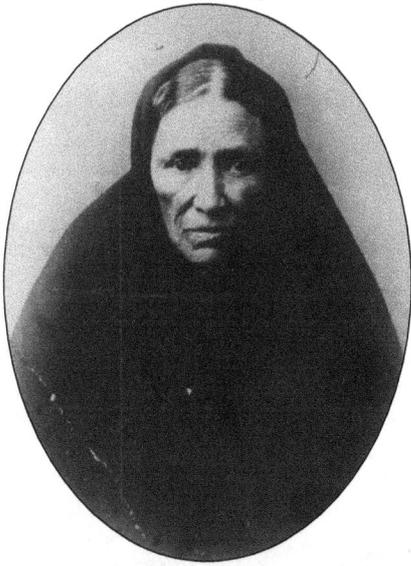

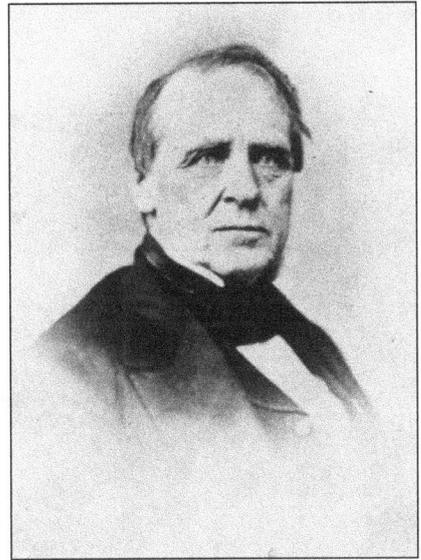

In the 1830s, Francisco Xavier Chávez, a former territorial governor of New Mexico, moved from his home in Los Padillas and built a hacienda (plan below) on land his family owned in Bosque de los Pinos (now Bosque Farms). His son, José Mariano Chávez, inherited the estate and lived there with his family until 1843. In that fateful year, José's son Antonio José, a well-known merchant and trader along the Santa Fe Trail, was murdered in central Kansas by a band of outlaws who were being paid by the Republic of Texas to disrupt the freighting trade between Santa Fe and Independence, Missouri. Antonio José's widow, Dolores Perea de Chávez (above left), subsequently married Henry Connelly (above right), the Civil War–era governor of New Mexico, and the couple moved to the Chávez estate in Los Pinos. (Above, Museum of New Mexico, 9846, 9847; below, National Archives.)

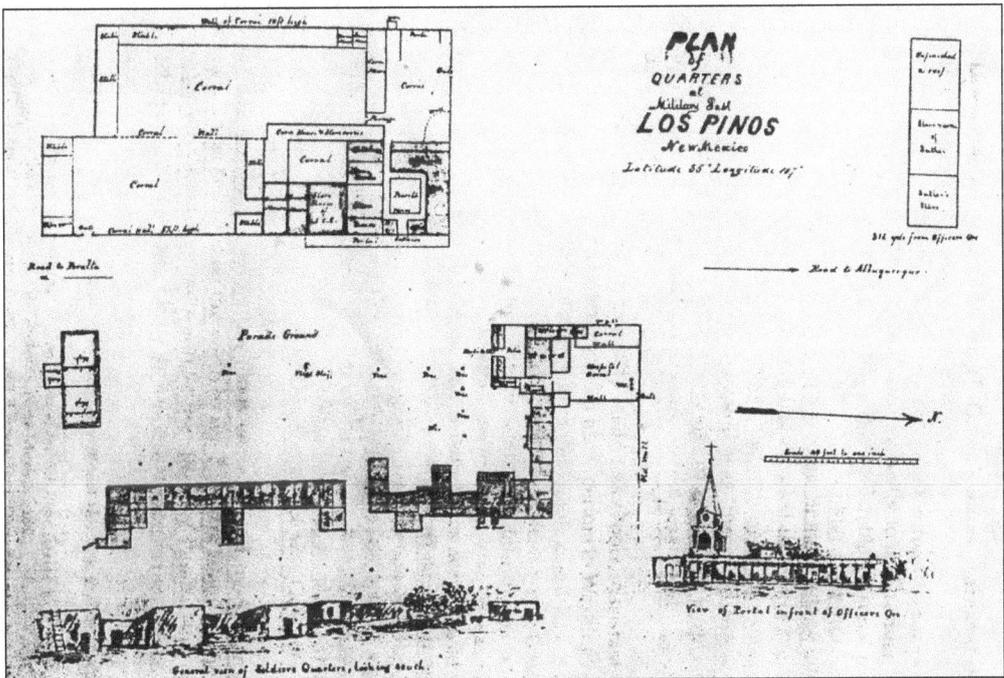

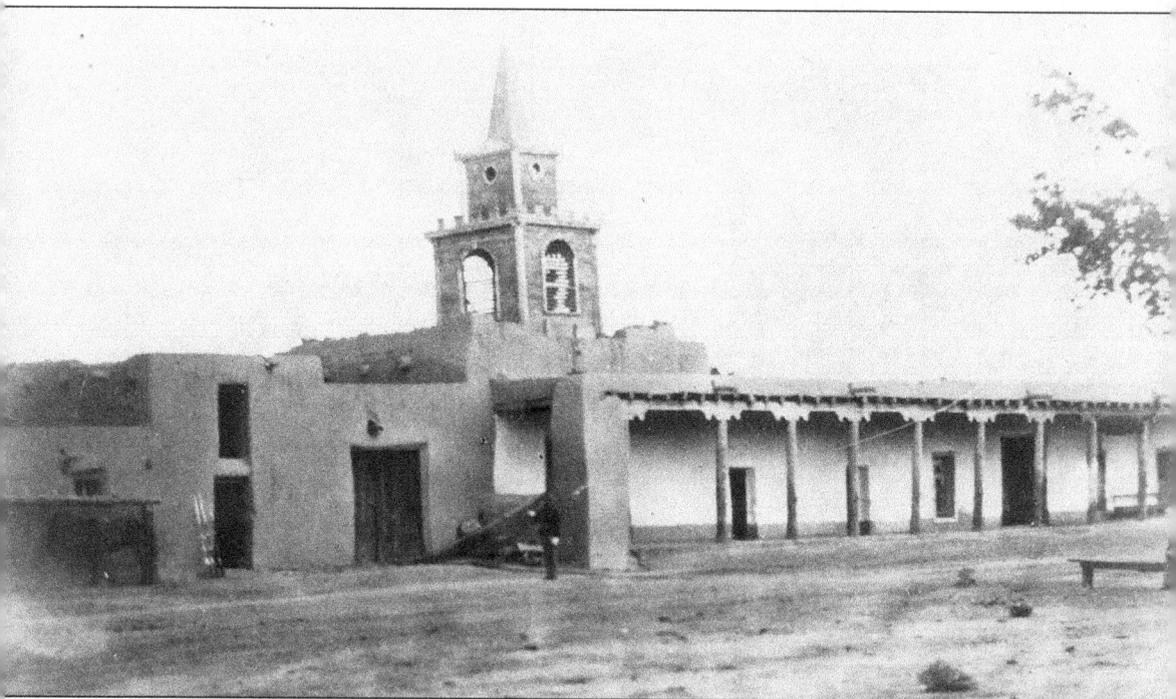

As was the custom, the Chávez hacienda included a chapel—in this case dedicated to Nuestra Señora de los Dolores (Our Lady of Sorrows)—visited on occasion by priests from Isleta. In 1859, the mission was attached to Tomé, and the patronage was changed from Our Lady of Sorrows to San José. It is very likely that during this time period the chapel was rebuilt in the French-influenced, neo-Romanesque style shown in this mid-19th-century photograph. The condition of the hacienda and chapel deteriorated near the end of the 19th century, and they were eventually torn down. (Museum of New Mexico, 101938.)

In 1941, Fr. Joseph Assenmacher of Tomé acquired a piece of land just east of El Cerro Loop and erected a small chapel to serve the growing population in that area. The new chapel was dedicated to Santa Ana (St. Ann), perhaps recalling a mission dedicated to St. Ann in nearby La Ladera that had burned in 1929. The chapel continued to be served from Tomé until 1974, when it was determined that parish resources were being overtaxed by its continued use. In addition, vagrants were breaking into the building, raising the specter of desecration of the structure and its furnishings. In accordance with the 1941 donation agreement, ownership reverted to the original landowner, and the structure was torn down. (Both, Ben Otero.)

Tomé may well hold the record for the length of a single pastorship. Fr. Jean-Baptiste Rallière, a priest from Mont-Ferrand (the French seminary attended by Archbishop Lamy), was one of 116 French priests recruited for service in New Mexico. In June 1858, Rallière was assigned to Tomé and remained at his post until his reluctant retirement in April 1913, a remarkable 55-year tenure. Rallière, who came to be known as "El Padre Eterno," was responsible for ministering to a parish of nearly 600 square miles and oversaw renovations at many of the churches as well as construction of missions at Peralta and La Ladera. (Left, Emma Gabaldon; below, Los Lunas Museum of Heritage and Arts.)

Three

THE CHURCHES OF
BELÉN PARISH

The land around Belén (Spanish for "Bethlehem") was formally granted in 1741, although there had been a previous settlement in the area, and there was probably a hacienda chapel, where priests from Isleta occasionally said Mass. Traditionally Belén has been dedicated to Our Lady of Belén, although it may have been dedicated to Our Lady of the Assumption during the 1850s. Belén was erected as a parish in 1793.

Belén was just one of several sleepy agricultural villages along the Rio Grande until 1909, when the Santa Fe Railroad opened a segment of the transcontinental railroad through Abo Canyon east of town. Suddenly the village was transformed into a bustling railroad hub. To accommodate the burgeoning population, the church was enlarged, making it for a time the largest church in the territory, with a capacity for over 1,100 worshippers.

Belén still has four active missions: Our Lady of Guadalupe in Los Chávez, San Francisco Xavier in Jarales, San Isidro in Pueblitos, and Cristo Rey in Bosque. Belén has also served a number of additional missions, including Sausal, Tomé, San Clemente, Sabinal, Santa Rita, Socorro, and the stations of Álamo and Tres Hermanos, which were located along the Río Salado west of Belén.

The parish of Our Lady of Belén has served the Catholics of Belén and the surrounding farming and mining communities for over 250 years, helping them to survive the ravages of floods, Native American raids, and economic ups and downs. Today it remains one of the anchor parishes in the Río Abajo.

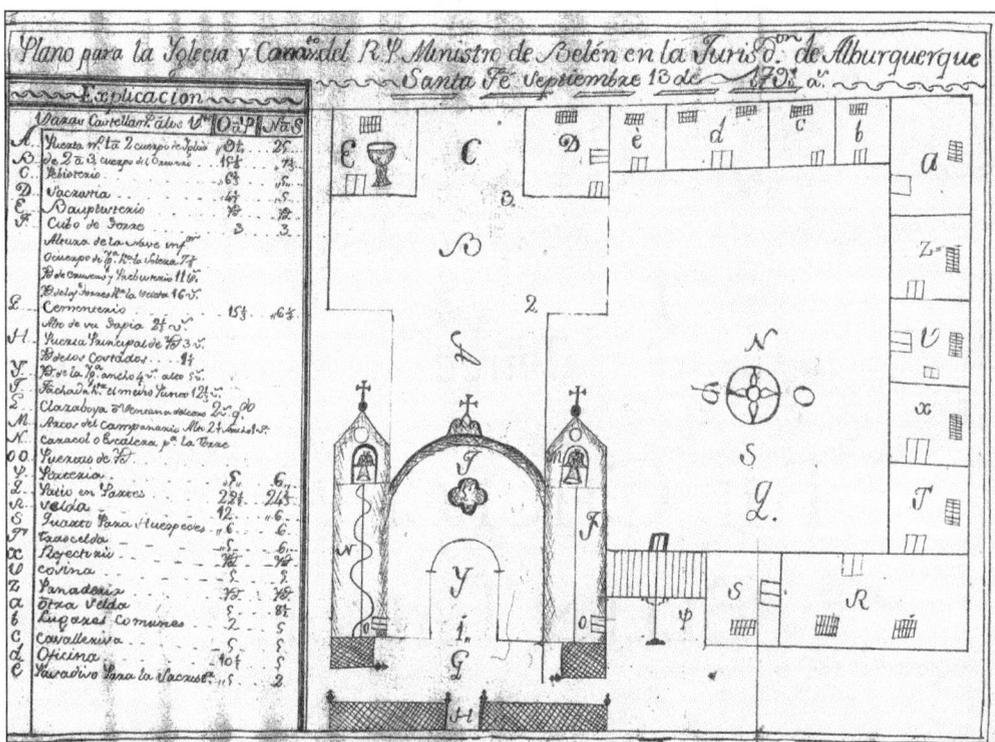

The original Belén church was located in Plaza Vieja near the intersection of Wisconsin and Ross Streets. A 1793 image from the Durango archives shows a nave-transept layout with a supporting convento on the east side. The church withstood periodic flooding until a disastrous inundation in the spring of 1855. (New Mexico State University Archives.)

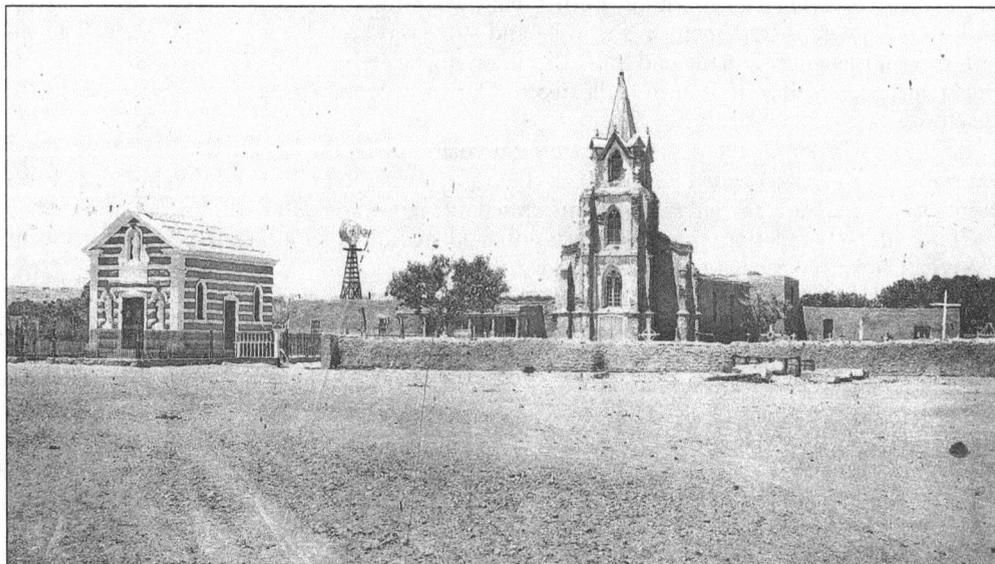

In 1860, a new church was dedicated on higher ground about a mile southwest of Plaza Vieja. Building materials from the original structures were used for the new church. The new structure had two towers until 1875, when they were replaced with a single neo-Gothic tower built by Francisco Follenfant, a local French architect and builder. (Los Lunas Museum of Heritage and Arts, 21.05.50.)

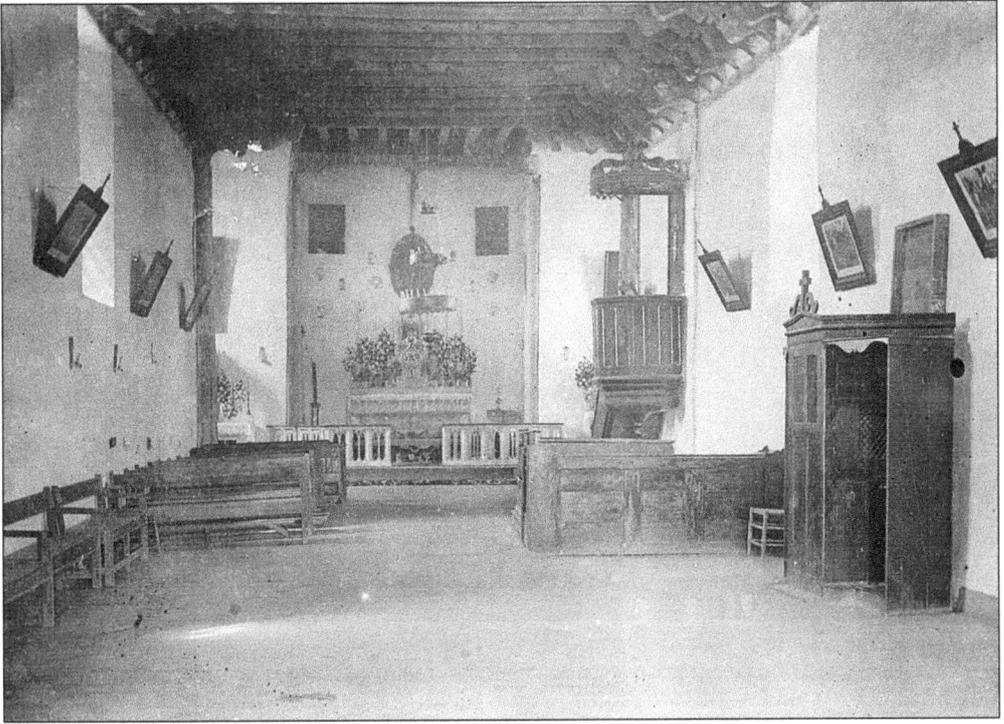

In 1894, Our Lady of Belén (above) still had very few pews and a dirt floor where the worshippers stood or knelt. The altar was small and plain, and the rear of the altar area was covered in tinwork by local artisans. Note the raised platform to the right of the altar from which the Gospel and other readings were proclaimed, and the confessional behind the pews on the right side of the nave. The classic viga roof construction is also apparent. By 1918, the church had been substantially enlarged (below), the altar was much more ornate, and the paintings and tinwork had been removed. In addition, there were more pews on a wooden floor. (Both, Los Lunas Museum of Heritage and Arts, 21.50.416, 20.52.15.)

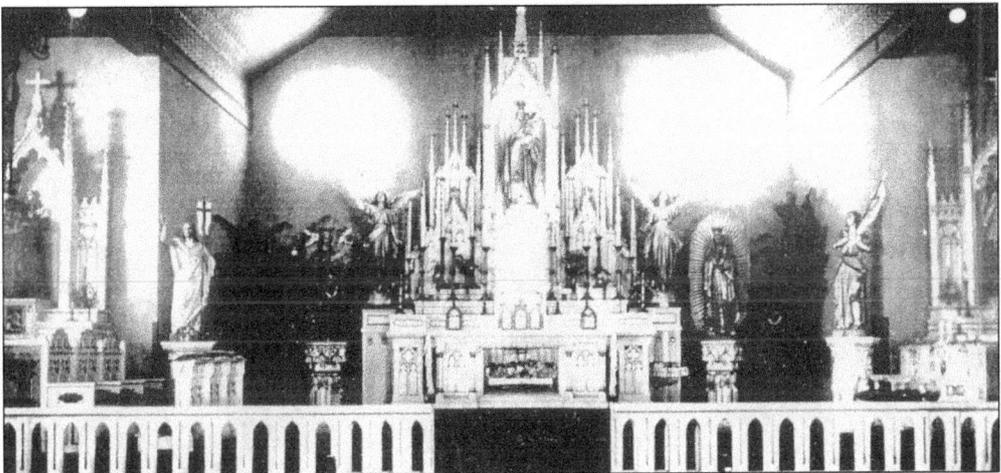

In 1971, an engineering evaluation of the 111-year-old church found that "the main church building is in a critical state of degenerating structural failure. While it is possible that the building may stand for a long period in the future, it is highly probable that an external force such as wind, rain and/or snow, earthquake or tremor, sonic boom, or subsoil movement could cause serious structural collapse." The decision was made to condemn the structure and rebuild a new one on the same location. In February 1972, no doubt with much sadness on the part of parishioners, the building was demolished. (Both, Los Lunas Museum of Heritage and Arts, 20.51.19, 21.02.58.)

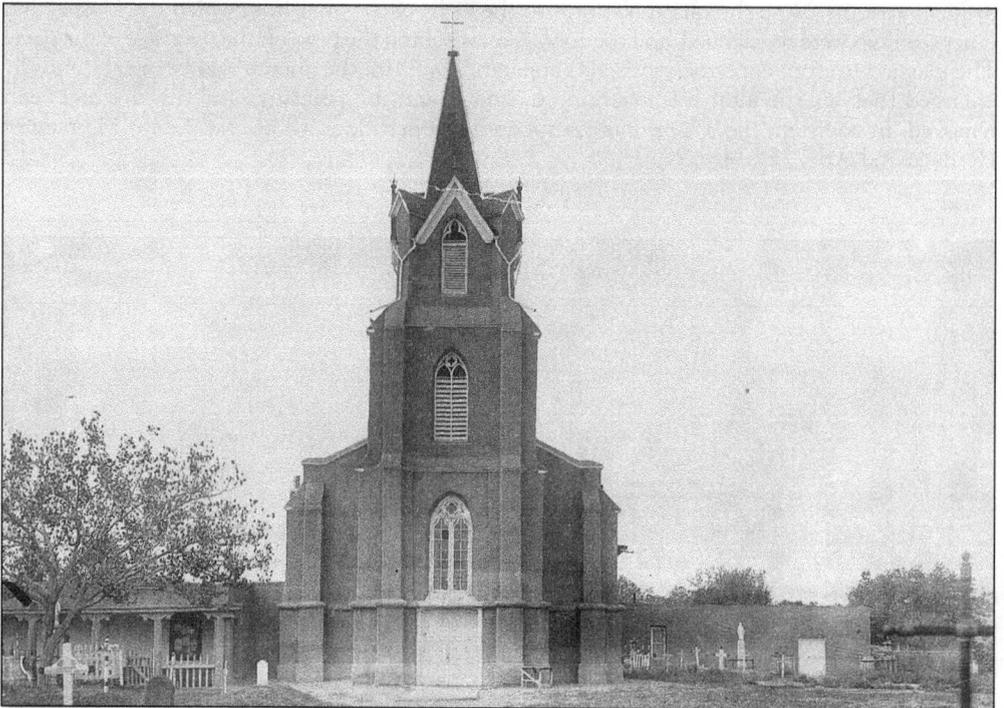

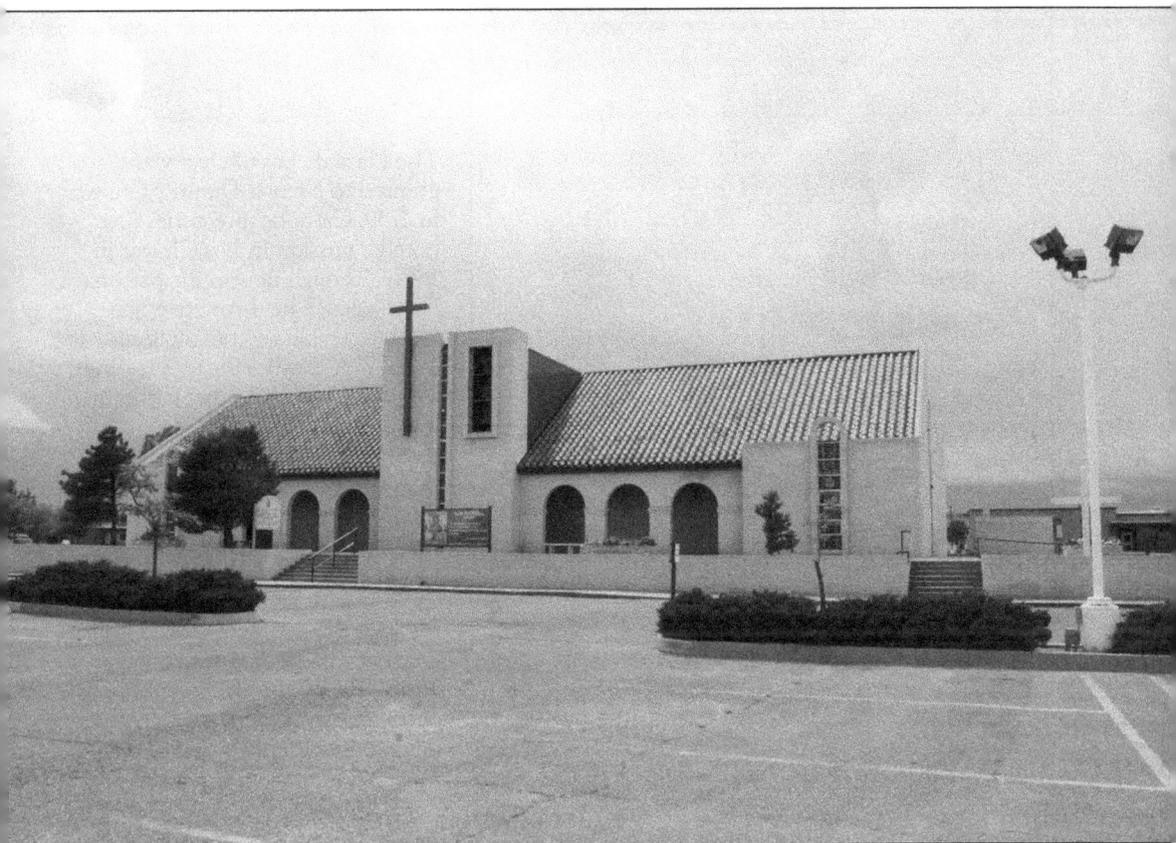

The new Belén church, designed in the Spanish modern style by Santa Fe architect Bernabe Romero, was constructed by local contractor Herman Tabet. Erected under the watchful eye of the priests of the Order of the Servants of Mary (known as Servites), leaders of the parish since the late 1920s, it is a thoroughly modern structure with an amphitheater-style interior. The structure, which took two years to complete, seats more than 1,000 worshippers. The church complex now includes the main sanctuary, associated administrative and educational facilities, a school dedicated to St. Mary, and the cemetery, which contains a monument and burial plot that replaced the mausoleum of Felipe Chávez (the striped building in front of the church in the earlier images). The first Mass was celebrated on Christmas Day 1973, and the new church was dedicated by Archbishop James Peter Davis on February 17, 1974. (B. G. Burr.)

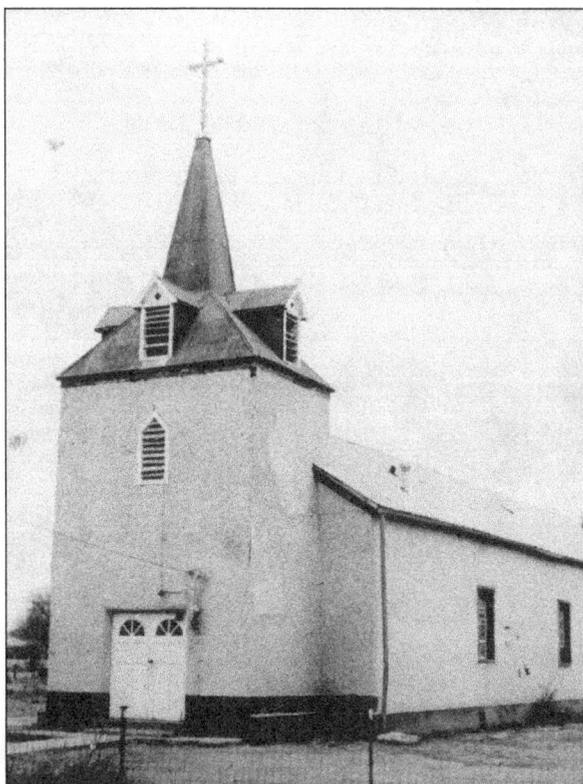

The Plaza de Los Chávez was granted to Nicolas Duran y Chávez in 1739. Catholic directories first noted a mission in Los Chávez in 1857, although no specific patronage is recorded. The distinctive neo-Gothic steeple was probably added in 1877. A north wing for meetings, meals, classes, and other gatherings was added in 1973, and the distinctive red tin roof was added in 2003 as a part of the repairs that followed a particularly violent hail storm. Many of the internal furnishings of the church, including an altar with an inset sculpture of the Last Supper, were moved from Our Lady of Belén to Los Chávez during the 1971 reconstruction of the parish church. (Left, Los Lunas Museum of Heritage and Arts; below, Patty Gallegos.)

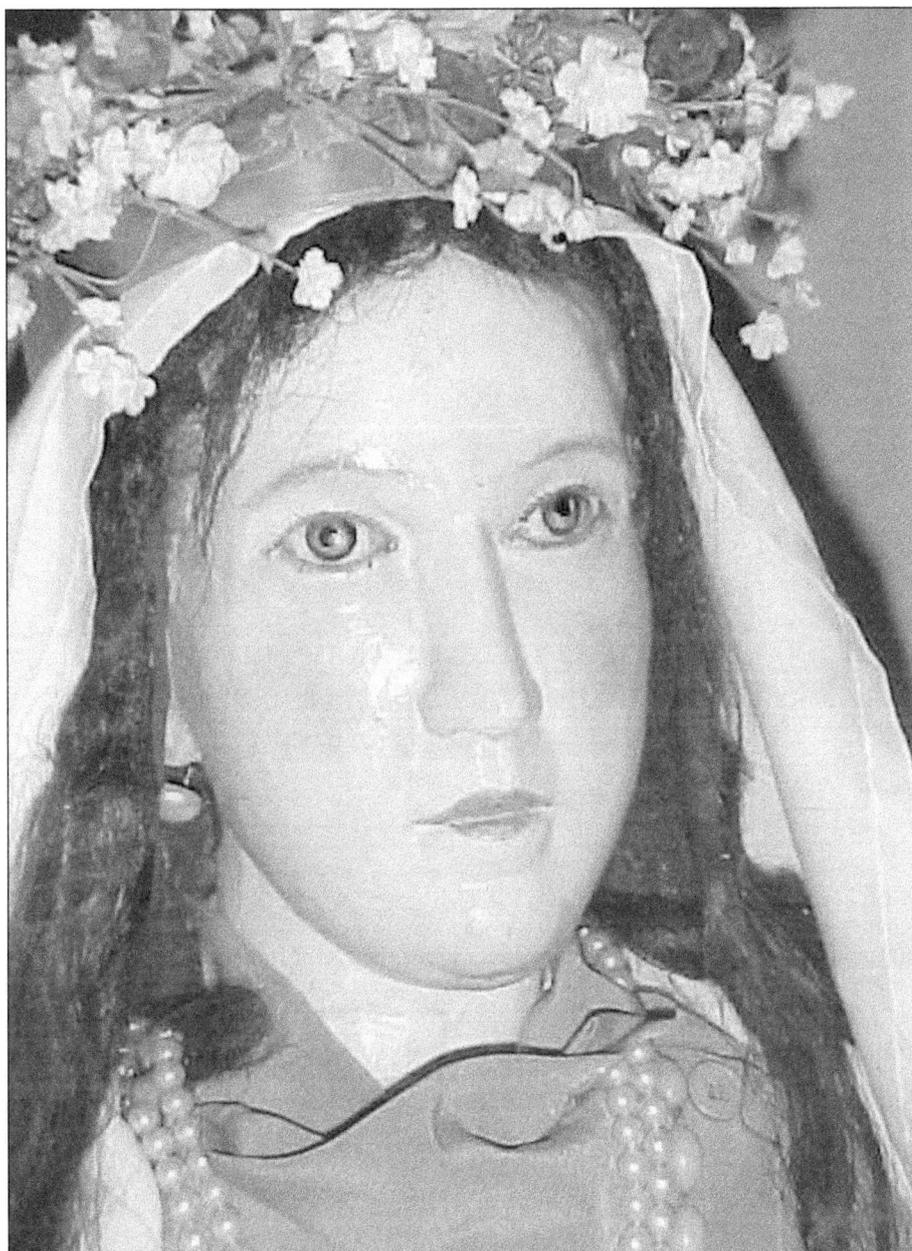

Carved statuary (*bultos*), as well as carved and painted *retablos* or altar screens (sometimes referred to by the archaic French term *reredos*), were a feature of churches and missions throughout New Mexico in the Spanish and Mexican periods. The mission of Our Lady of Guadalupe in Los Chávez includes a bulto of the Blessed Mother attributed to the artist Antonio Silva, whose carvings also adorn the Río Abajo churches in Tomé and Valencia. Silva, who may have been from Tomé, worked in central and southern New Mexico during the end of the 18th and the beginning of the 19th centuries. This particular statue of the Virgin Mary was found in a pile of mud and brush following a bad flood in the late 19th century. It was kept in local homes until it was cleaned, restored, and donated to Los Chávez. Parishioners continue to dress and adorn the statue, especially for special festive occasions.

43

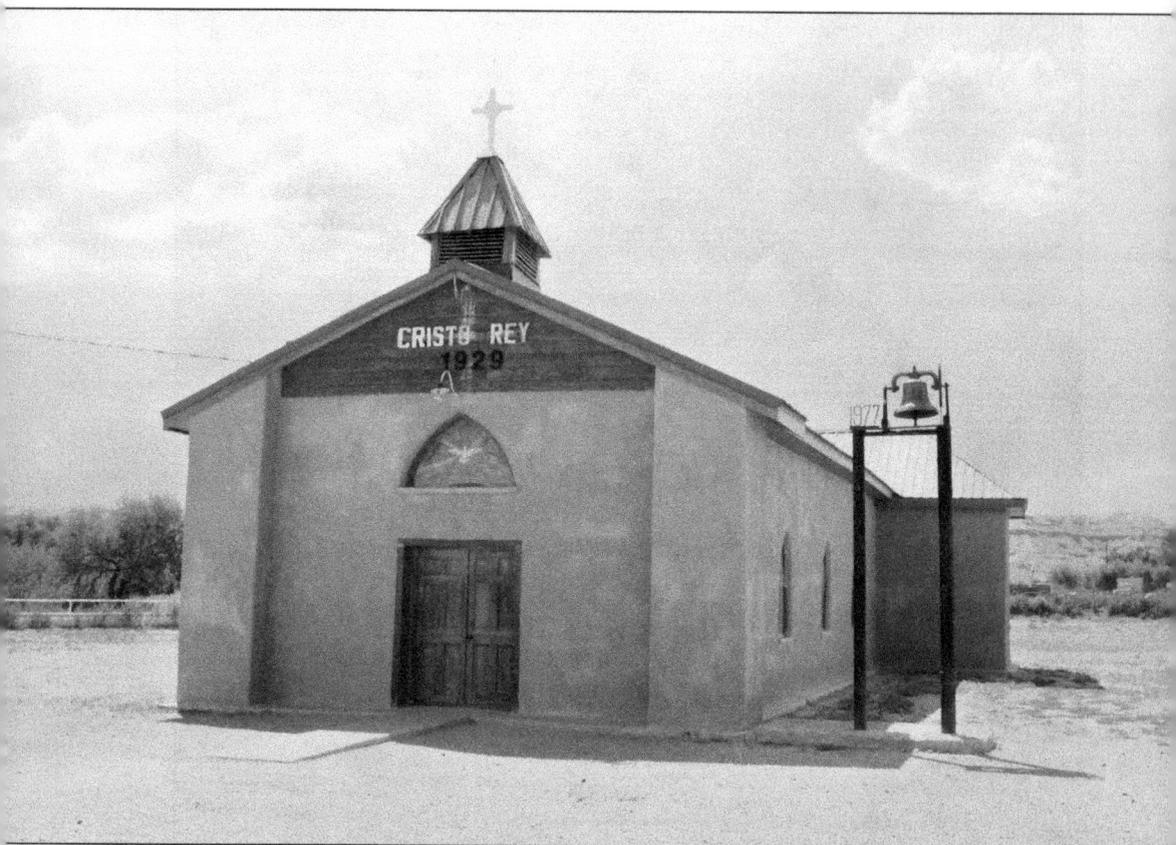

The village of Bosque (the Spanish word for the area of dense plant growth along a river) lies about 7 miles south of Belén and was settled on the west side of the Rio Grande in the 1750s. The chapel in Bosque probably predates the Mexican-American War of 1846–1848, and it was intermittently mentioned in the Catholic directories as attended from Belén during the 1850s. It disappeared from the records for about 60 years, reappearing in 1913 as one of several missions of Belén. There is another 18-year hiatus in the records from 1919 to 1931. The dedication to Cristo Rey, a patronage instituted by Pope Pius XI in 1925, was given to the new church at the request of a Chicago donor who provided a considerable sum of money to the Parish of Belén in exchange for the dedication. Prior to 1925, the church may have been dedicated to Our Lady of Victory. The present structure dates from 1929. (B. G. Burr.)

The area now known as Jarales may have been named for one of its first residents, Pedro Jarales, or for the jara plant, a local scrub willow. It may also have been the site of the pre-1741 settlement of Belén. It was formally established in 1776 as Los Ranchos de Los Jarales. The mission was noted in 1852 and 1853, then again in 1874. A new church with two columns and a central steeple dedicated to St. Francis Xavier was documented in 1875 (right). Later during the 20th century, the side columns were capped, the center steeple was enlarged, and the building was stuccoed (below). (Right, Los Lunas Museum of Heritage and Arts; below, B. G. Burr.)

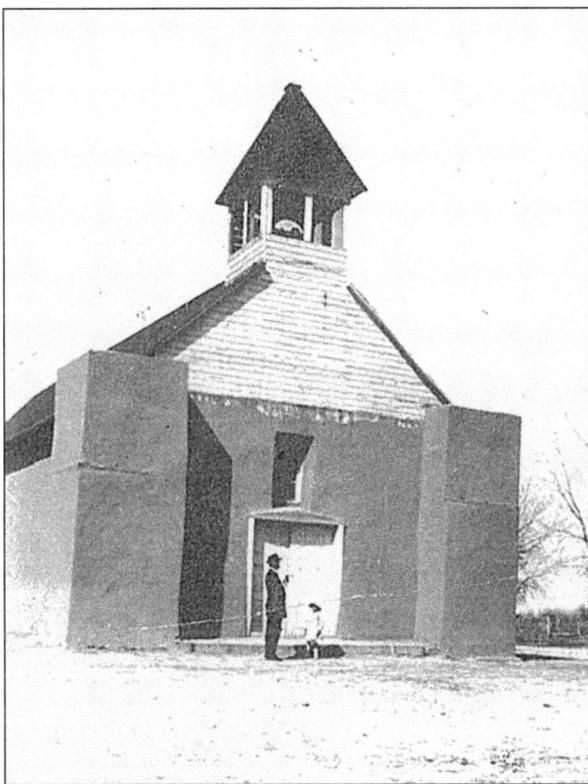

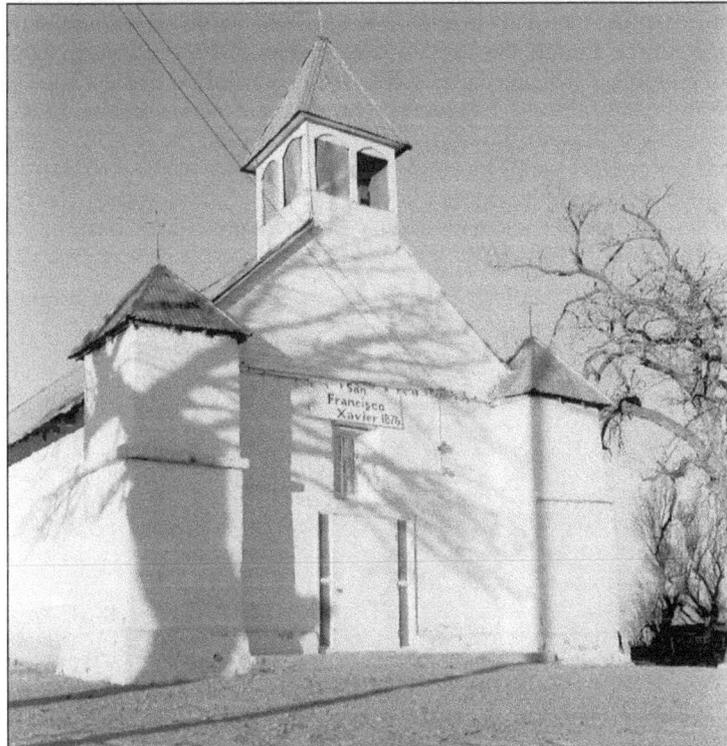

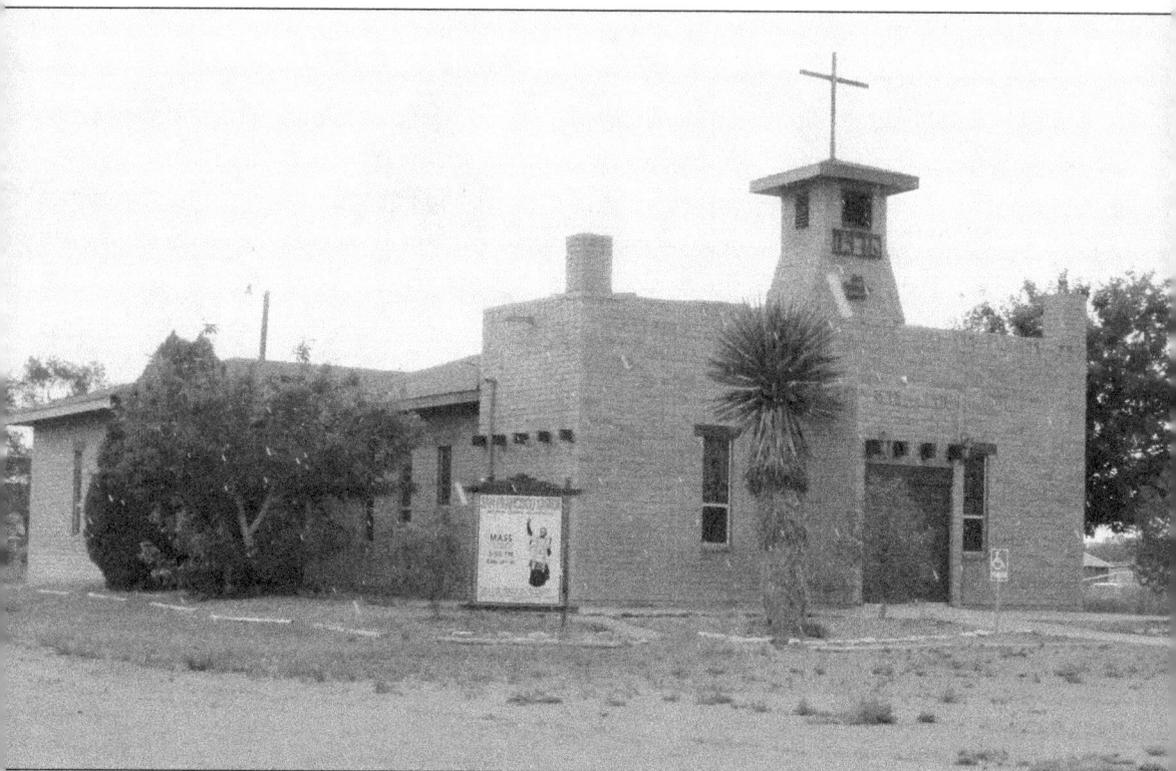

The 1875 St. Francis Xavier mission had suffered significant deterioration, and like the mother church in Belén, the columns that had originally been installed without sufficient footing were separating from the main body of the church. As a result, the structure was torn down in 1976 and replaced with the current building. Although reminiscent in some ways of the earlier chapels, this church has a distinctive architectural style. The two side columns are merely representative (recall the similar design at San José in Laguna, shown in the first chapter), and the central steeple has a flared base with a much less angular cap. The yucca plants in the front of the church give it an almost Moorish appearance. Although the exterior has been substantially changed over the years, the interior cruciform design with a classic nave and transept remains. (B. G. Burr.)

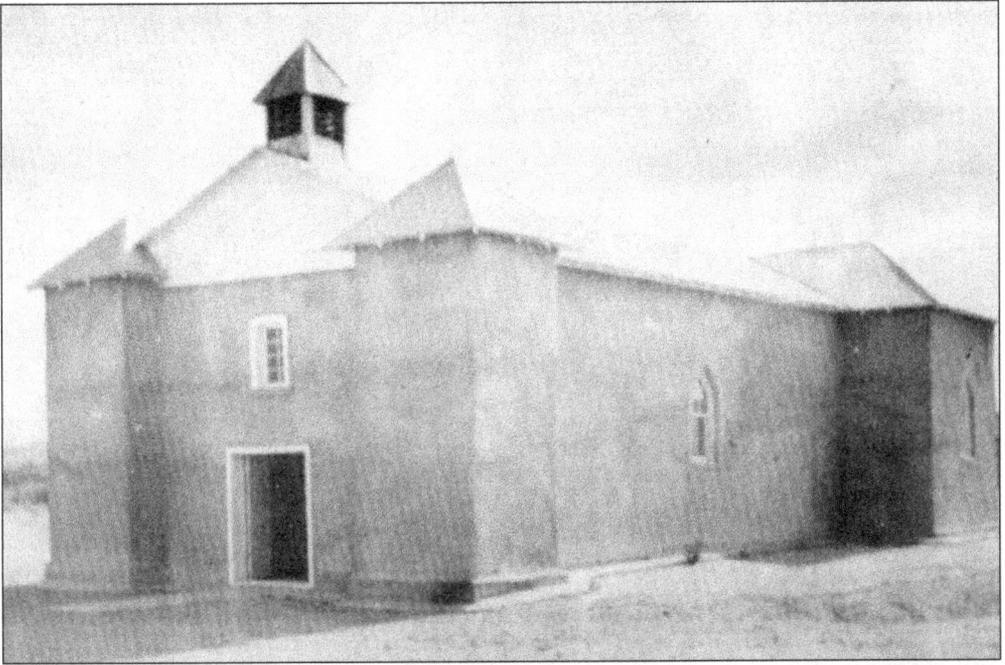

The small farming village of Pueblitos (Spanish for "little village") is nestled south of Belén and west of Jarales on the west side of the Rio Grande. The first chapel in Pueblitos was dedicated to San Isidro in 1877. It was noted as Los Pueblitos y el Bosque and assigned to Belén for the first time in 1880. Since Pueblitos is only 5 miles north of Cristo Rey, it apparently served the Catholic populations of both Bosque and Pueblitos for much of the late 19th and early 20th centuries, perhaps filling in some of the lost time noted earlier for Cristo Rey. The current structure is a simple rectangular building with a front portico supported by carved columns, capitals, and a bas-relief statue of the patron. The building was dedicated on May 14, 1961. (Above, Celso Armijo; below, B. G. Burr.)

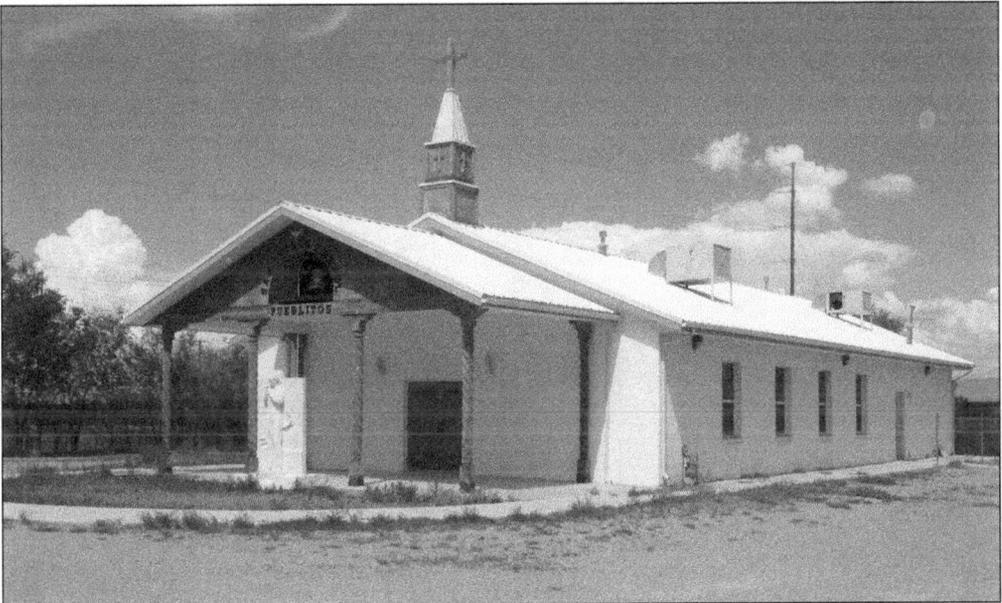

The chapel of Our Lady of Refuge, another of the Río Abajo chapels with a neo-Gothic steeple that forested the area in the late 19th century (i.e., Belén, San Clemente, Tomé, Los Chávez, Los Pinos, and San Antonio de Los Lentes), was originally constructed in 1850 on the east side of Sausal (Spanish for "plantation of willows") on a rancho belonging to Juan Cristóbal Chávez. The location may have been about half a mile east of the present-day intersection of Route 314 and Gabaldón Road. In 1877, the so-called "roaming chapel" of Sausal was rebuilt in the area of La Ladera, where it remained until 1905. It was then moved to its present location, a hacienda originally built by the Felipe Castillo family in 1878 and 1879. Sausal was listed as a mission of Belén from 1859 until 1912. Although now deconsecrated and a part of a family home, the former mission is occasionally used for nondenominational weddings. (B. G. Burr.)

Four

LA JOYA, A JEWEL IN THE VALLEY

La Joya (Spanish for "bowl" or "jewel") was originally settled in the early 17th century at the site of a Piro pueblo. The settlement was abandoned and set ablaze by Native American raiders sometime before 1626, but was resettled in the late 1620s. A visita of Socorro dedicated to San Luis Obispo (St. Louis the bishop) was established at the site but abandoned in 1658. The area was resettled a few years thereafter, only to be evacuated during the Pueblo Revolt. This time it remained unoccupied for 120 years.

In 1800, the area was resettled and named La Joya de Sevilleta. The new settlers built a church that they dedicated to Nuestra Señora de Los Dolores (Our Lady of Sorrows). La Joya was a point of defense against Native American raids, as well as being the mustering point for caravans moving south along El Camino Real.

From the early 19th to the mid-20th centuries, this region was a transitional area between the larger parishes of Belén and Tomé to the north and Socorro to the south. Over the decades, the parish included a mother church, 10 missions, and six stations. In 1949, La Joya attained its present configuration with the mother church, Nuestra Señora de Los Dolores, and five missions—San Juan Bautista (St. John the Baptist) in Veguita, San Isidro in Las Nutrias, San José in Contreras, San Antonio in Abeytas, and San Antonio in Sabinal. Three former missions, San Acacia, Santa Barbara, and Chupadero, still exist in ruins, and two others, San José in La Joyita and San Andrés in Bowling Green, have disappeared entirely.

This area typifies the independence and devotion of rural New Mexico that has helped to preserve the Catholic faith throughout the Río Abajo for nearly 450 years.

La Joya (shown above) was a mission of Sabinal from 1867 until 1881. After a flood destroyed the church in Sabinal in 1881, the parish was relocated to La Joya. In 1905, Sabinal was restored as the parish church, and La Joya reverted to mission status. The roles were again reversed in 1920, and La Joya has remained the mother church of the parish since that time. (B. G. Burr.)

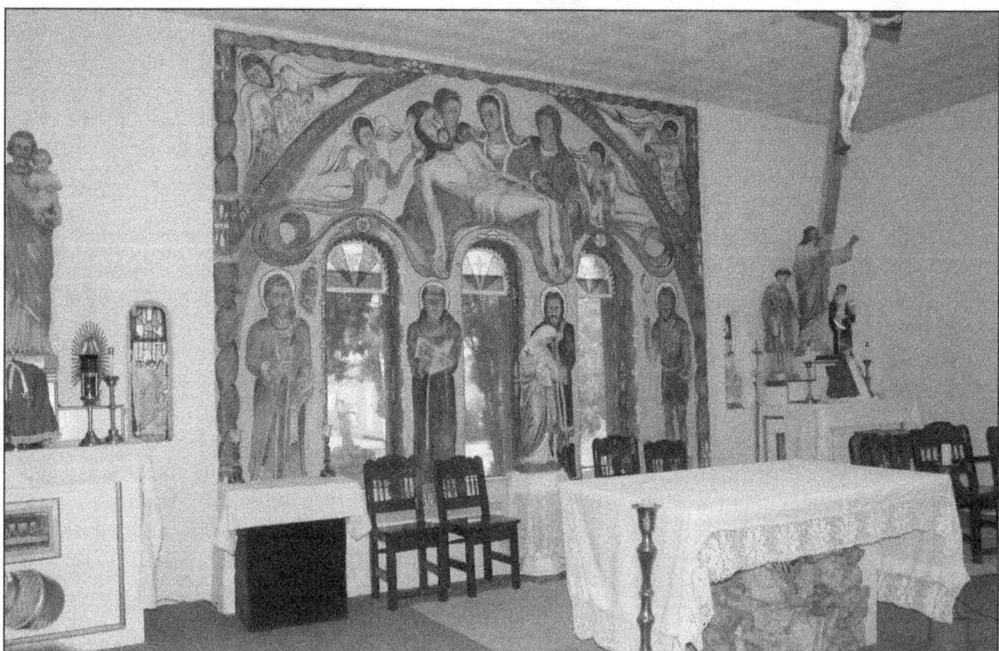

In 1986, Federico Vigil created a fresco of Our Lady of Sorrows behind the church altar. The four saints' images between the windows are the four patrons of the parish missions: San Antonio, San Juan Bautista, San José, and San Isidro. The faces of the angels are those of deceased parishioners, and the figure of one of the consoling women is parishioner Filomena "Nene" Lovato.

The current church in Veguita (below) was built in the 1970s to replace a structure that had been there since 1905 (above). The village's original name and the dedication of the church can be traced to 1598, when Oñate noted "the pueblo of San Juan Bautista, four leagues north of La Joya." Note that dedications to John the Baptist are rendered both as "Baptista" and "Bautista" in church records. The name of the village was changed to Veguita (little meadow) sometime before 1917. San Juan Bautista has been a mission of La Joya/Sabinal since 1894. (Above, Museum of New Mexico, 86709; below, John Taylor.)

Las Nutrias (*nutria* can mean either beaver or a beaver-like animal such as a muskrat; both are common to the area) was originally settled in 1765, and a chapel was constructed and dedicated to San Gabriel (St. Gabriel the Archangel). It is also shown on Miera's 1779 map of the Rio Grande province. Las Nutrias was some distance from the river, so water shortages and Native American raiding led to its early abandonment, and it was not resettled until the 19th century. The church, now dedicated to San Isidro, was made a mission of La Joya in 1894. (Both, B. G. Burr.)

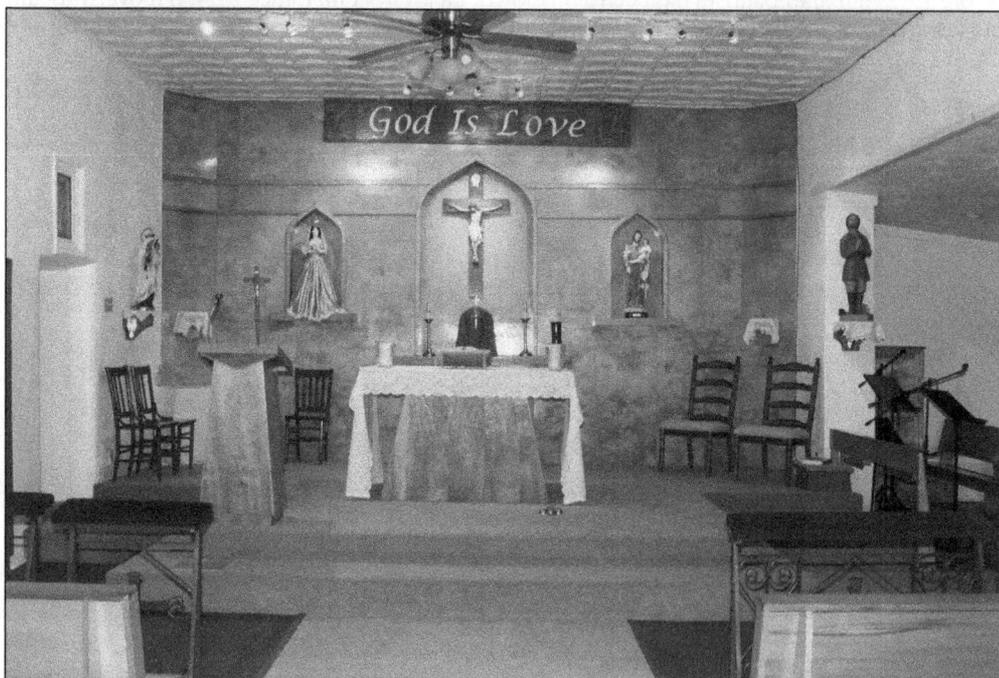

Several of the missions in the Río Abajo show a strong influence of the California mission architectural style. This style is characterized by features such as deep set and ornamented entrances, *espadaña* facades (the subsiding curved front walls), *companarios* (walls pierced for bells), and *corredors* (arcades to provide outdoor shade along the sides of the building). San Isidro at Las Nutrias includes three of these four features: the doorway beneath an ornamented portico, the espadaña facade, and the companario-like opening in the facade. Note that the bell itself is in the small steeple structure in front of the facade. Corredors were less common in the small Río Abajo churches, although San Agustín de Isleta had one during the 19th century. (Patricia Gallegos.)

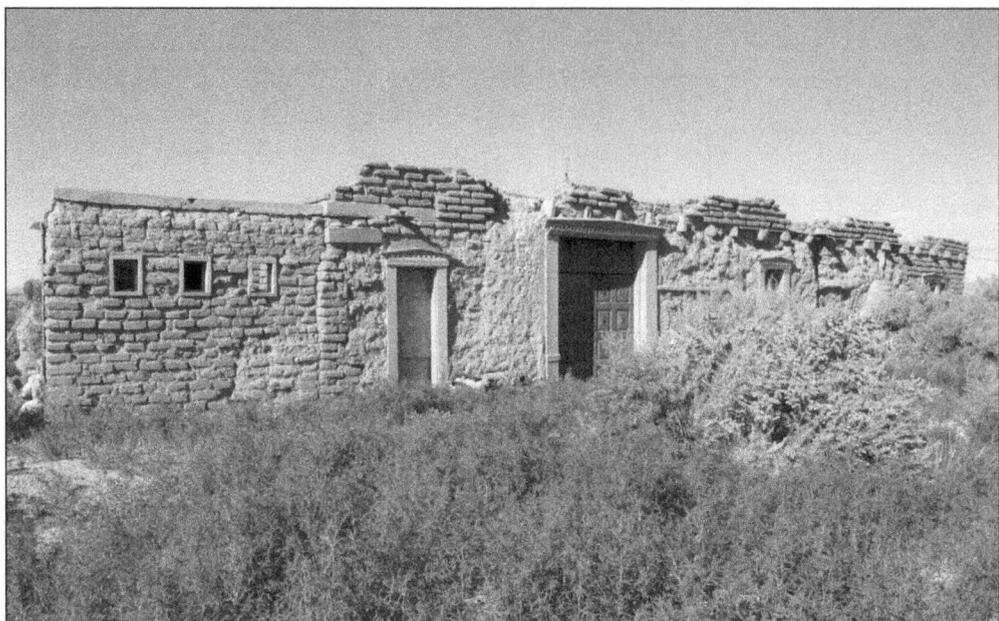

Contreras was named for Matías Contreras, a 19th-century sheep and cattle rancher. It dates to 1880, although it is likely that the rancho predated formal recording of the settlement. The first church, dedicated to San José, was built around 1880 and assigned to the parish of Sabinal. The building (above), known locally as the oratorium, was used as a private home by the Contreras family after 1906, when the new church (below) was constructed about 100 yards to the north. Alvino Contreras, a descendant of Matías, recalls that the adobes for the Contreras church were extra hard because pigs trampled and wallowed in the adobe mixture before it was molded into bricks. (Both, B. G. Burr.)

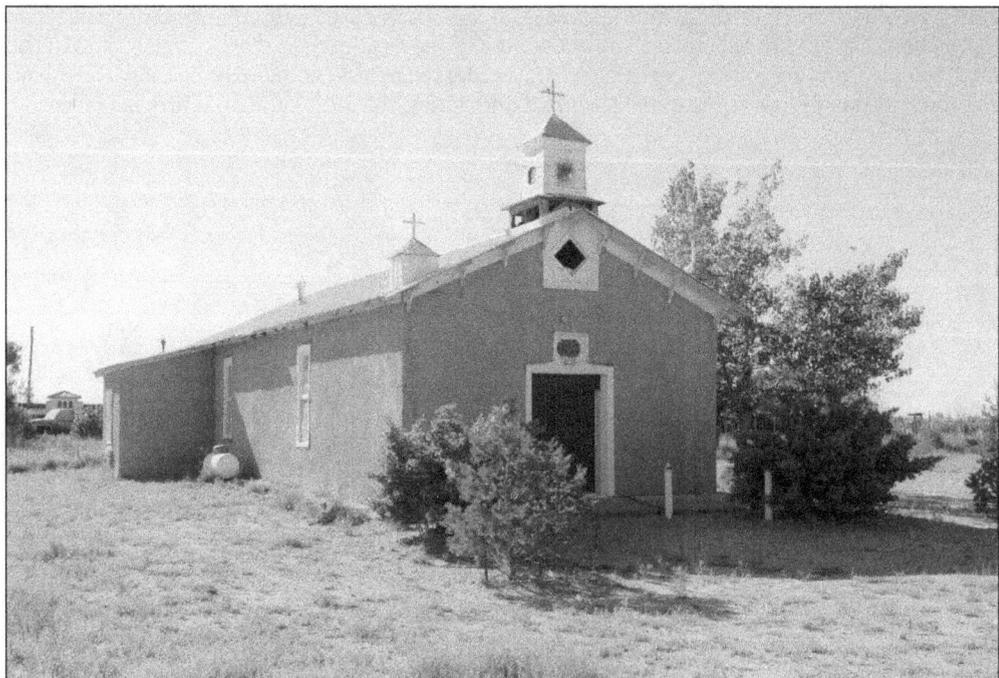

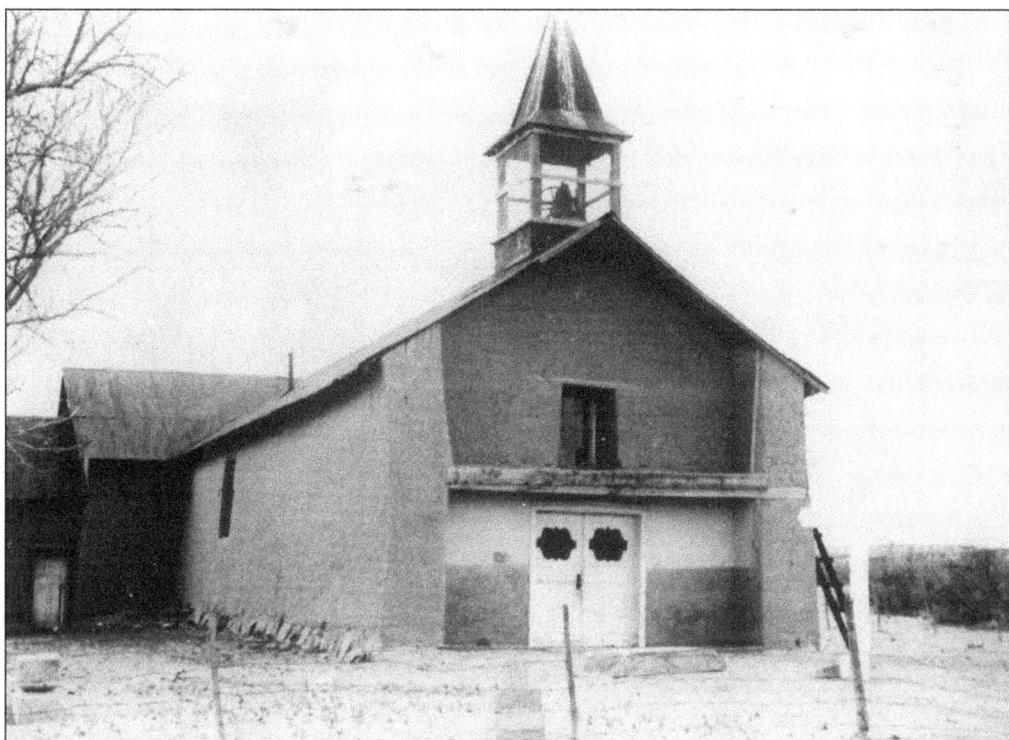

Abeytas was the site of an abandoned Piro pueblo and was settled in the 18th century. The area was named for the family that first settled in the area. It had at least one family chapel, which according to parish lore was dedicated to St. Rose of Lima. This 16th-century Peruvian woman was the first saint canonized in the New World and is considered by some as the patroness of the Americas. Initially known as Ranchitos de Sabinal, Abeytas became a mission of Sabinal in 1880 and was rededicated to San Antonio in 1881, probably when the flood destroyed the Sabinal parish church. The present structure dates to the 1920s. (Above, Museum of New Mexico, 86707; right, Patricia Gallegos.)

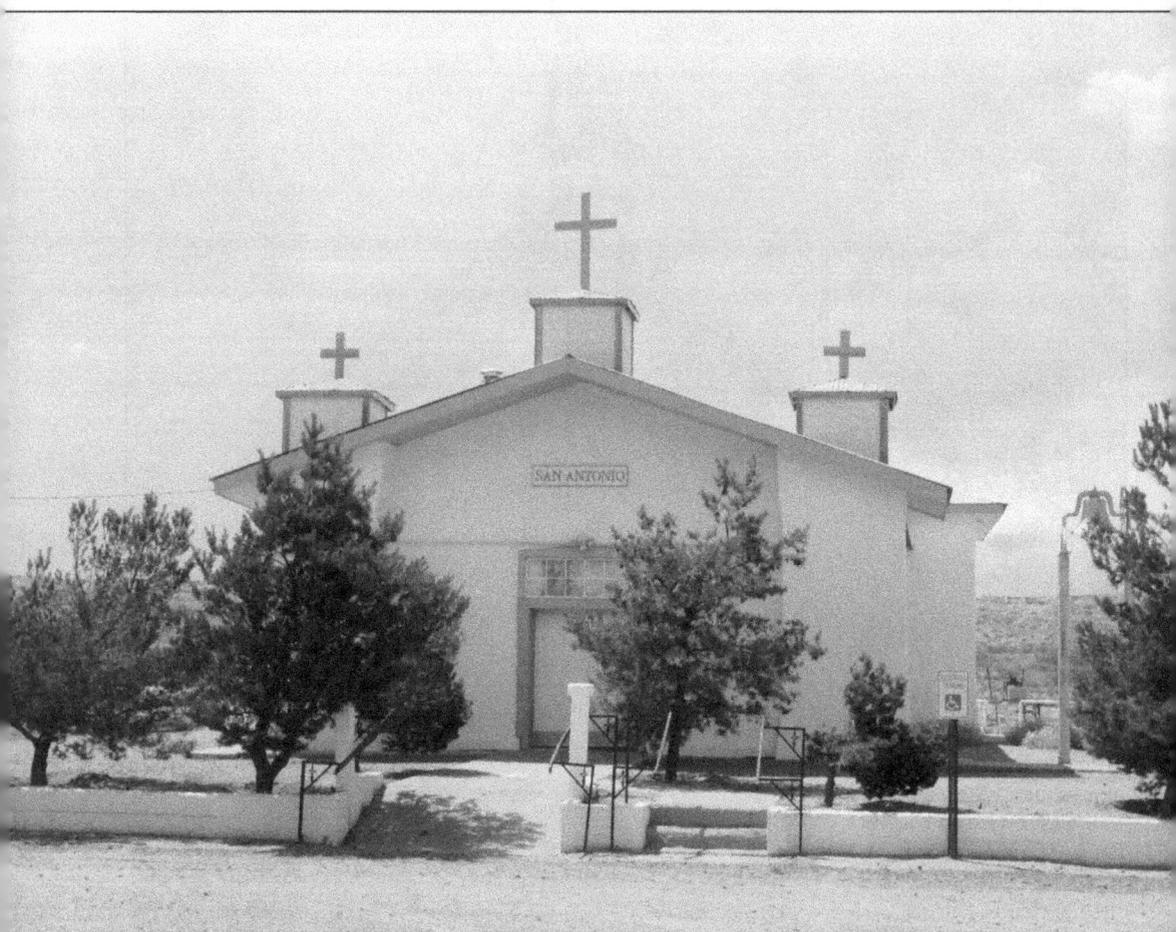

Thought to be the pre-Pueblo Revolt location of the Felipe Romero hacienda, Sabinal (Spanish for "juniper") was reoccupied in 1741. An early chapel probably existed in Sabinal, and there is a record of a visit by the bishop's vicar in 1817. The church was built between 1829 and 1832, about a half-mile east of the present church location. It was a mission assigned to Belén with an initial patronage to San Juan Nepomuceno (John of Nepomuk, a Czech martyr to the seal of the confessional) from 1852 to 1868, followed by subsequent dedication to San Antonio. When flooding destroyed the building in 1880, local residents moved the statues of their patron saint to Abeytas, even though the parish headquarters had relocated to La Joya. Although major flooding in the mid-1880s and early 1890s made reconstruction difficult, a new church was completed by 1905 on higher ground near the present location, and the parish moved from La Joya back to Sabinal. The current structure dates from 1936. (B. G. Burr.)

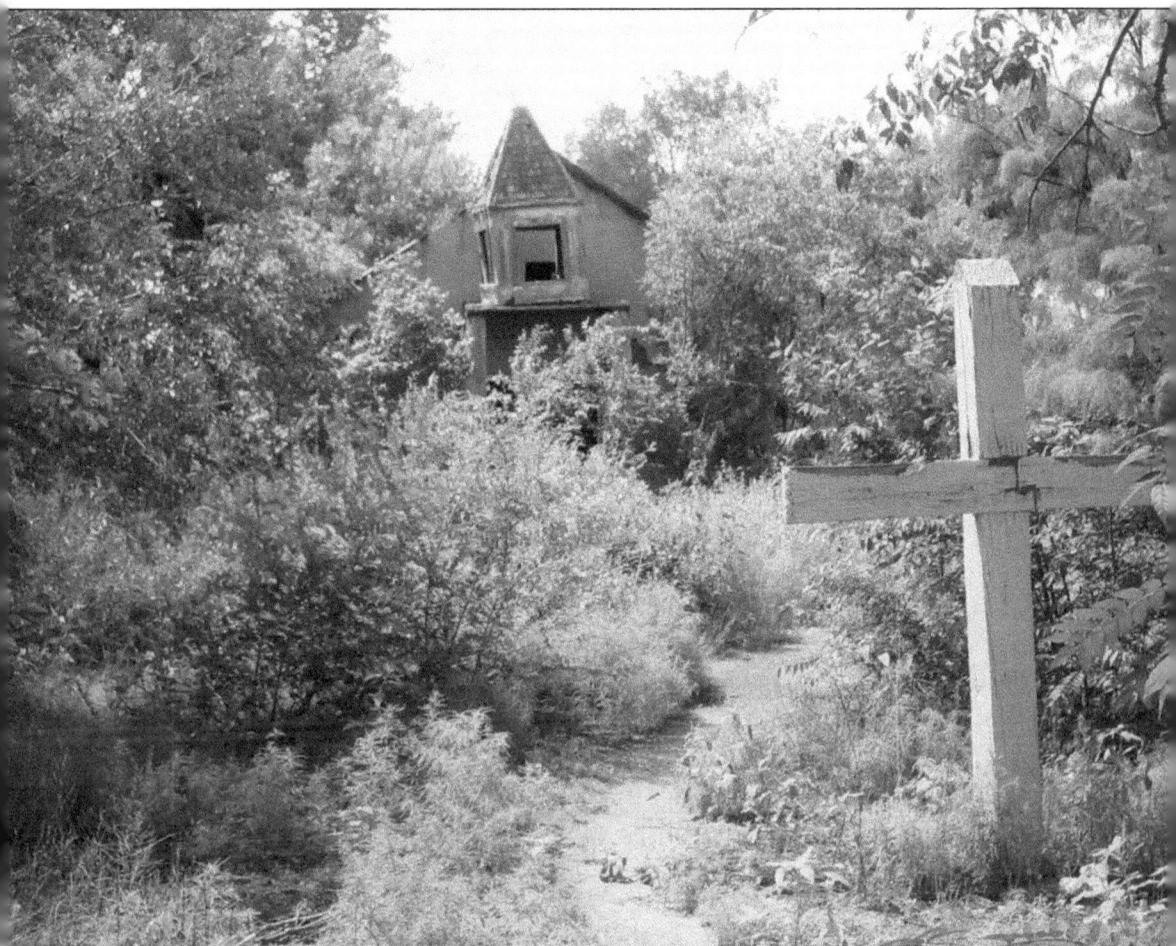

San Acacia is first mentioned in 1880, and was probably named for St. Acacius, a fourth-century Roman centurion who was martyred after his conversion to Christianity. The "o" in Acacio appears to have been changed to an "a" when the railroad arrived in 1880, perhaps because the English-speaking railroaders confused the saint's name with that of the acacia bush, which is common in the area. A mission in San Acacia, dedicated to San José, appears for the first time in 1894 as a part of the La Joya mission complex, and it remained with La Joya until 1925, when it was reassigned to Socorro. The church was heavily damaged in the flood of 1929 and completely destroyed in the 1937 inundation. The current structure, no longer used and slowly decaying, dates to 1949.

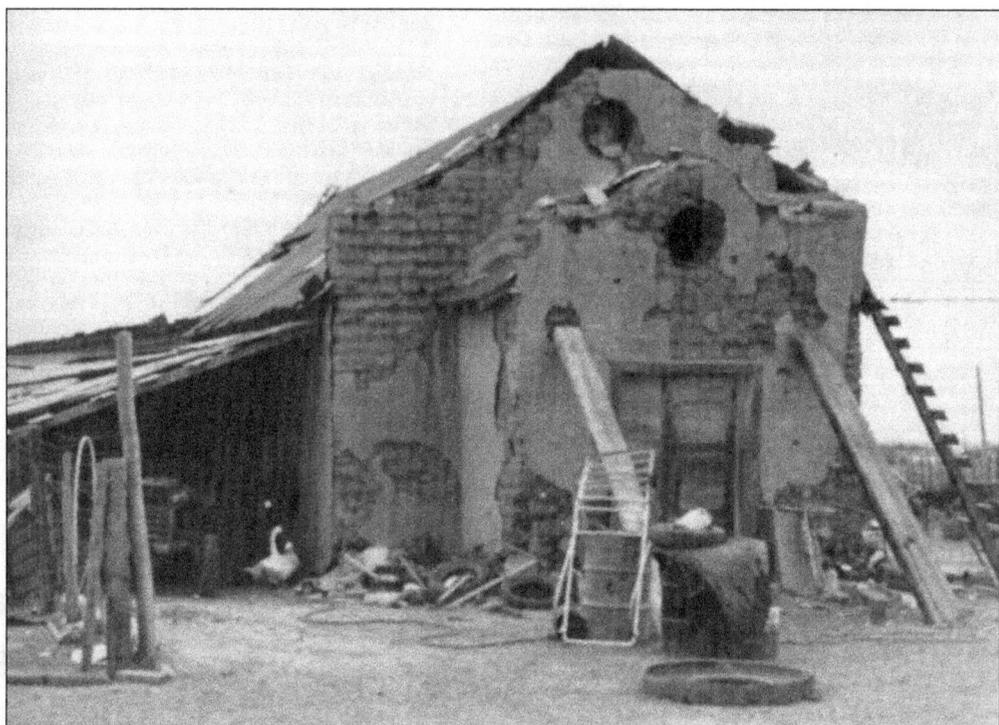

San Francisco, also known as Río Puerco, lies near the confluence of the Río Puerco and the Rio Grande. A mission in San Francisco, assigned to La Joya and dedicated to Santa Bárbara, was located here from 1922 to 1953. By the early 1980s, the former mission was in disrepair and was being used as a barn by one of the local residents. (Henry Walt.)

Chupadero (Spanish for "sinkhole"), a small mountain settlement east of La Joya, was the site of a rancho originally owned by Alvino Contreras. The chapel of San David (the patron saint of Wales) was a mission of La Joya from 1921 to 1943. In 1944, it was transferred to the new parish in Willard. It dropped from the list of active missions in 1952. (Museum of New Mexico, 119984.)

Five

THE CHURCHES OF SAN CLEMENTE PARISH

Two small Native American villages, Be-jui-tu-ay (Rainbow Village) and Los Lentes Pueblo, were located south of Isleta on the west bank. A few miles further south was a larger pueblo near what is now the village of Los Lunas. The first Spanish explorers named this village Piguina-Quantengo. Some 450 years later, churches in this area would constitute San Clemente parish.

In the mid-17th century, Mateo de Sandoval y Manzanares and his family built a hacienda with a chapel dedicated to St. Clement. This church, used by the family for their personal devotions, may have been visited on special occasions by Franciscans from Isleta. Mateo died sometime before 1680, and the rest of the Sandoval y Manzanares family fled south during the Pueblo Revolt. It is likely that Piguina-Quantengo, Rainbow Village, and the Pueblo of Los Lentes were also abandoned during the uprising.

In 1715, Mateo's daughter Ana petitioned the governor to reoccupy the land. Tradition has it that when her petition was denied, Ana trekked to Mexico City to plead her case before the viceroy, who upheld her claim. In actuality, her claim was granted by the governor. In 1716, the widowed Ana and her family settled on the land that was designated as the Merced de San Clemente (the Mercy of St. Clement). After Ana's death in 1734, the land was gradually sold and eventually acquired by the Luna family. As this clan continued to expand, the area came to be known as Los Lunas.

The Isletans considered the people who settled between the San Clemente grant and Isleta Pueblo as "others," labeled as "*entes*" in the southern Tiwa dialect spoken at Isleta. This established the name for the settlement in the area as Los Lentes.

In 1859, diocesan records noted a "chapel at Los Lunas" assigned to Isleta. Shortly thereafter, the diocese reassigned the chapel to the Parish of Our Lady of Belén. The parish of San Clemente in Los Lunas was formally established in 1961, with San Antonio de Los Lentes as its only assigned mission. San Juan Diego mission in Meadowlake was added as a parish responsibility in 2009.

During the middle of the 19th century, Los Lunas had an active military post, which was overrun by Confederate invaders in March 1862. The image above looks west across the village of Los Lunas in 1867. Note the distinctive outline of Los Lunas Hill clearly visible in the background. (Museum of New Mexico, 56272.)

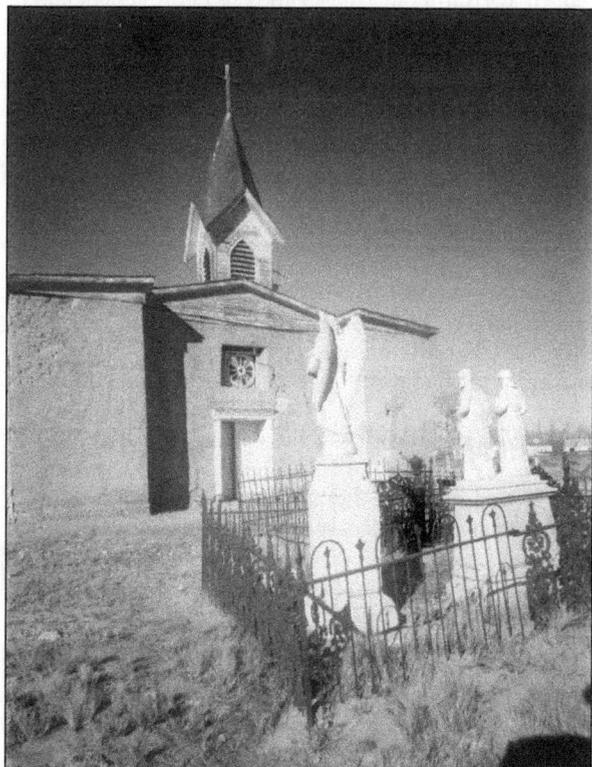

A new Los Lunas chapel with some neo-Gothic characteristics was dedicated in 1894. Although it cannot be confirmed, both the 1859 and the 1894 chapels may have been close to the original location of the Sandoval y Manzanares hacienda. This location was probably near the old cemetery on the south side of what is now Main Street, just east of the railroad tracks. (Museum of New Mexico, 100514.)

In addition to the neo-Gothic steeple, the Los Lunas church had a pitched roof, two columns with slightly inclined caps at the front of the structure, and a small rose window above the door alcove. The statues in the cemetery were typical of the *campo santo* (holy ground) that surrounded many small rural missions. (Museum of New Mexico, 100513.)

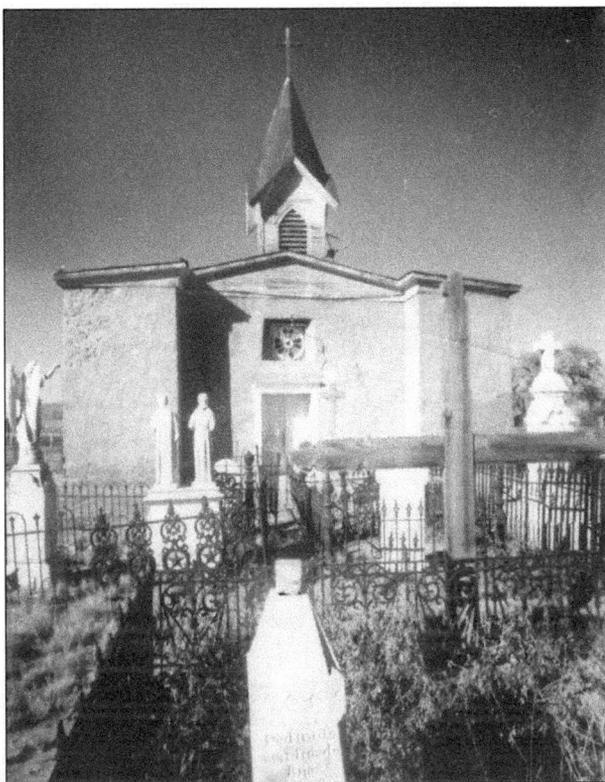

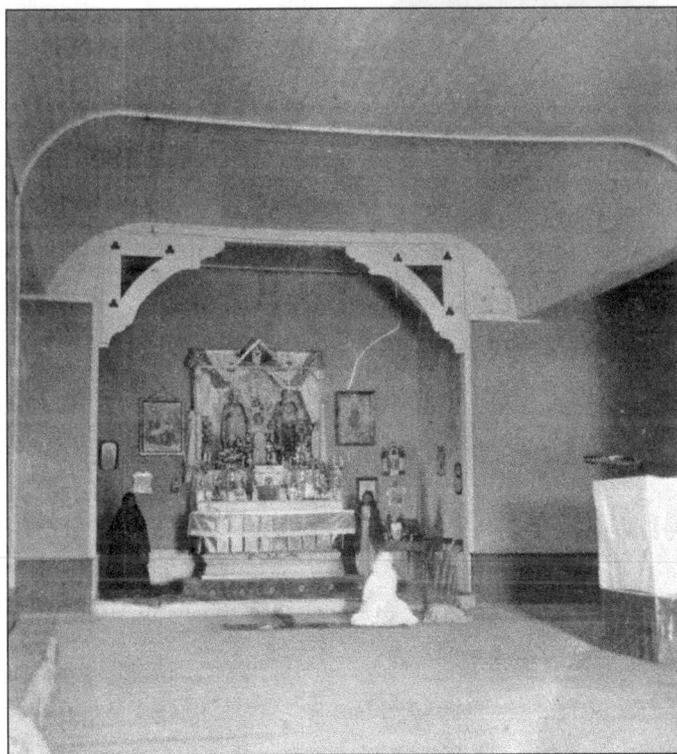

The interior of the San Clemente Church in the late 19th century was typical of similar chapels with numerous statues and few, if any, pews. Note the benches along the side of the nave. By the time of this photograph, the dirt floor had apparently been covered with wood. (Museum of New Mexico, 002987.)

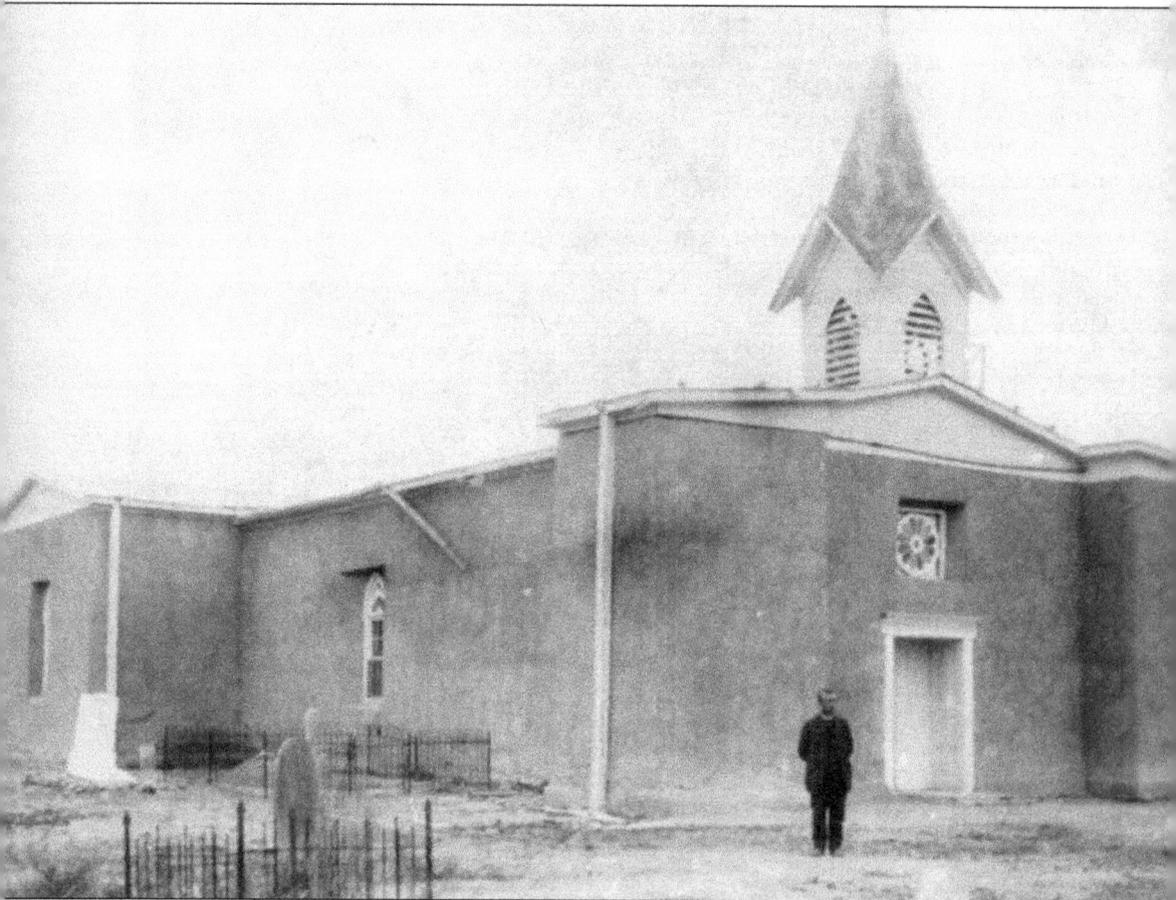

The 1894 San Clemente church, shown here in about 1900, was not subject to the ravages of flooding to the degree that other missions were. In addition, Los Lunas was not a particular target of the Native American raiding that was a problem until the late 19th century for parishes like Tomé and for outlying missions of Belén, La Joya, and Socorro. However, building techniques did not include poured concrete foundations (many were just built on rocks set into some semblance of a slab), and the intense downpours from summer monsoon thunderstorms tended to undermine the walls. Some churches eventually suffered fatal structural damage. The decision to rebuild San Clemente helped to avoid the almost inevitable damage suffered by its sister missions. (Los Lunas Museum of Heritage and Arts.)

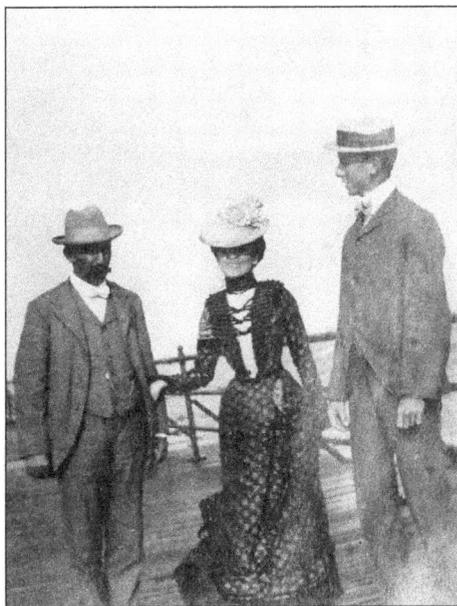

Over the years, some of the Sandoval y Manzanares land was acquired by the descendants of Domingo Luna, including Antonio José Luna, the so-called "Father of Los Lunas." As the Luna clan continued to expand, the area came to be known as Los Lunas. During the 19th century, the Lunas of Los Lunas and the Oteros of Peralta and Valencia joined in a venture to sell sheep in the lucrative California market. These commercial ties were cemented when the then-patriarch of the family, Saloman Luna (above left), married Adelaide Otero (shown above right with her husband on the left and an unidentified man on the Atlantic City Boardwalk). Their family home in Los Lunas came to be known as the Luna Mansion and is now a popular restaurant. (All, Los Lunas Museum of Heritage and Arts.)

A new church, financed and constructed almost exclusively by volunteers from the parish, was built between 1949 and 1952. The location was about a quarter-mile northeast of the original structures on land donated by the Baca family of Los Lunas. The Baca land adjoined a building used by the Baptist church of Los Lunas, and the Catholics of San Clemente purchased that building for use as a parish hall. The new building, with a distinctive hexagonal cupola designed and built by parishioner William Gomez, was dedicated by Archbishop Edward Vincent Byrne on February 17, 1952. (Above, Archdiocese of Santa Fe; below, Parish of San Clemente.)

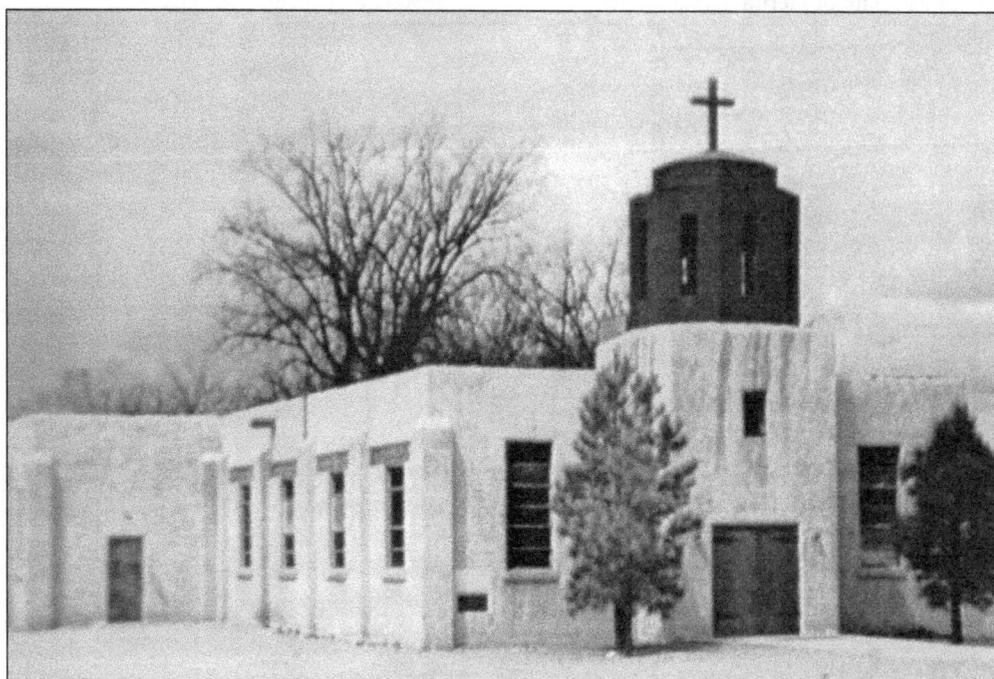

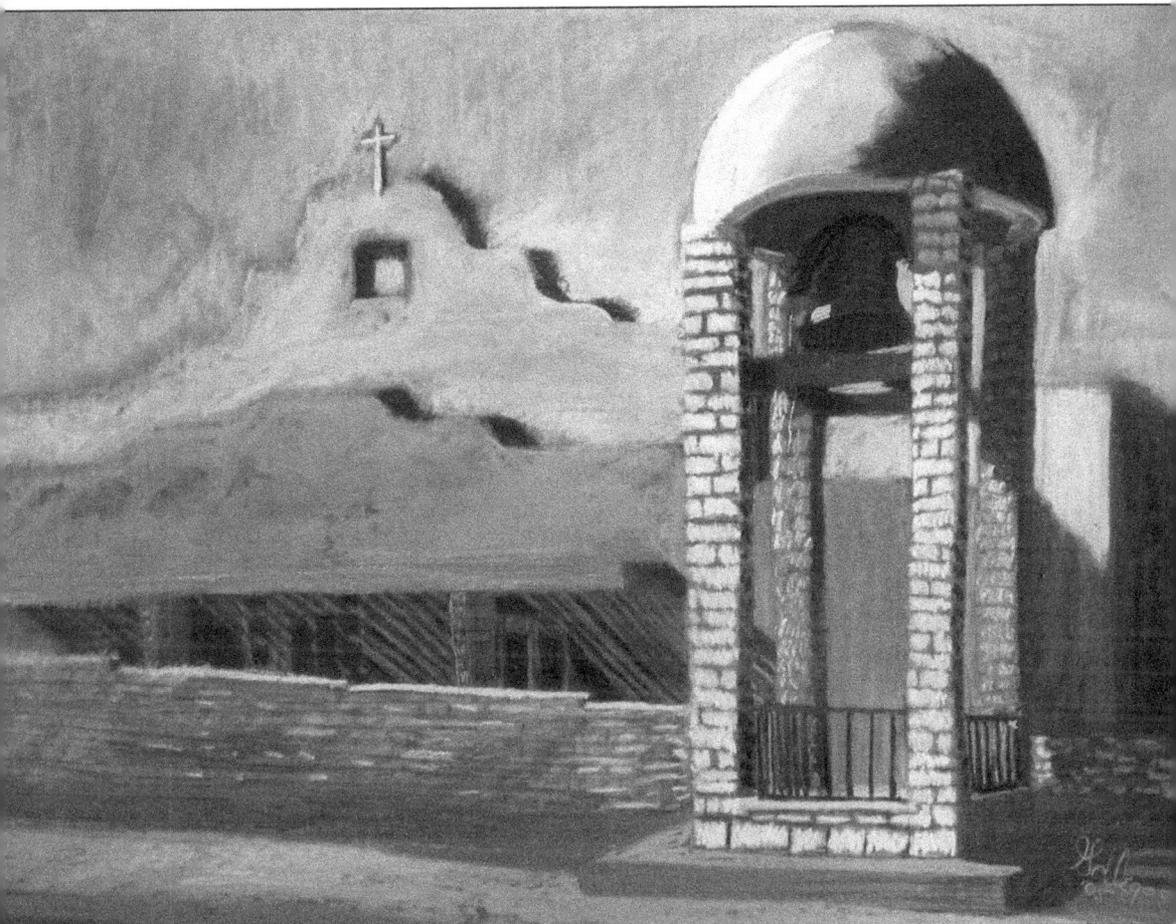

In the late 1990s, San Clemente Parish began to experience a significant growth spurt. In addition, the parish church was nearly 50 years old. Fr. Rick Zerwas and the parish leadership made the decision to embark on a campaign to replace the old structure and build an entirely new church on the site. After a few years of fund-raising, the old church was torn down and a new one rose in its place. The new building has an espadaña facade with a companario-like opening. However, the bell itself was placed in a separate structure, somewhat reminiscent of the cupola on the 1949 building. The new church has amphitheater seating and is substantially larger than the former building. During the reconstruction, supporting structures for religious education, parish meetings, and parish administrative activities were added. The new church was dedicated by Archbishop Michael J. Sheehan in 2004. (Patricia Gallegos.)

In 1789, the residents of Los Lentes built a small community chapel on the ruins of the abandoned pueblo. According to contemporary descriptions, the chapel was a simple, flat-roofed structure with a dirt floor. The structure was dedicated to San Antonio, perhaps to recall the patronage of the mother church at Isleta before the Pueblo Revolt. The distinctive French Gothic steeples replaced the espadaña facade shown in this 1864 sketch (above) sometime during the late 19th century. The chapel of San Antonio de Los Lentes (below) continues to the present as one of the two active missions of San Clemente parish. (Above, Parish of Isleta baptismal records; below, Los Lunas Museum of Heritage and Arts.)

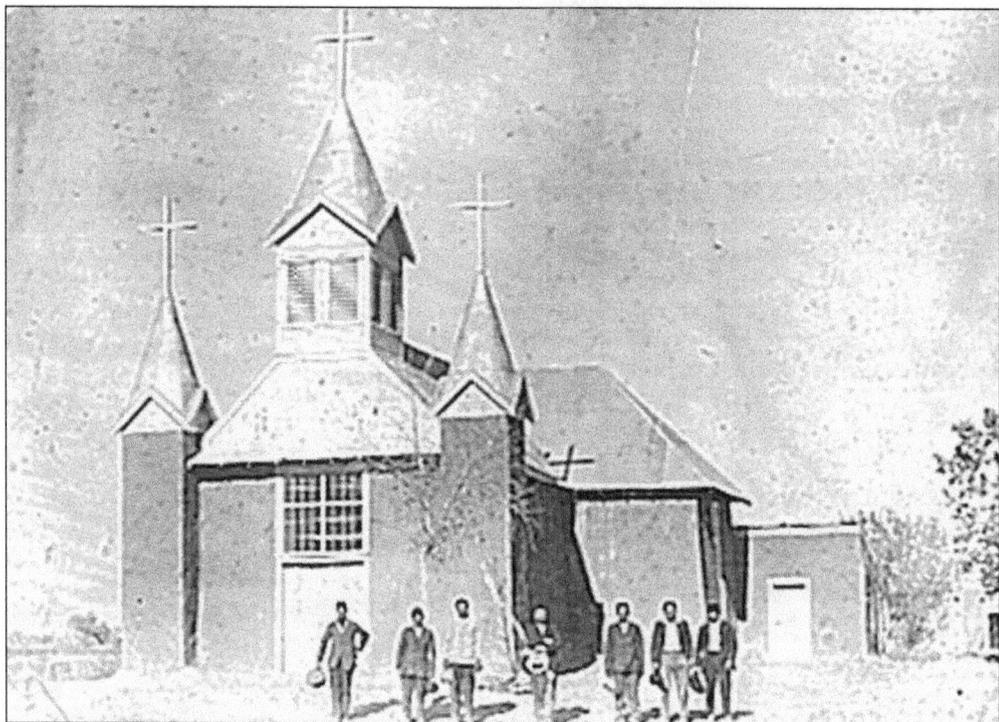

Six

Our Lady of Guadalupe, Peralta

The parish of Our Lady of Guadalupe in Peralta lies on the east bank of the Rio Grande between Isleta and Tomé. Between 1630 and 1640, Francisco de Valencia and his family settled in the central portion of this area near the site of an abandoned Tiwa pueblo, perhaps the pueblo referred to as Caxtole by the 1581 Chamuscado-Rodríguez expedition. The Valencias remained at their estancia until they were driven out during the Pueblo Revolt. Some Albuquerque residents sought and received permission to relocate to the Valencia area in 1740, and two plazas had sprung up by 1790.

In 1718, Gov. Antonio Valverde y Cosio granted Diego de Padilla of Los Padillas 52,000 acres of land south of Isleta. Travelers crossing Padilla's land would have ridden through stands of cottonwood trees interspersed with open fields of native gramma grass. A few miles south of the Padilla grant (and about 1 mile north of the Valencia hacienda), the same travelers would have arrived at the hacienda of Juan Antonio Otero, which was located at what is now the center of the recently incorporated village of Peralta. This area seems to have acquired its own separate identity rather gradually in the 1830s and 1840s, perhaps taking its name from the tall pear trees (*pera alta*) that were cultivated by some residents.

The church of Our Lady of Guadalupe in Peralta was completed in 1892 and served as a mission of Tomé until 1971. That year it became a separate parish, taking with it the mission church of Sangre de Cristo in Valencia.

Union forces under Canby
reach river bottomland
after midnight

Colorado Volunteers
intercept supply train--
early morning

Chivington and Paul
encircle Confederate
forces

Chical

Rio Grande

7 am

present-day Bosque Loop

Artillery exchange--
throughout morning

Graydon's Spy
Company raids
Peralta--midmorning

Los Pinos
Hacienda

12 noon

10 am

Green's retreat
2 pm to 10 pm

Peralta Plaza

North

Sibley and Scurry
attempt to relieve
Green--noon

THE BATTLE OF PERALTA

15 APRIL 1862

2 PM SW WIND

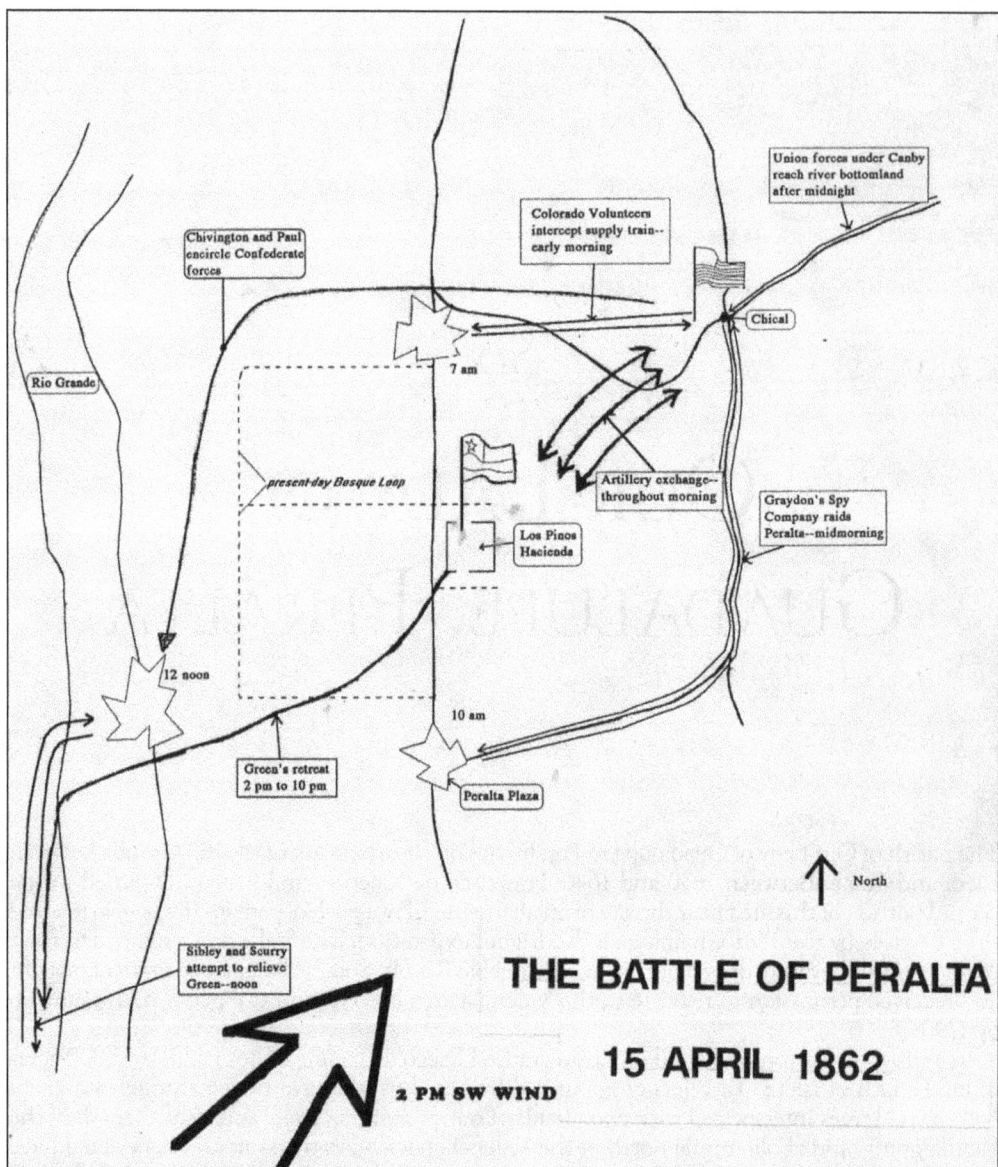

On April 15, 1862, the Battle of Peralta, the last major engagement of the Civil War in New Mexico, was fought between Union forces under Col. Richard E. R. S. Canby and Confederate forces led by Col. Tom Green in and around Los Pinos, now known as Bosque Farms. The engagement began in the early morning hours with a Union bombardment of Gov. Henry Connelly's Los Pinos hacienda, where the Confederates had encamped on the night of April 14. Localized skirmishing and a raid into the Peralta village plaza lasted into the early afternoon. The engagement ended when the Confederates fled across the river to Los Lunas under the cover of a mid-afternoon dust storm.

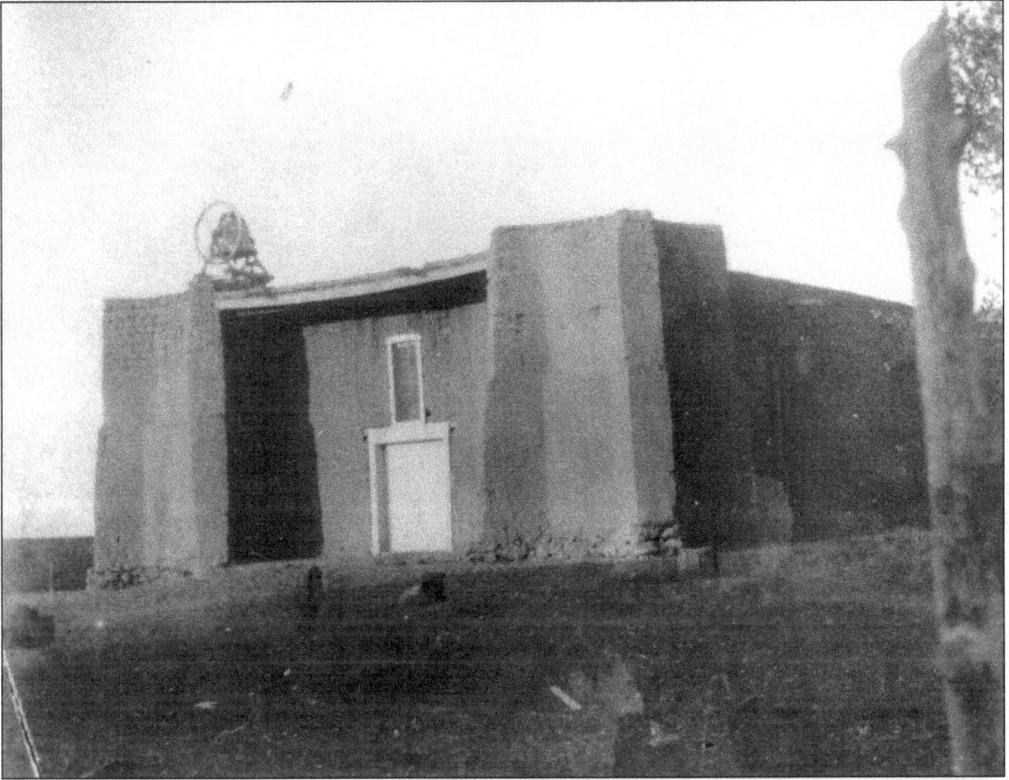

The first church in Peralta was probably a small chapel at the hacienda of Juan Antonio Otero. The chapel was built on land donated by Otero's widow, Mercedes, and was dedicated as a mission of Tomé in 1892. The structure has a standard nave-transept design and was originally constructed with a flat roof supported by vigas. Our Lady of Guadalupe in Peralta is distinguished from others in the Río Abajo by the distinctive cruciform buttresses that provide structural support for the front walls of the nave (above). In 1912, the flat roof was replaced with a pitched roof, the towers were capped with tin gables, and the bell was moved to a new central steeple (right). The parish of Our Lady of Guadalupe was officially separated from Tomé on April 1, 1971. (Above, Ben Otero; right, Patricia Gallegos.)

The church of Our Lady of Guadalupe stood on the west side of the village plaza. Across from the church to the east was a portal that included, at one time or another, several mercantile establishments, a dance hall, a gas station, a small hotel, a lawyer's office, a post office, a bus station, and a saloon. South of the church, on the west side of the main street, was a public shower facility and a public school. In 1916, New Mexico historian Ralph Twitchell characterized the village as "one of the smaller settlements that dot the fertile valley every few miles, affording markets and supply points for the many farmers. Like many others, it is a comparatively old settlement, as the valley where it is located has been cultivated for many years. It is a prosperous place because it is supported by the rich farming area around it." The Peralta portal burned in 1954 and was not rebuilt. (Cati Aragon.)

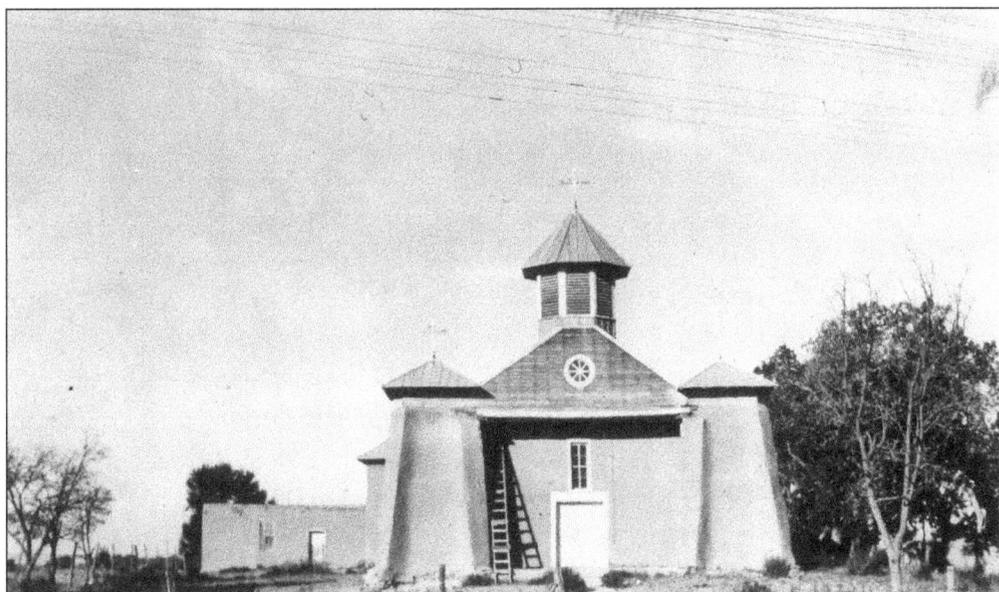

Valencia County offices were located in the *sacristia*, the small, chapel-associated extension on the southwest side of the Peralta Plaza (left side in the image above), from 1848 to 1852. This was very likely the oratorio at the Juan Antonio Otero hacienda, since that building was reported to have been used as a church before being used by the county. The sacristia was also the Peralta school until construction of the new school in 1911. The structure has changed very little since the 1912 roof and steeple modifications. The sacristia was removed and gas heating replaced the wood stove. Note the exhaust pipes visible in the 1947 photograph below. (Both, Museum of New Mexico, 124379, 86714.)

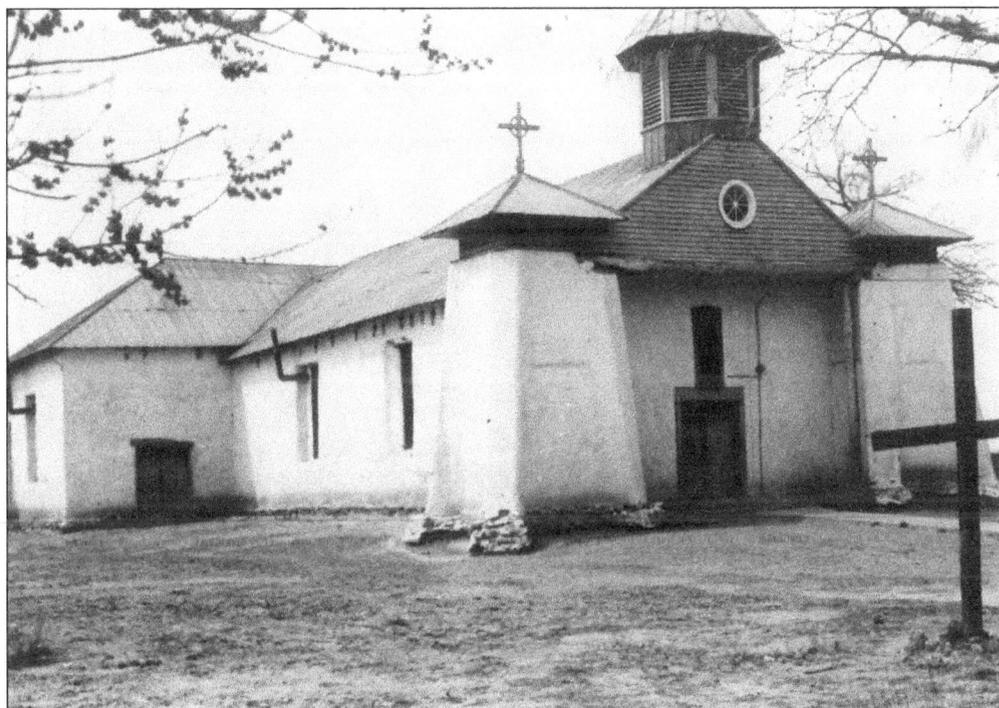

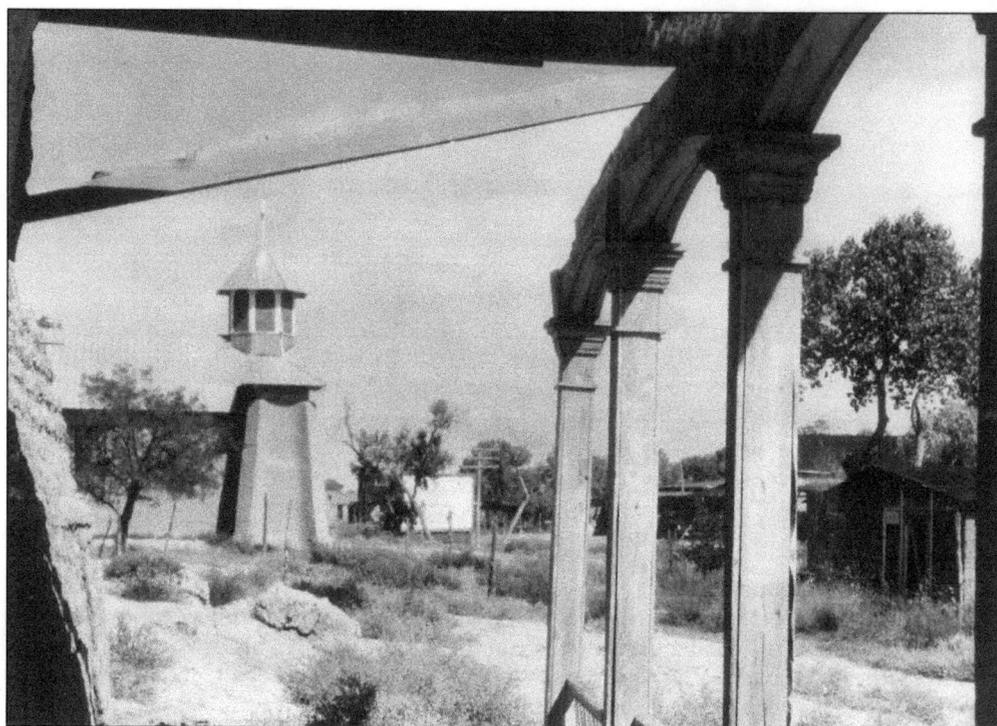

Although Catholicism dominated the Río Abajo in the 19th century, Baptists, Methodists, and Presbyterians also had congregations in the area. In 1855, a group of Methodists began construction on a mission church immediately adjacent to the Catholic church in Peralta. (The image above shows the Peralta Catholic church viewed from the portal of the Methodist mission; below is a photograph of the mission itself.) By 1861, the Methodist congregation numbered about 100, and stories were told of the Methodists ringing their bell while the priest was saying Mass in an attempt to drown out the much-despised Romanist doctrine. (Both, Museum of New Mexico, 59278, 24378.)

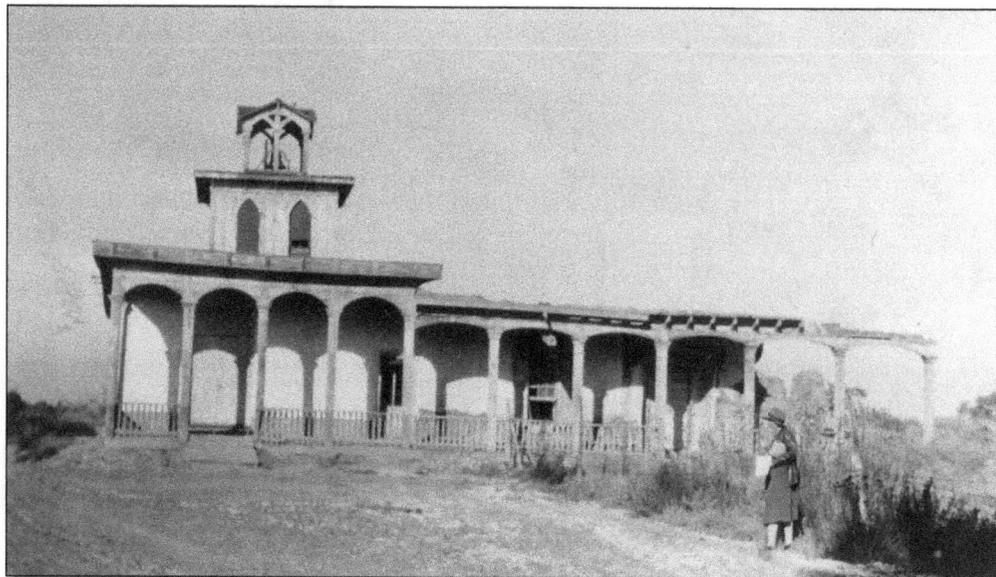

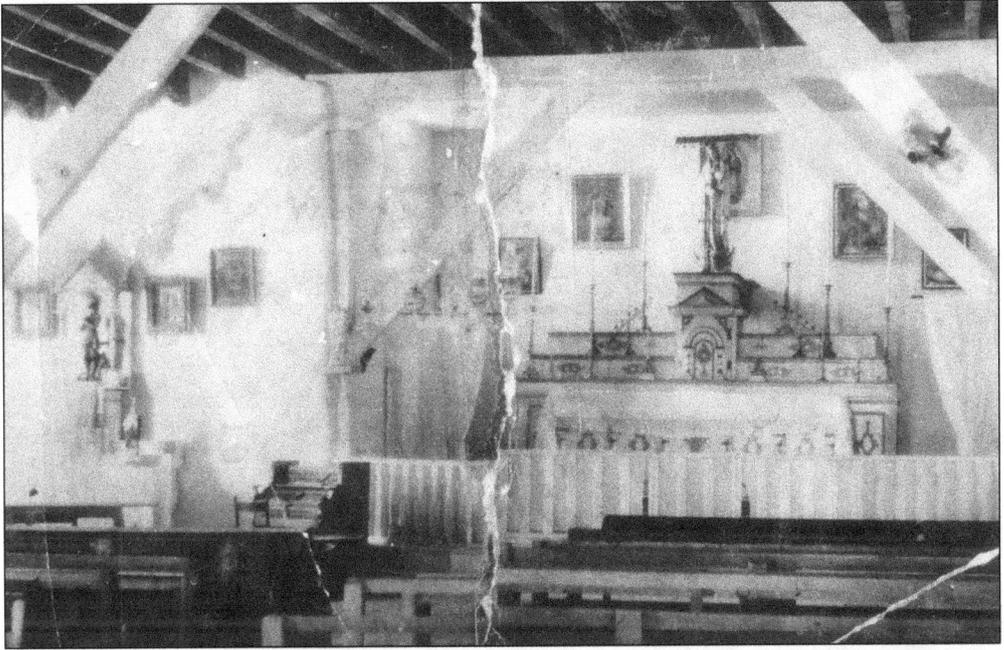

The internal configuration of Our Lady of Guadalupe remained essentially the same from its initial construction until the 2004–2005 renovation. The statue of Our Lady of Guadalupe in the center of the altar in the 1900 image above was moved to the south side by 1927, though the basic altar and tabernacle are identical. The paintings that were common altar decorations in the 19th and early 20th century are gone, although many of the original statues, including the venerable statue of Our Lady, in addition to several new ones added during the 1987 renovation, still grace the chapel. In the photograph below, the chapel is decorated for the Fiesta of Our Lady of Guadalupe in December 1927. (Above, Marlene Monteith; below, Emma Gabaldon)

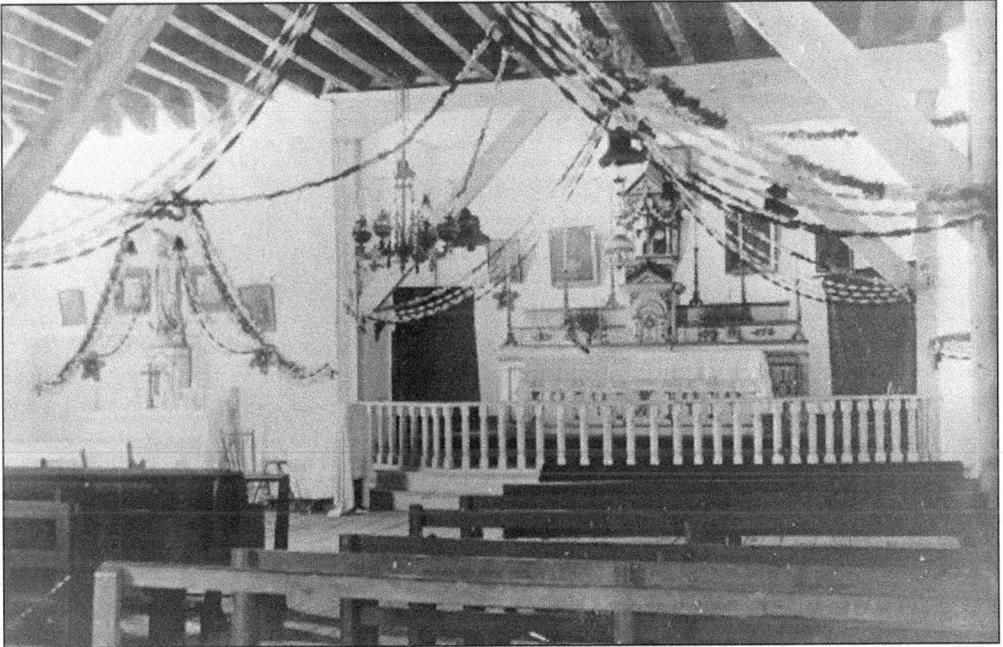

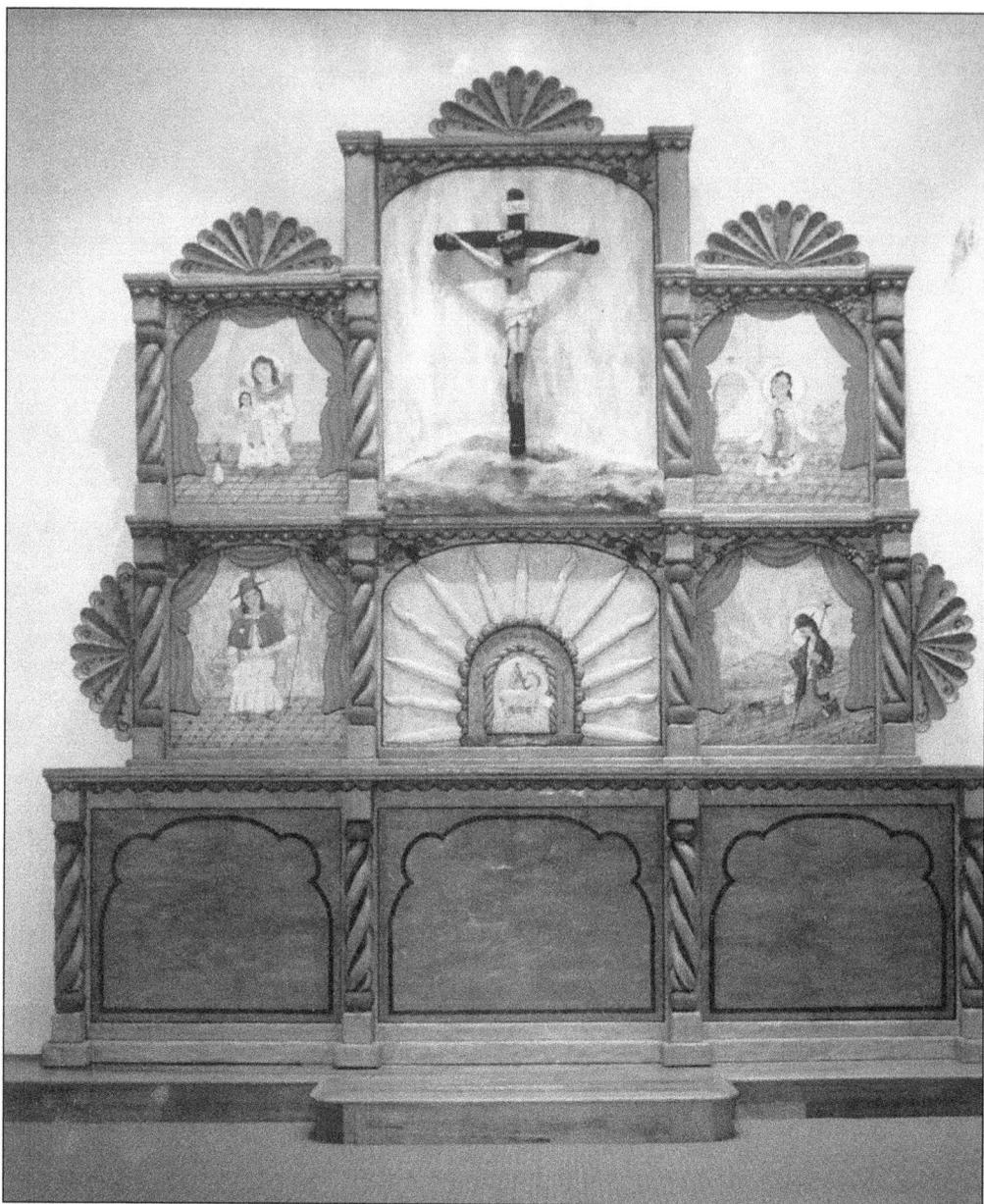

The retablo, or altar screen, in Our Lady of Guadalupe in Peralta was created during the 2004–2005 restoration by Carlos Otero, local parishioner and *santero* (an artist who works in the traditional New Mexico style of religious sculpture). Moving clockwise from the upper left, the four panels that bracket the cross and tabernacle are St. Ann, the mother of the Virgin Mary and a patron of missions in the El Cerro and La Ladera neighborhoods; St. Juan Diego, the Aztec native to whom the Blessed Mother appeared at Tepeyac, Mexico, in December 1531; St. Isidro, the patron of farmers; and Santo Niño de Atocha, the patron of pilgrims and prisoners. Santo Niño is included to recognize several parishioners who were captured by the Japanese during World War II and endured the Bataan Death March. The altar (not seen in this image) is carved to match the retablo and is flanked by two angel candleholders. This particular altar set is considered to be representative of the pinnacle of the modern santero art in New Mexico. (Gil Duncan.)

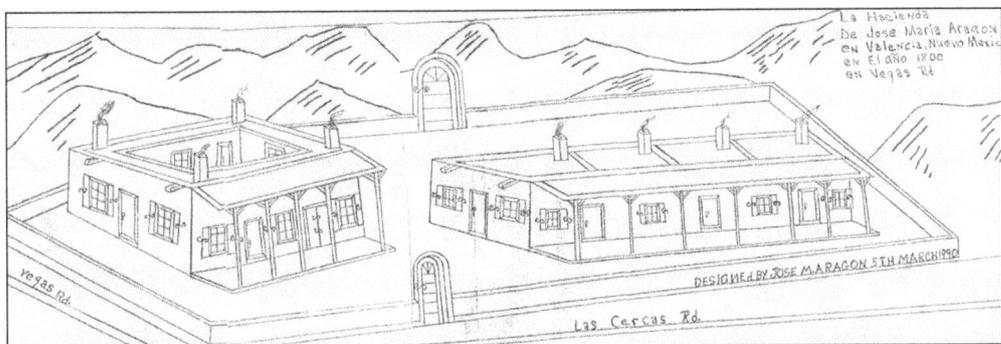

La Hacienda De Jose Maria Aragon en Valencia, Nuevo Mexico en El año 1800 en Vegas Rd

Vegas Rd.

DESIGNED BY JOSE M. ARAGON 5TH MARCH 1990

Las Cercas Rd.

The area now known as Valencia had two plazas by 1790: a northern one near the present-day Valencia Wye (probably the site of the original Francisco de Valencia hacienda), and one about a mile south near what is now the intersection of Vega and Las Cercas Roads. The sketch above was made by a descendent of the original settlers and depicts the southern plaza about 1800. The first church in Valencia (below) was constructed between 1801 and 1802 at the northernmost of the two plazas. The building was dedicated to Sangre de Cristo (the Blood of Christ) in commemoration of the settlement of a bloody feud between two local brothers. In its earliest stages, the chapel was a simple flat-roofed adobe structure served from Tomé. Towers designed by Peralta storekeeper Abraham Kempenich were added in 1902. (Above, José Aragon; below, National Archives.)

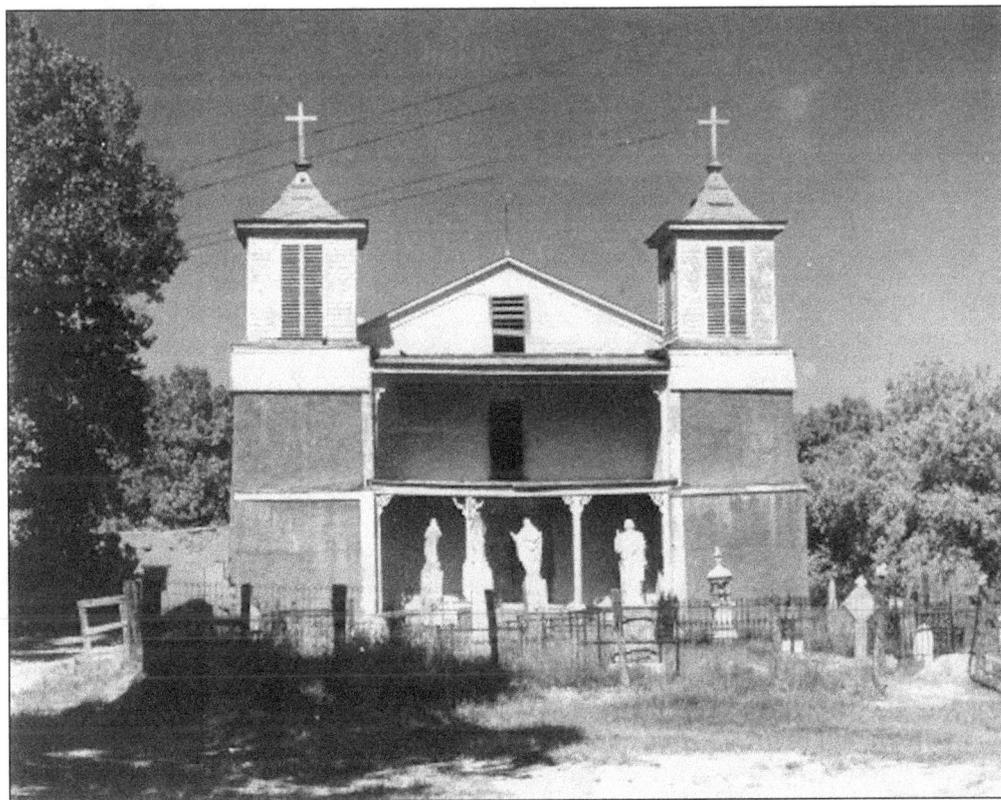

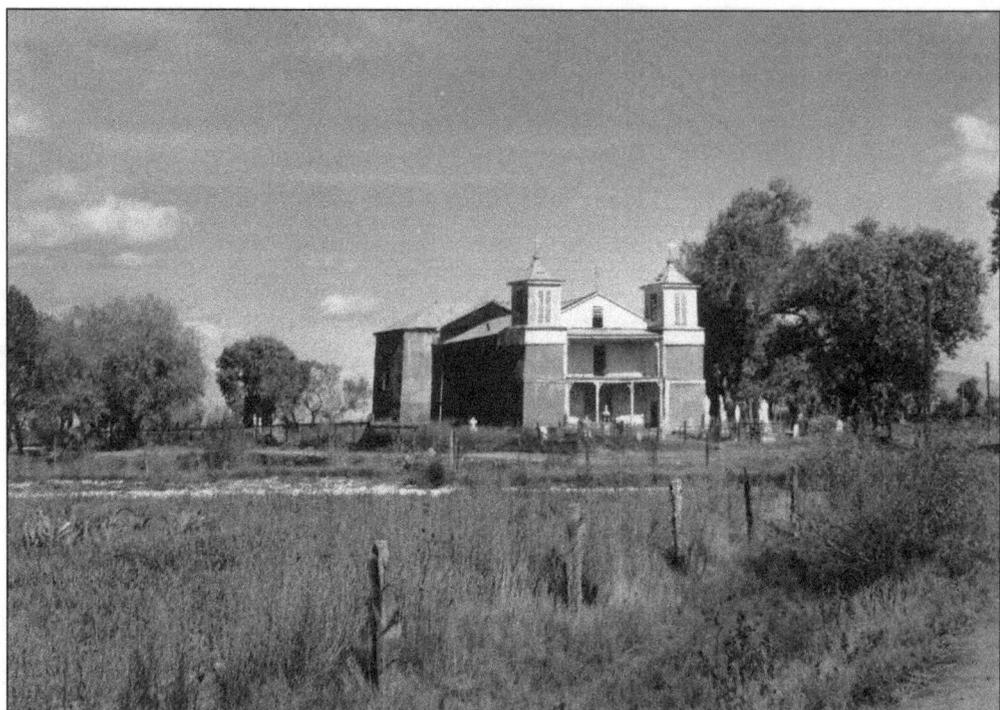

Prior to 1937, when Gov. Clyde Tingley (left) "straightened the road out," Route 66 ran north from Santa Rosa to Santa Fe, then south through Albuquerque. It crossed the river at Isleta, and ran through downtown Peralta on what is now State Route 47. It turned west in Valencia about a mile south of Sangre de Cristo, then recrossed the Rio Grande and passed along Main Street in Los Lunas. West of Los Lunas it transited the Laguna reservation to the point where New Mexico Route 6 meets Interstate 40. As a result, the famous "Mother Road" ran right in front of both the Sangre de Cristo mission in Valencia and Our Lady of Guadalupe in Peralta. The above photograph was taken in the early 1930s from the center of Route 66, then mostly a dirt road in the Valencia area, looking northwest toward Sangre de Cristo. (Above, Ben Otero; left, Museum of New Mexico, 047793.)

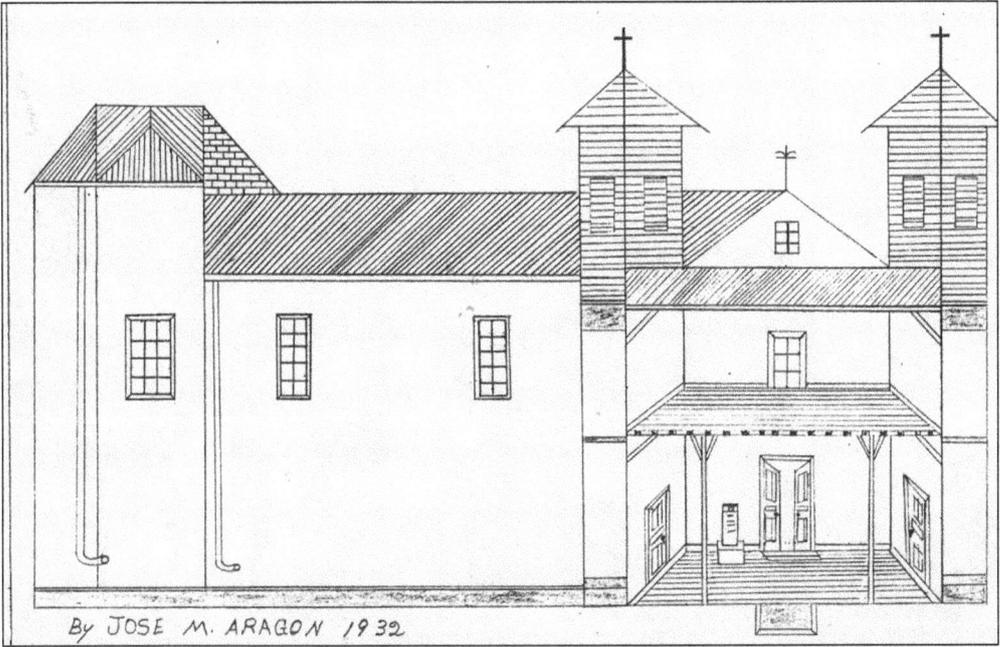

By JOSE M. ARAGON 1932

Despite continual attention, years of flooding and summer rains took their toll on the venerable Sangre de Cristo chapel, and part of the north wall collapsed in the spring of 1941. The remaining structure, which had been dedicated to *Paz en la Familia* (peace in the family) as a result of settling the feud, was completely razed and rebuilt, retaining the original floor plan on the original foundation, and was rededicated in early 1943 to *Paz en la Tierra* (peace in the world) in consideration of the world war that was currently raging in both Europe and the Pacific. Sangre de Cristo remained a mission of Tomé until the Peralta parish was erected in 1971, at which time it became a mission of Our Lady of Guadalupe. The sketches illustrate before (above) and after (below) views of the chapel. (Both, José Aragon.)

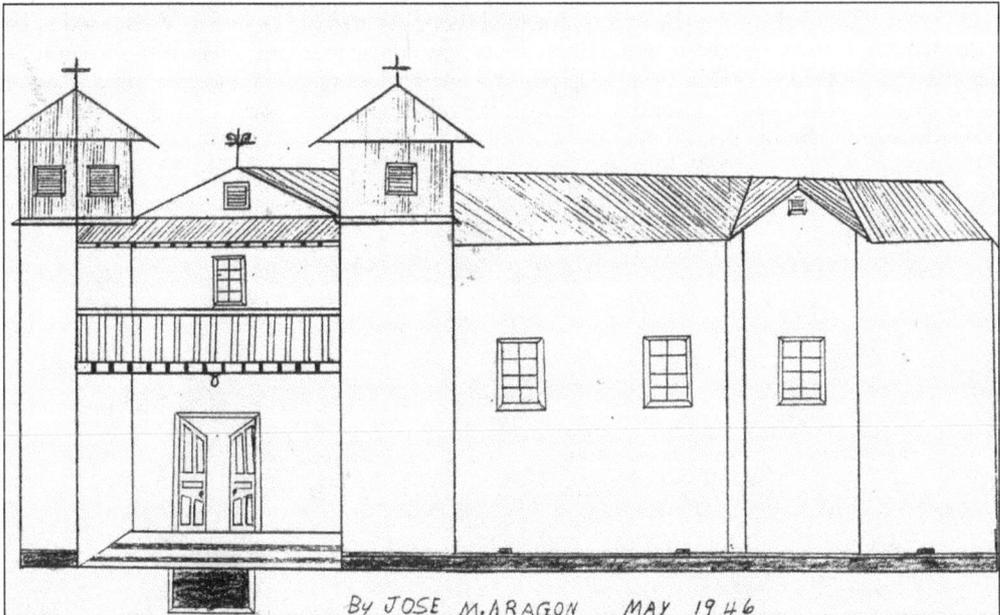

By JOSE M. ARAGON MAY 1946

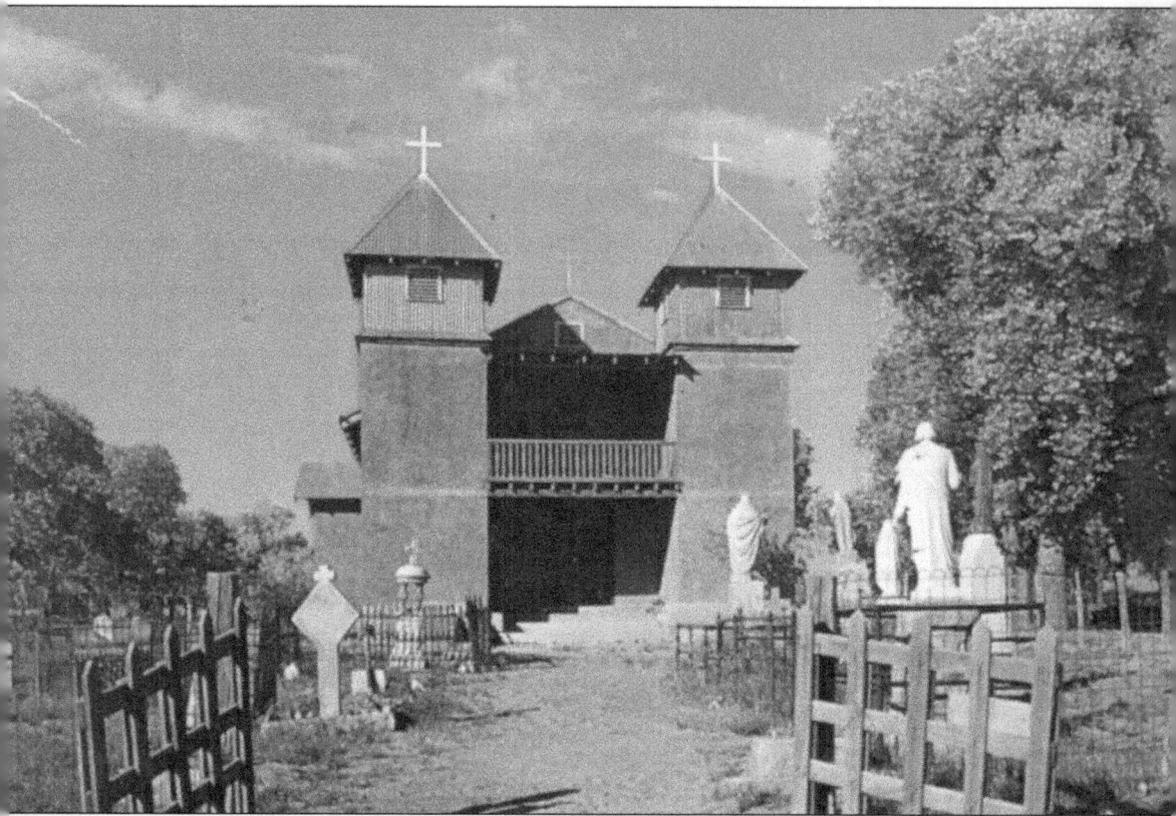

The mission chapel of Sangre de Cristo in Valencia occupies one of the oldest Catholic sites in the Río Abajo, dating to the earliest Spanish colonial period. It has been razed, repaired, reconstructed, and maintained for hundreds of years, yet it still retains much of its original character. This image from the mid-19th century shows the chapel with its distinctive campo santo in what is a very rural setting. Today the church is in a commercial shopping area of Los Lunas. What used to be a dirt road carrying adventurers along Route 66 is now a busy four-lane street with restaurants, gas stations, and stores on both sides. Despite the encroachment of the modern world, Sangre de Cristo still retains its quiet, rural nature with the tall draping cottonwoods and the clear blue New Mexico sky. (Emily Brito.)

Seven

SAN MIGUEL IN SOCORRO

The village of Socorro was founded in 1598 and named out of gratitude for the aid, or succor, the colonists had received from the Piro Indians of Pilabo after surviving their trek across the dreaded desert area north of El Paso known as Jornada del Muerto (Journey of the Dead Man). Socorro's first documented church, built between 1615 and 1630, was named Nuestra Señora de Perpetuo Socorro de Pilabo (Our Lady of Perpetual Help at Pilabo). This church served as the nerve center of the Franciscan ministry to the Piros in central New Mexico. During the Pueblo Revolt, the settlement was abandoned, and the Spanish settlers, together with the Piro Indians, fled south to the El Paso area.

Resettled after 1800, Socorro became one of the bulwarks against raiding Apaches along El Camino Real and was home to more than 600 residents by the late 1850s. The town's population surged to 4,000 when the railroad arrived in 1880. The town was formally incorporated in 1886 and supported farming, ranching, mining, and smelting, as well as a thriving mercantile community. The New Mexico School of Mines (now New Mexico Institute of Technology) was established in Socorro in 1889.

Today the parish of San Miguel in Socorro has six permanent missions: Alamillo, Polvadera, Lemitar, Luis López, San Antonio, and Magdalena. In addition, there are two occasional missions at Kelly and Riley. The parish of Socorro also served a number of other missions and stations, including Sabino; La Parida; El Tajo; Escondida; Herrick Camp; Culebra, Álamo, and Tres Hermanos; La Joya; La Joyita; and San Acacia, which were more closely associated with La Joya parish; San Marcial, La Mesa, San Pedro, Valverde, Paraje, Engle, Carthage/Tokay, and Bosquecito, which were more closely associated with San Marcial; San Ignacio in Monticello, which was more closely associated with Hot Springs/Cañada Alamosa; and several missions in the western mountains, which were most closely associated with the parish of Mogollón.

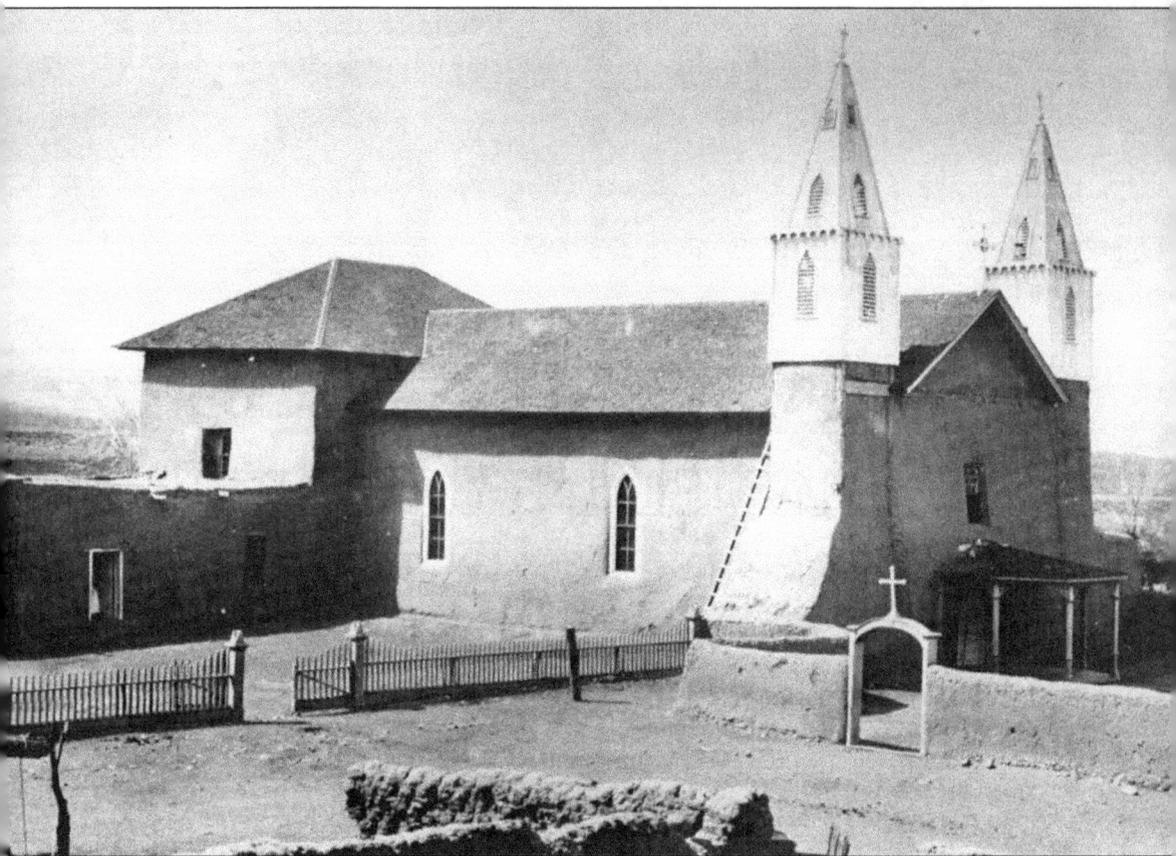

This image shows the Socorro church in the late 19th century. Socorro was abandoned and the church and convento were burned during the Pueblo Revolt. There are stories of resettlement as early as 1790, but the best evidence is that Socorro was resettled after 1800 and the church was rebuilt in 1815. During the reconstruction, the priest rededicated the church to St. Michael because a group of marauding Native Americans apparently broke off an attack on the village when they saw a vision of the archangel wielding a sword as he hovered over the church. (New Mexico State University.)

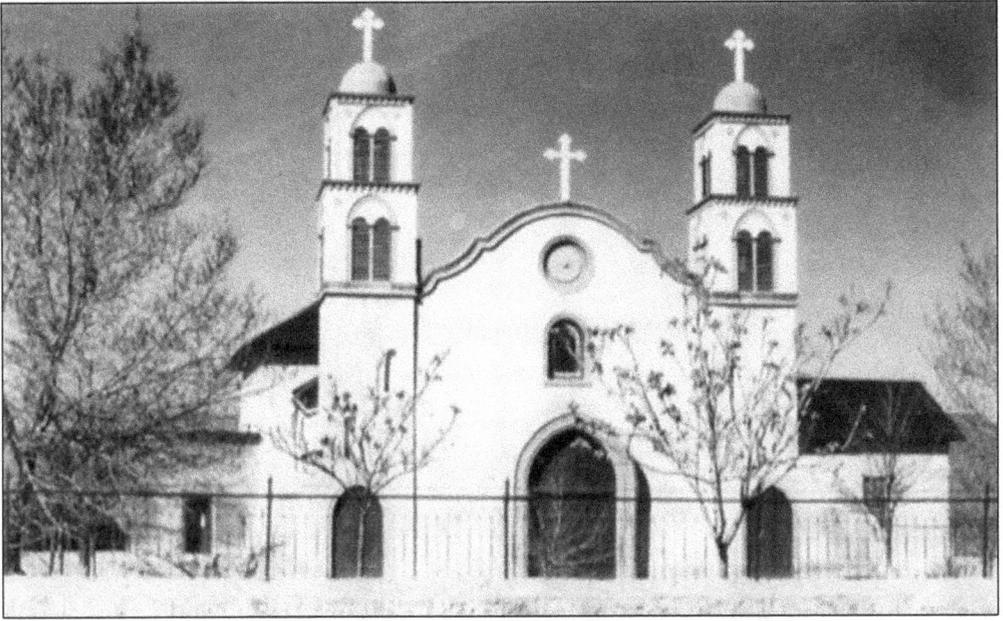

By the 1930s, San Miguel had been reconfigured into more of the California mission style that it retains today (above). Note the espadaña facade and the rounded tower caps, now two levels high. These replaced the neo-Romanesque steeples that had been so popular throughout the valley since the middle of the 19th century. The church and its surrounding structures have been modified over the years, including reinforcing the buttresses and removing or modifying windows and doors. However, the changes have been largely cosmetic and the essential character of the structure remains to the present (bottom). In 2010, the venerable church was temporarily vacated for major structural repairs due to water infiltration in the adobe walls. (Above, New Mexico State University, 2232101; below, San Miguel Parish.)

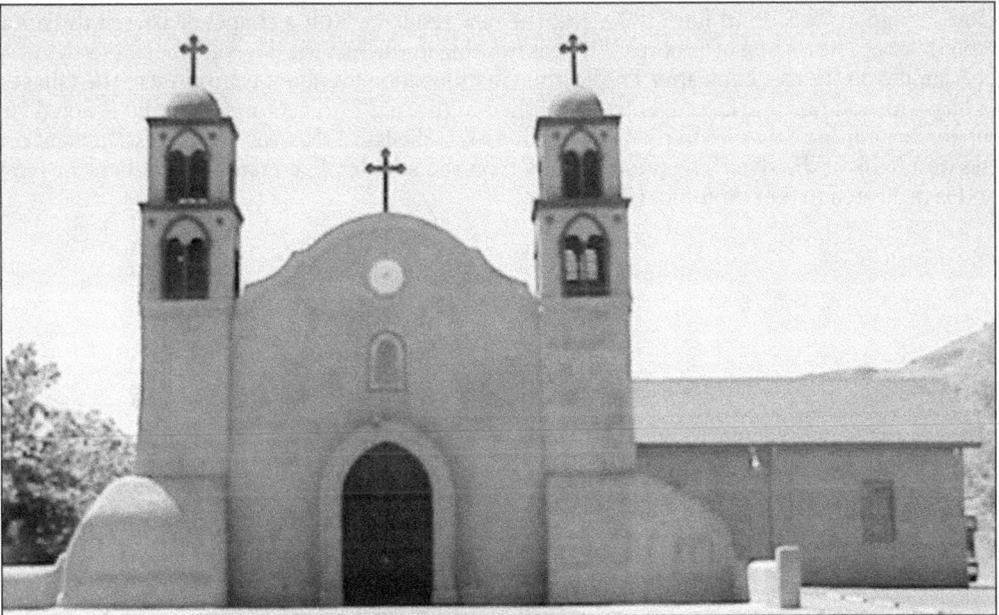

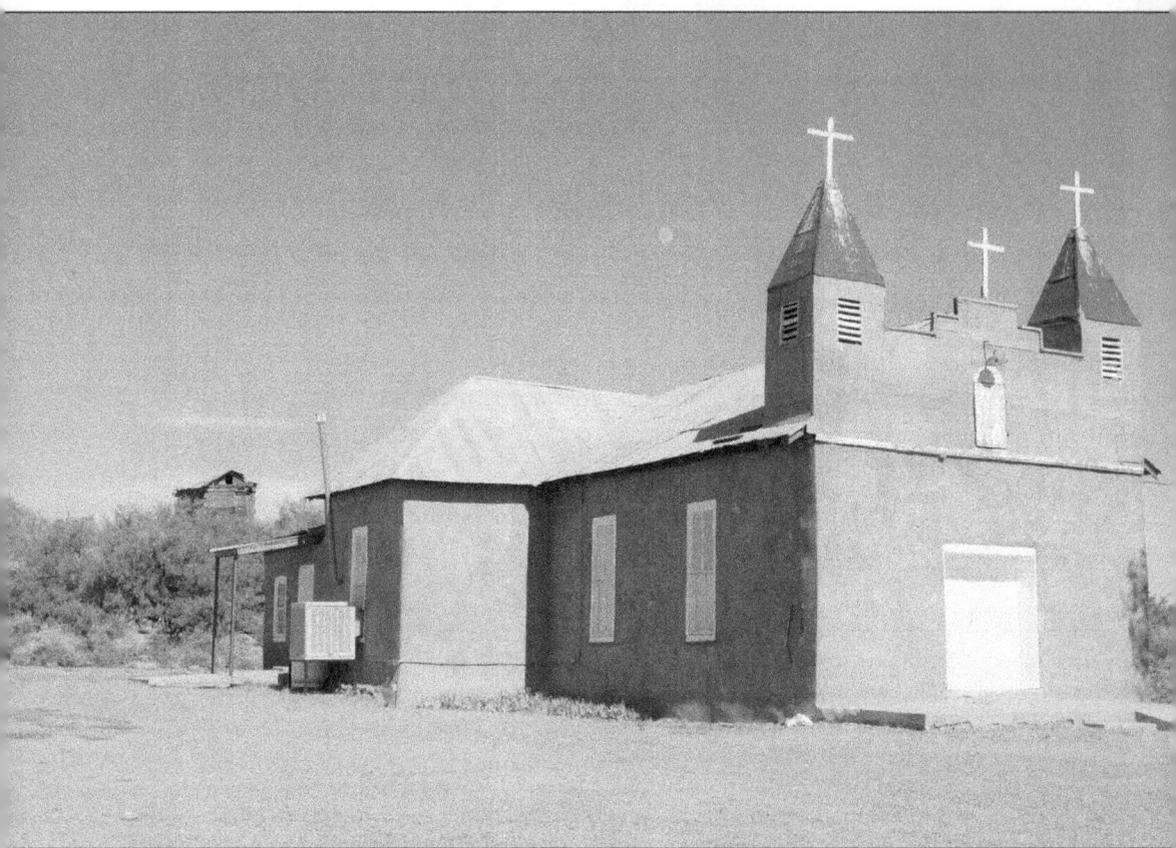

The small farming village of Alamillo (Spanish for "little cottonwood") was located on the east side of the river near the site of a Piro pueblo occupied between 1659 and 1680, before it was abandoned because of the Pueblo Revolt. The area was forcibly resettled under the direction of Gov. Fernando Chacón in June 1800, and the new residents built a chapel dedicated to Santa Ana that became a visita of Socorro. There is nothing in the historical record about a settlement of Alamillo on the east bank after 1800, although its location may have been close to the villages of La Joyita and Bowling Green, both established in the mid-19th century. Alamillo is noted for supporting mining activities in the Sierra Ladrones in the late 1850s, suggesting resettlement on the west bank of the river. The present mission on the west bank at Alamillo was built in 1929 and is dedicated to San Antonio. (B. G. Burr.)

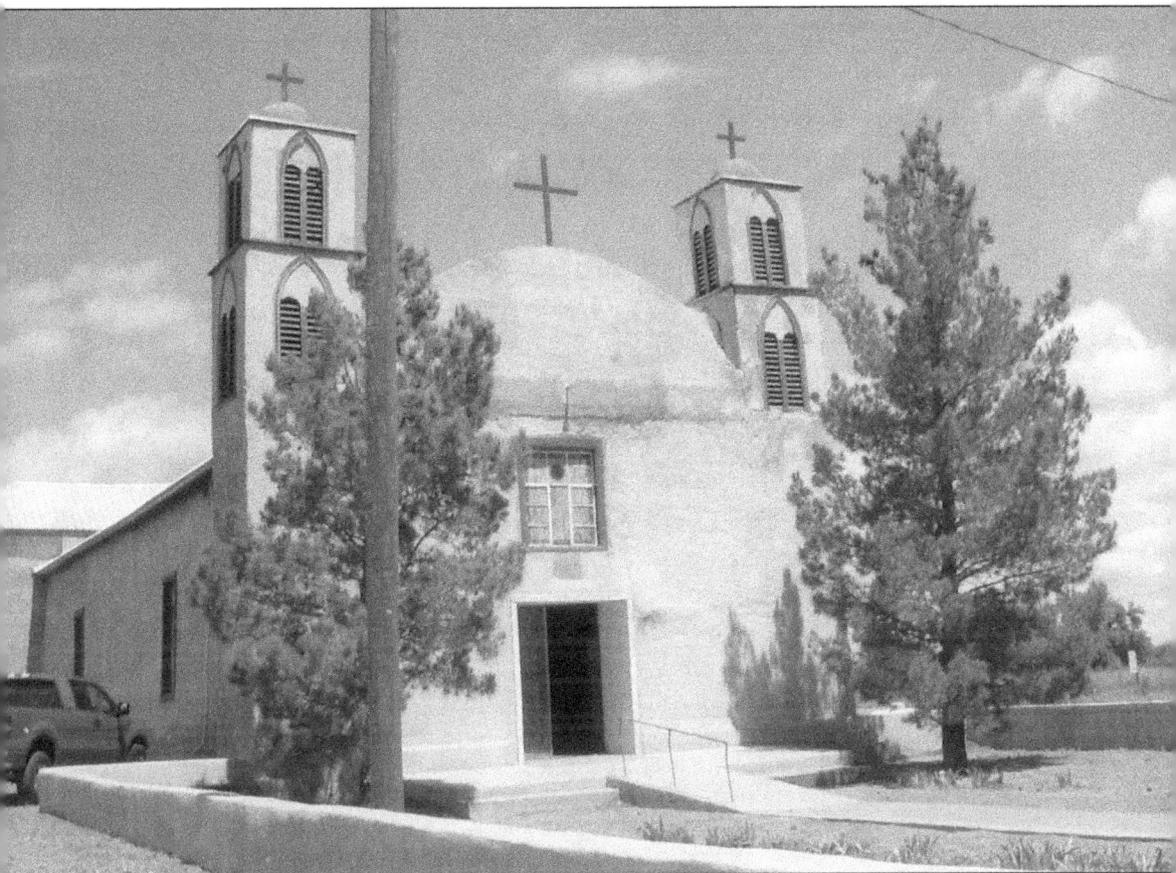

The name Lemitar may be a corruption of a local family name, may relate to a plant (*lemita* or squawbush) whose berries were used to make a beverage, or it may be a corruption of the Spanish word for a boundary or threshold. This small village was founded in 1831 and was the home of Don Manuel Armijo, the last Mexican governor of New Mexico and the general who confronted the U.S. forces under Gen. Stephen Kearny during the Mexican-American War. Armijo retired to the family estate in Lemitar in 1849 and is buried beneath the floor of the parish church of San Miguel in Socorro. Lemitar has had a church dedicated to the Holy Family (occasionally listed as the Holy Names of Jesus, Mary, and Joseph) since its founding. The present structure, which dates to 1841, has been renovated on numerous occasions since that time. Its design, with two towers and a simple arched espadaña, is similar to the California mission style of the mother church of San Miguel. (Lynn Taylor.)

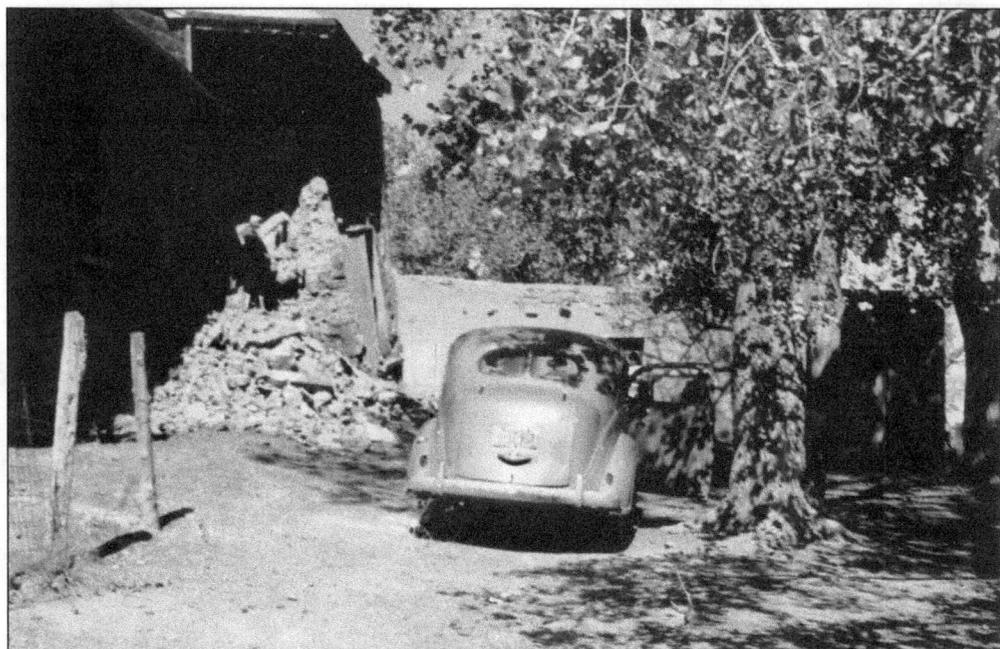

Several of the chapels in the Rio Abajo have suffered catastrophic water damage. Some have literally been flooded out when the river rose and engulfed the buildings. Others, like Sangre de Cristo in Valencia (above), La Sagrada Familia in Lemitar (below), San Miguel in Socorro, and San Antonio in San Antonio have been victimized by water infiltration, leading to wall collapse. On June 29, 2010, while efforts were underway to provide additional support to the west wall of the 149-year-old Lemitar chapel, it collapsed. Fortunately the collapse occurred while the workers were at lunch, and no one was injured. Plans are presently in the works to replace the church. (Above, Ben Otero; below, Paul Harden.)

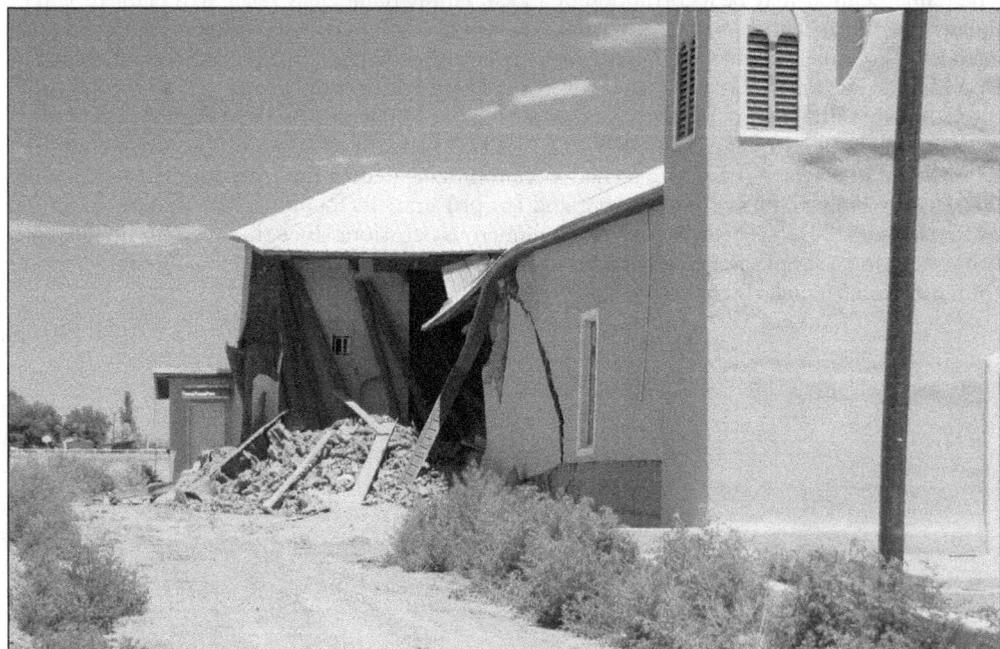

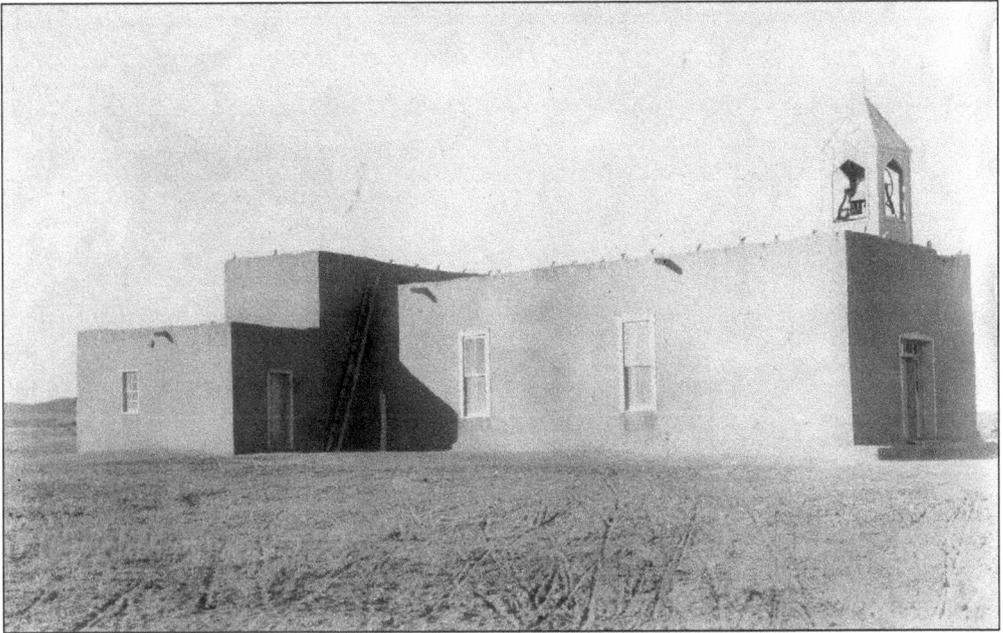

The village of Polvadera (a corruption of the Spanish word *polvareda*, meaning "cloud of dust") was established by Oñate during his 1598 colonization expedition in the area of a Piro pueblo known as Nueva Sevilla. The church has always been dedicated to San Lorenzo (St. Lawrence). In fact, the statue of San Lorenzo, the patron saint of rain, is given credit in Polvadera for a number of miracles and healings; farmers also made pilgrimages to the site in times of drought. The current Polvadera chapel (below) dates to 1925 and replaced a chapel built in 1902 (above). The village and church were heavily damaged in the August 1929 flood but were rebuilt. (Above, Socorro County Historical Society; below, B. G. Burr.)

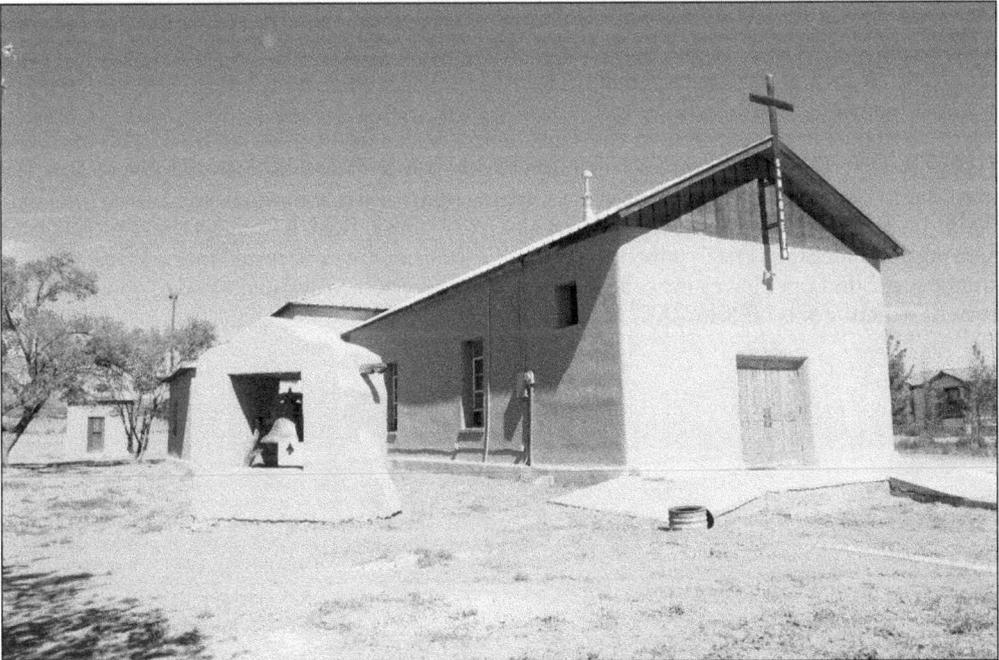

Luis López is a small farming community located on the west side of the Río Grande between Socorro and San Antonio. Luis López, the *alcalde major* (senior colonial administrator) of Senecú, a large Piro pueblo immediately to the south, had a hacienda in this area from 1660 until the Pueblo Revolt. The settlement was abandoned during the Pueblo Revolt and not reoccupied until the 1830s. The López hacienda was a stopping point and safe haven from Native American raiding as well as a campground for travelers along El Camino Real. It was also the center of local farming and ranching. The first mention in the Catholic archives occurred in 1833. The mission churches of Luis López have always been associated with Socorro and dedicated to San José. The current structure was built in 1900.

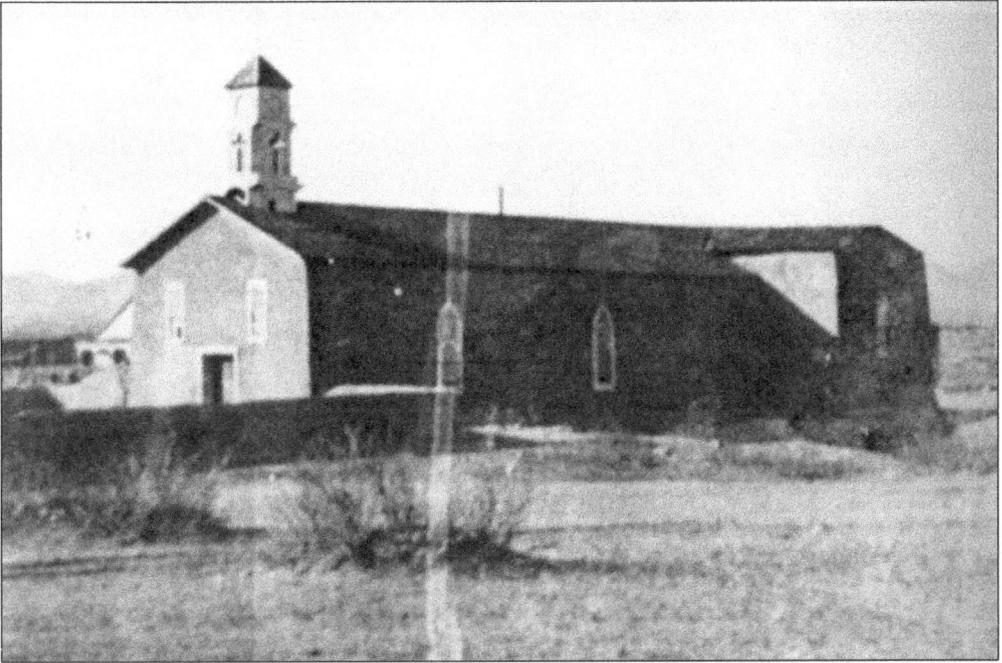

San Antonio de Senecú was established by the Franciscans in the 1620s. The mission was destroyed during an Apache raid in 1675, resettled in 1677, abandoned once again during the Pueblo Revolt, and resettled in 1728. San Antonio was a major fixture on the north-south trade route and became a center of mercantile activity. The railroad arrived in 1880, and the town center moved north to a location near the present-day church. Shortly thereafter, coal was discovered at Carthage, about 10 miles east of San Antonio. San Antonio supported coke ovens for the coal mines at Carthage and later Tokay until the early 20th century. The first church (above) is said to have been destroyed by an earthquake in 1906, but a new church (below) was rebuilt shortly thereafter in its present location. (Above, Henry Walt; below, Mary Rose Baca.)

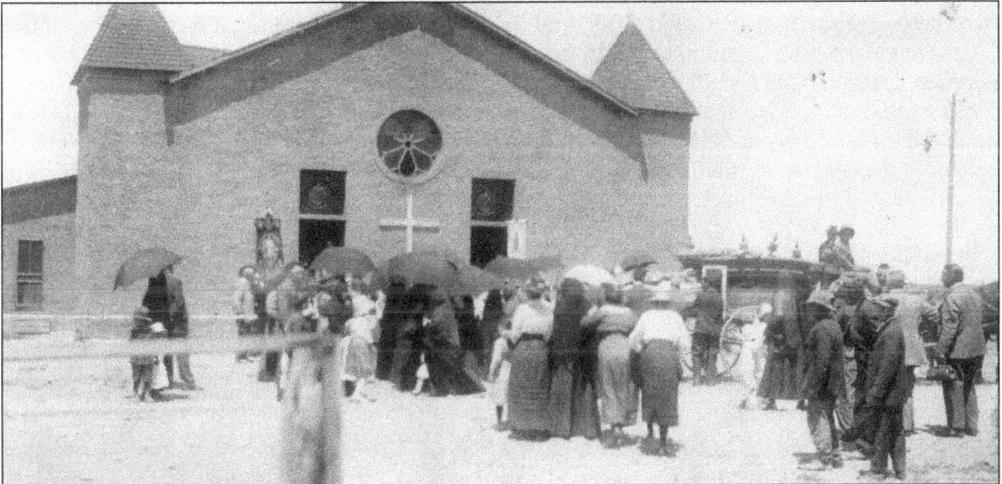

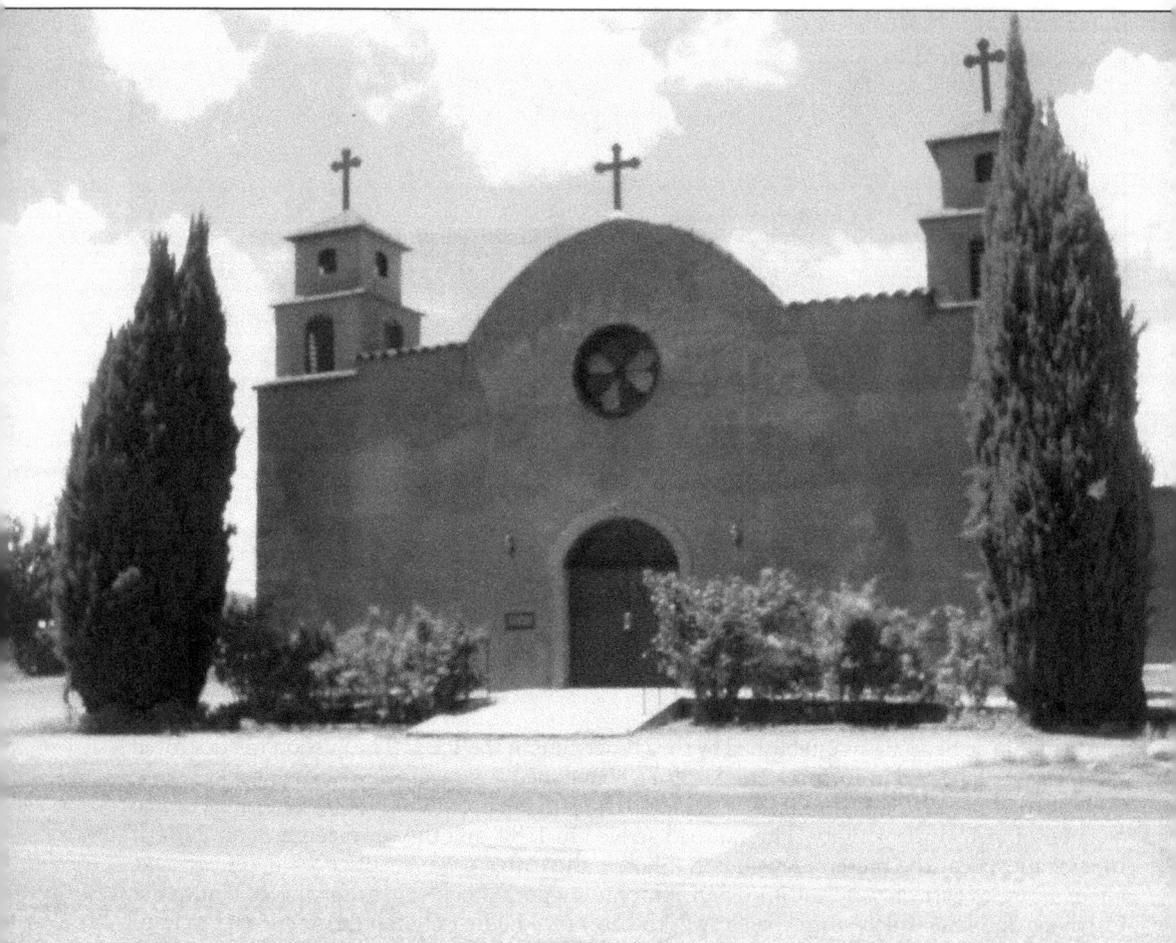

In 1882, a Norwegian merchant named Augustus Hilton moved to the San Antonio area. Because of his many commercial enterprises, including hotels, mercantile stores, and supply services to the army, he became known as the Merchant King of San Antonio. His son, Conrad Hilton, who was born in San Antonio, founded the Hilton hotel chain. Parishioners built the second San Antonio church in 1930 after a fire, and like Holy Family in Lemitar, it has elements of the California mission style architecture. In fact, the current church in San Antonio has the same two-tiered steeples and rounded espadaña as the mother church in Socorro and the Holy Family mission in Lemitar. Also like Lemitar and San Miguel, it has suffered significant water damage to its adobe walls and is presently not in service until repairs can be completed. San Miguel parish held ecclesiastical responsibility for San Antonio until 1894, when it shifted to the new parish of San Marcial. Responsibility shifted back to Socorro in 1940. (Lynn Taylor.)

Magdalena began in the 1860s and 1870s when lead, silver, and zinc were discovered in the nearby mountains. It later served as a major cattle drive destination. Legend has it that a nearby rock formation reminded early Spanish explorers of the face of Mary Magdalene. The chapel of St. Mary Magdalene began as a station served from Socorro in 1887. It remained a station until 1911, when it transitioned to mission status. It became a parish with missions at Kelly and Santa Rita in 1919 and remained so until 1976, when it reverted back to mission status under the mother church in Socorro. The current church was originally designed as the basement of a much larger edifice. However, funds ran out and the existing basement was simply roofed over, yielding a unique, below-grade structure. The church is also characterized by near-life-sized statues of various saints that line both sides of the nave. (Both, B. G. Burr.)

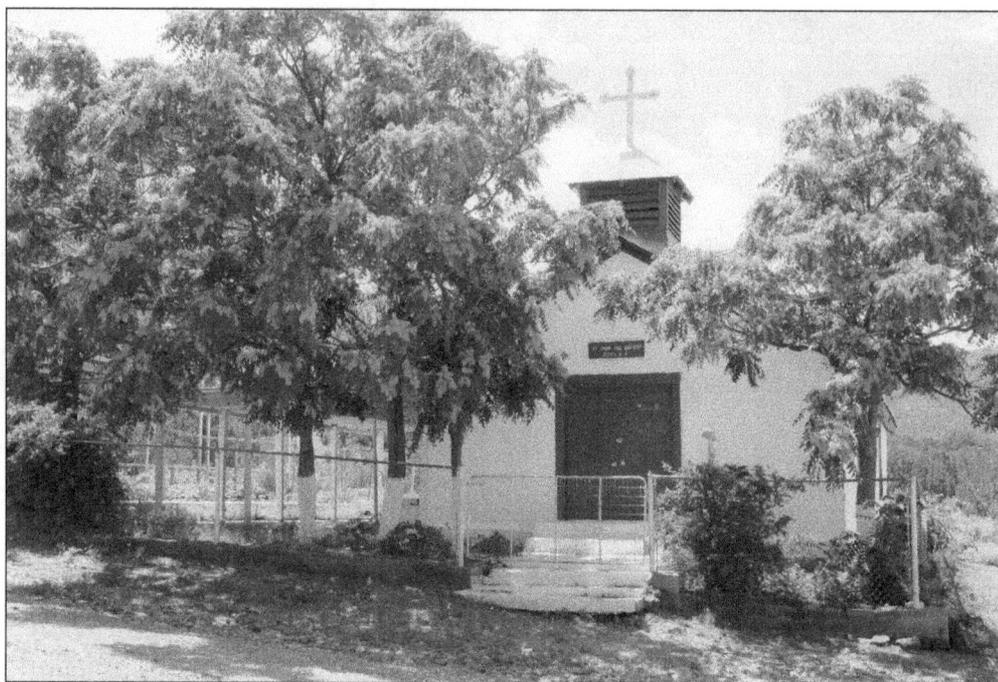

The ghost town of Kelly, at one time home to over 3,000 residents, is located in the mountains south of Magdalena. The area was named for Andy Kelly, a local storekeeper, who established a sawmill there in 1866. Although the last resident of Kelly left in 1947, former residents and their descendants maintain the mission church of St. John the Baptist. This chapel was a station served from Socorro from 1894 to 1915. It attained mission status in 1915 and was a mission of Socorro until Magdalena became a parish in 1919. Kelly once again became a mission of Socorro when Magdalena reverted to mission status in 1976. (Above, B. G. Burr; below, Paul Harden.)

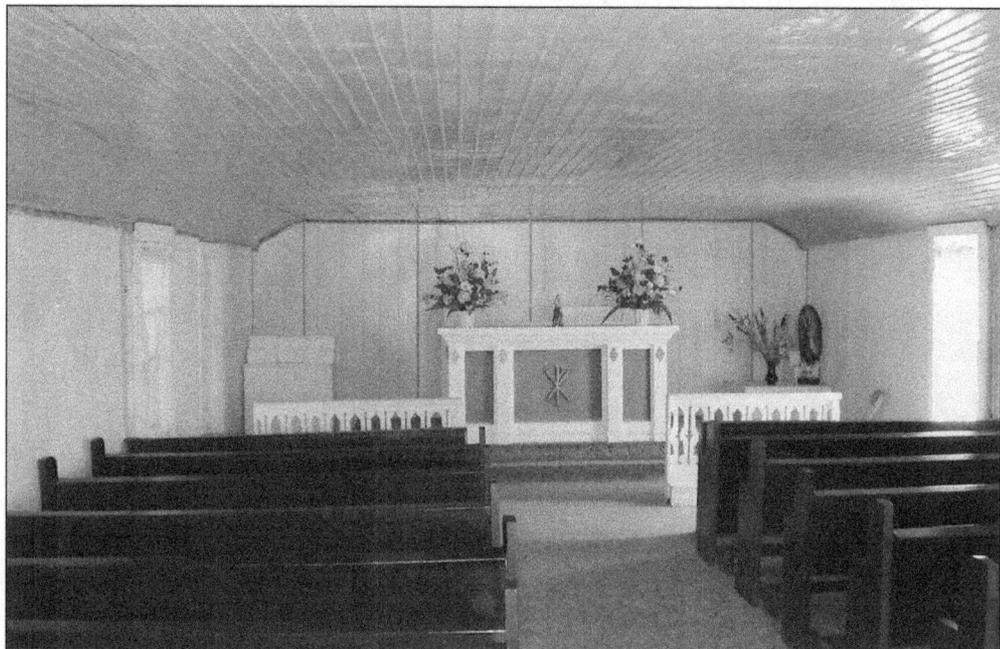

Riley, known as Santa Rita after its original settlement in the 1880s, lies northwest of Socorro along the Río Salado. The settlement was renamed Riley in the 1890s after a local resident. The original chapel in Riley was constructed in 1883 and dedicated to Santa Rita de Cascia until 1913. The dedication was changed to San Isidro for a time in the 20th century. (San Miguel Parish.)

The parish of Our Lady of Belén maintained ecclesiastical oversight for Santa Rita from 1896 until 1913, when responsibility shifted to Socorro. When Magdalena became a separate parish in 1919, it took the Riley mission with it. Santa Rita remained a mission of Magdalena until 1976, when that parish and its associated missions once again were placed under the oversight of San Miguel in Socorro. (Paul Harden.)

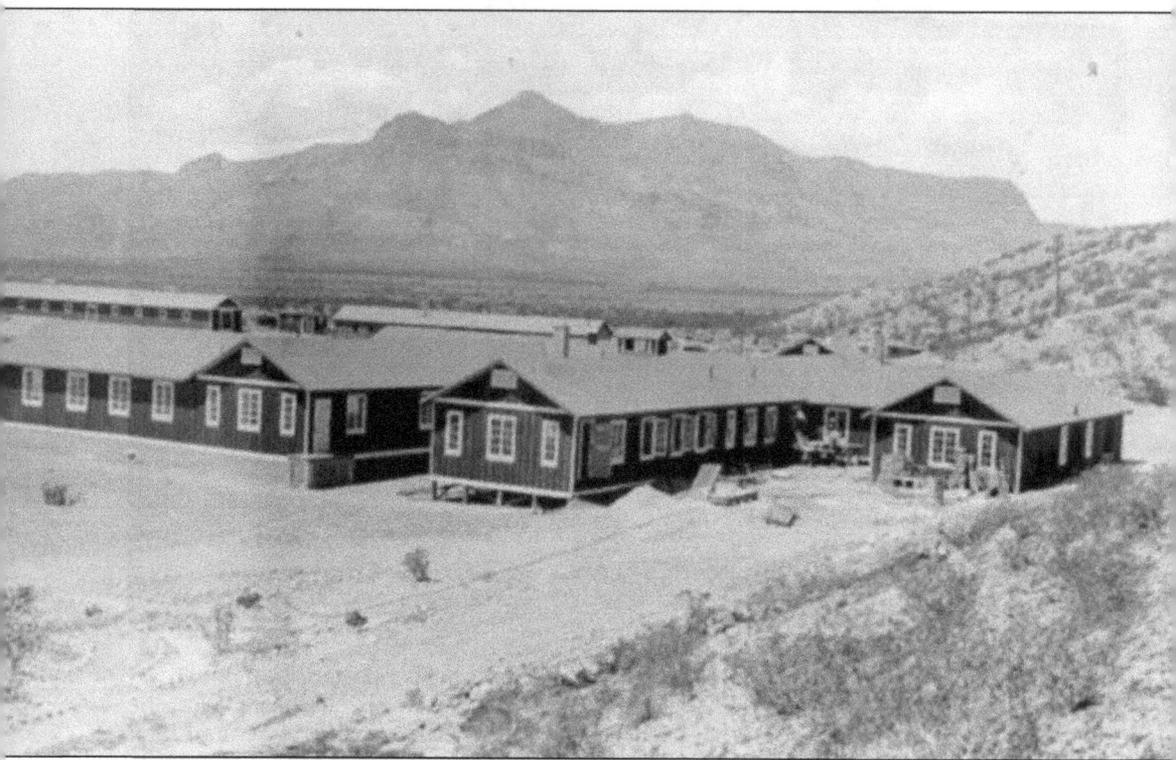

In the late 19th and early 20th centuries, it was widely believed that patients suffering from tuberculosis (or consumption, as it was commonly known) would benefit from living in a dry desert climate. As a result, several treatment centers, or sanitariums, sprang up in New Mexico. Two prominent facilities were the Presbyterian and St. Joseph's Sanitariums in Albuquerque. However, outlying locations also played in the consumption game. In 1932, the New Deal's Civilian Conservation Corps built the New Mexico State Tuberculosis Sanitarium in Escondida (a word meaning hidden), a small village just north of Socorro, to treat patients who could not afford private treatment. From 1955 to 1958, priests from Socorro formally served the mission at Escondida in the sanitarium. Now in ruins, the former hospital is used as a weekend paintball venue. (Socorro County Historical Society.)

Florida, a small northern suburb of Socorro, had a mission dedicated to Our Lady of Fátima from 1951 to 1986. The church was built by the Saavedras and others who lived nearby on land owned by the Saavedra family. It was dedicated by Archbishop Edward Vincent Byrne in December 1951. Families came to Fátima from both sides of U.S. Highway 85, many in mule-drawn wagons, but when Interstate 25 was completed through Socorro, most of the highway crossings were eliminated. The trip from east of the road to the church suddenly jumped from a few miles to more than 8 miles, and attendance dropped precipitously. By 1986, the structure had fallen into disrepair, so it was razed. (Both, Paul Harden.)

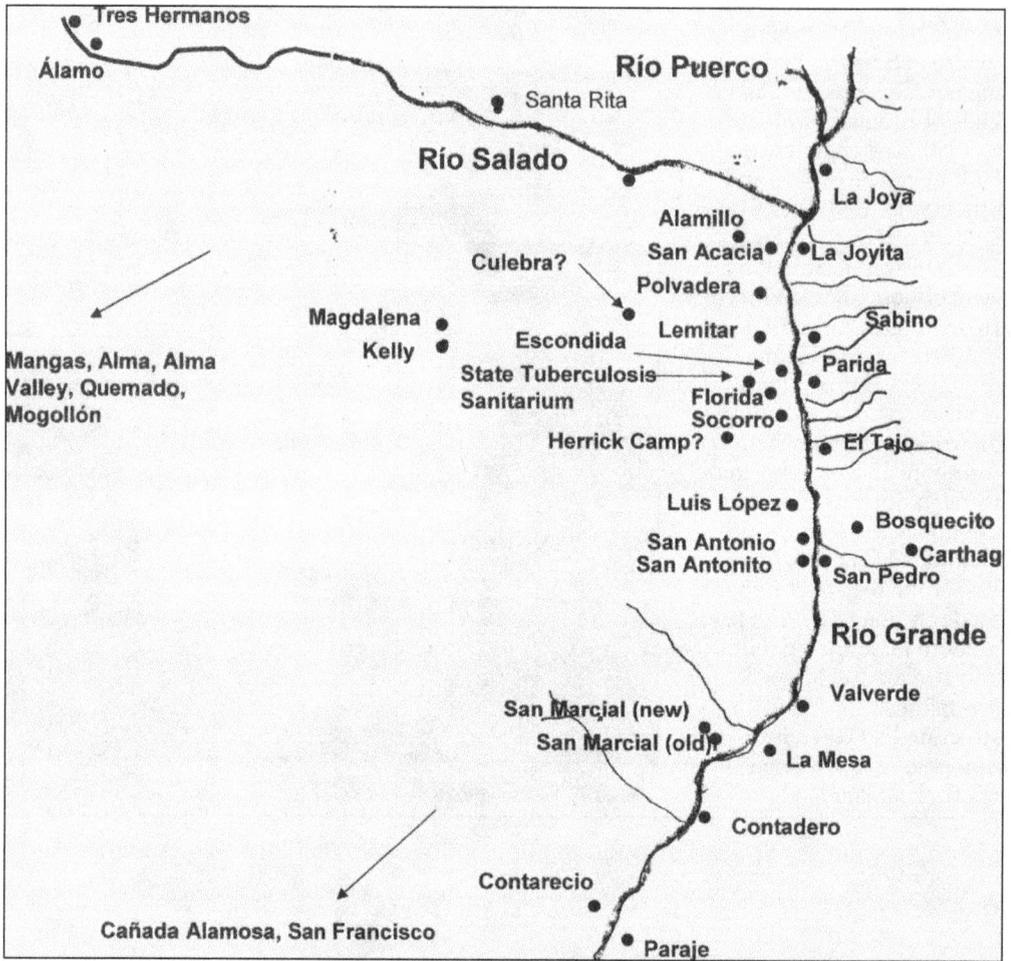

Tres Hermanos

Álamo

Río Puerco

Santa Rita

Río Salado

La Joya

Alamillo

San Acacia • La Joyita

Culebra? Polvadera

Magdalena Lemitar Sabino

Kelly Escondida Parida

Mangas, Alma, Alma
Valley, Quemado,
Mogollón

State Tuberculosis
Sanitarium Florida

Socorro

Herrick Camp? El Tajo

Luis López Bosquecito

San Antonio Carthag

San Antonito San Pedro

Río Grande

Valverde

San Marcial (new)

San Marcial (old) La Mesa

Contadero

Contarecio

Cañada Alamosa, San Francisco Paraje

Under the watchful eye of the Archangel Michael, the parish of San Miguel (1615–present) has accumulated some truly amazing statistics. At one time or another, its boundaries stretched from La Joya on the north to Cañada Alamosa on the south, and from east of the Rio Grande to the Arizona border. It carried responsibility for nearly 40 churches, missions, visitas, and stations (although fortunately for the parish priests, not all at once), and was responsible for spinning off at least five new parishes—Magdalena, San Marcial, Cañada Alamosa, Mogollón, and La Joya. In addition, it has given several priests and one bishop, Robert Fortune Sánchez, the 10th archbishop of Santa Fe, who was born and educated in Socorro.

Eight

MINISTRY IN THE MOUNTAINS

Mountain areas to the east and west of the Río Grande Valley had formative and ongoing connections with the riverine parishes. The mountains east of the Río Grande and south of Tijeras were home to Tiwa-, Piro-, and Tompiro-speaking Native Americans. Franciscan missions to these natives were established at Chililí, Tajique, Quarai, Abo, and Gran Quivera in the 17th century. These missions were abandoned in the 1670s because of the near-constant Native American raiding, combined with the effects of an extended drought. In 1829–1830, residents of Valencia and Tomé resettled the area, which they called Manzano (Spanish for apple tree).

The passage of the Sherman Silver Purchase Act in 1890 spurred a mining boom in south-central New Mexico, which led to the founding of a number of villages and mining camps in the area. These western settlements were visited by priests from several parishes.

Monticello oscillated between parish and mission status from 1881 until 1962, being variously served from Socorro, San Marcial, Paraje, and Hot Springs. In 1962, Our Lady of Perpetual Help in Truth or Consequences (formerly Hot Springs) became the mother church of the parish. Including the mother churches in Monticello and Hot Springs, this complex of churches was at one time or another responsible for 28 churches, missions, or stations.

Because of the extreme distances from the mother churches in Socorro and Monticello to the western villages and camps, Mogollón served as a separate parish from 1920 to 1939. In 1939, Pope Pius XII established the Diocese of Gallup, and most of the western churches that had previously been served by priests from Socorro, Monticello, and Mogollón were assigned to the new diocese.

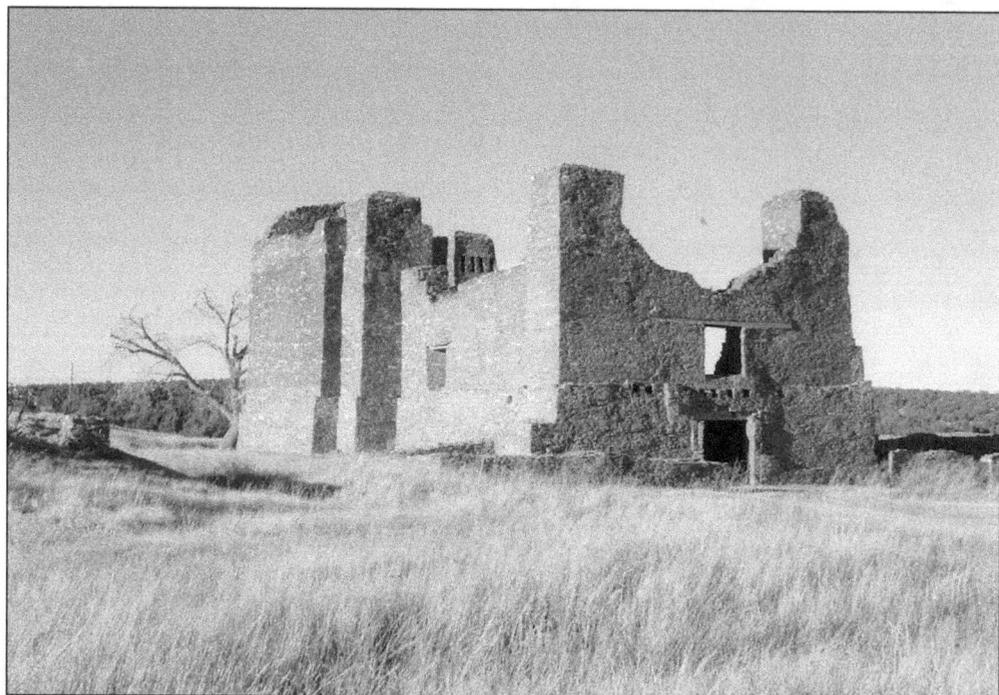

The first Manzano settlement was located near the ruins of the La Purísima Concepción (Immaculate Conception) mission, built in 1630 at Quarai. This site was abandoned because of drought and Native American raids in 1674 and was not reoccupied until 1829. The residents relocated to the present village of Manzano in 1830. (Daniel Rogers.)

The present church of Our Lady of Sorrows in Manzano dates from 1885. It was served from Tomé until it became a separate parish in 1857. The new parish served seven missions—Chililí, La Ciénega, Tajique, Torreón, Punta de Agua, Abo, and Escabosa. In 1973, Manzano became a mission of St. Alice in Mountainair. (Museum of New Mexico, 55475.)

Chililí (Tiwa for "weakly running water") is located on the eastern slopes of the Manzano Mountains. It is one of the oldest recorded named locations in New Mexico, dating back to the 1581 Chamuscado expedition. Franciscan missionary activity began here with the construction of a small mission dedicated to La Natividad de Nuestra Señora (The Nativity of Our Lady) in 1614, but the area was subjected to continual Native American raids and was abandoned between 1669 and 1674. It was resettled in 1841. The current church in Chililí, a mission dedicated to San Juan Nepomuceno and now a part of Holy Child Parish in Tijeras, dates from 1842, although it has clearly been refurbished and remodeled several time since then. Chililí was also home to a *morada* (worship center) of the Penitente Brotherhood until the structure burned in 1957. (Both, Holy Child Parish.)

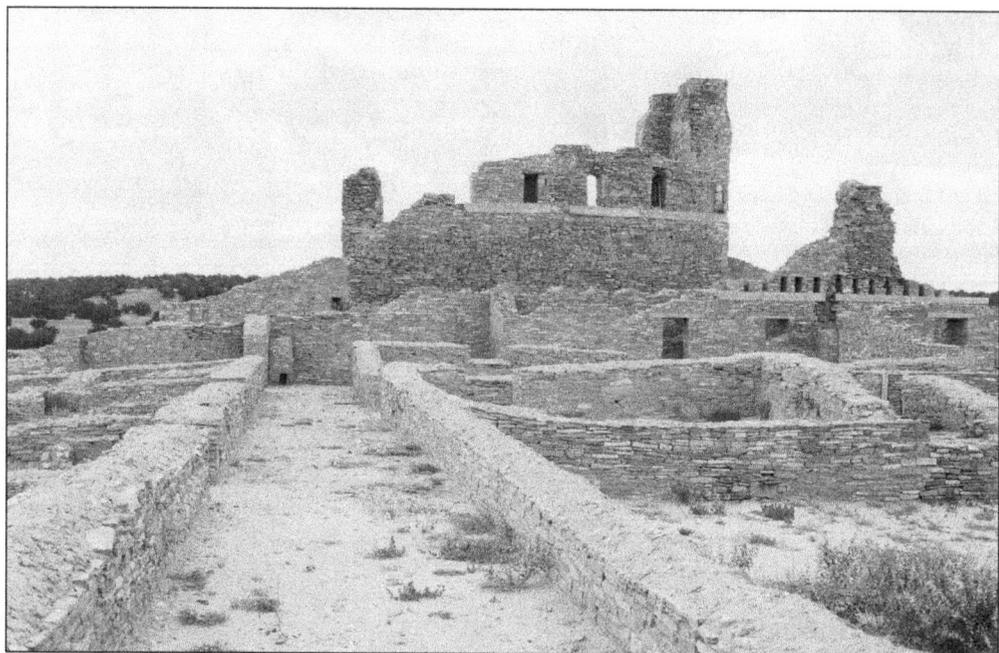

Abo, a name that is said to mean "water bowl" in the Tompiro language, was the site of one of the three main Salinas pueblos. Abo was visited by Oñate, and the mission church of San Gregorio was built here by Fray Francisco de Acevedo in 1626. It was intended to be one of the centers for Franciscan outreach to the Tompiro-speaking Native Americans who lived on the southeastern slopes of the Manzanos. The mission was abandoned due to persistent Native American raiding and drought in the 1670s. The area around the ruins of the old mission was resettled early in the 20th century, and a mission dedicated to San Lorenzo was constructed. The mission was served from Manzano from 1914 to 1943, when it was assigned to St. Alice in Mountainair. (Above, Cynthia Garner; below, Sid Gariss.)

Escabosa was named for the stiff local grass that residents used to make brooms. Escabosa has been a formally noted mission of Manzano dedicated to San Isidro Labrador (St. Isidore the Plowman) since 1939. The current stone structure was built in 1932 or 1933 and was probably a family chapel or station before it became a mission of Manzano parish. Stories are told that dances were held to raise money to purchase the lumber for the roof of the new church. San Isidro Labrador was reassigned from Manzano to Holy Child Parish in Tijeras in 1973. (Both, Holy Child Parish.)

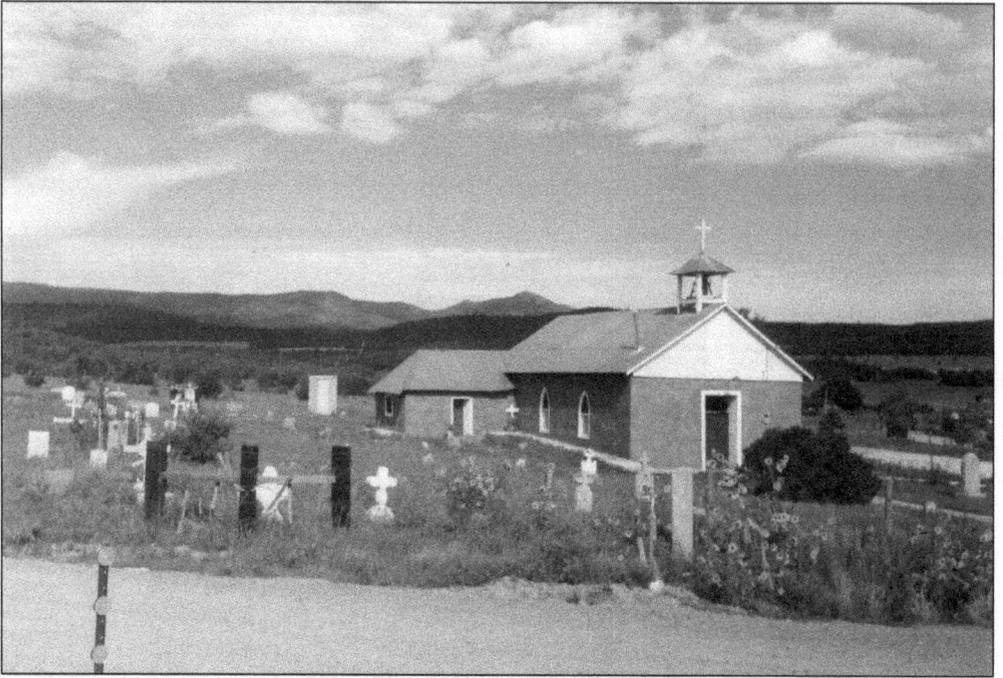

Tajique (a corruption of the native name for the local area) was the site of the large Franciscan mission church of San Miguel, abandoned in 1672. The area was resettled in 1834 and attended from Tomé. The present church, built in 1915 and now a mission of Estancia Valley Parish, is dedicated to San Antonio. Earlier churches at that site may have been similarly dedicated.

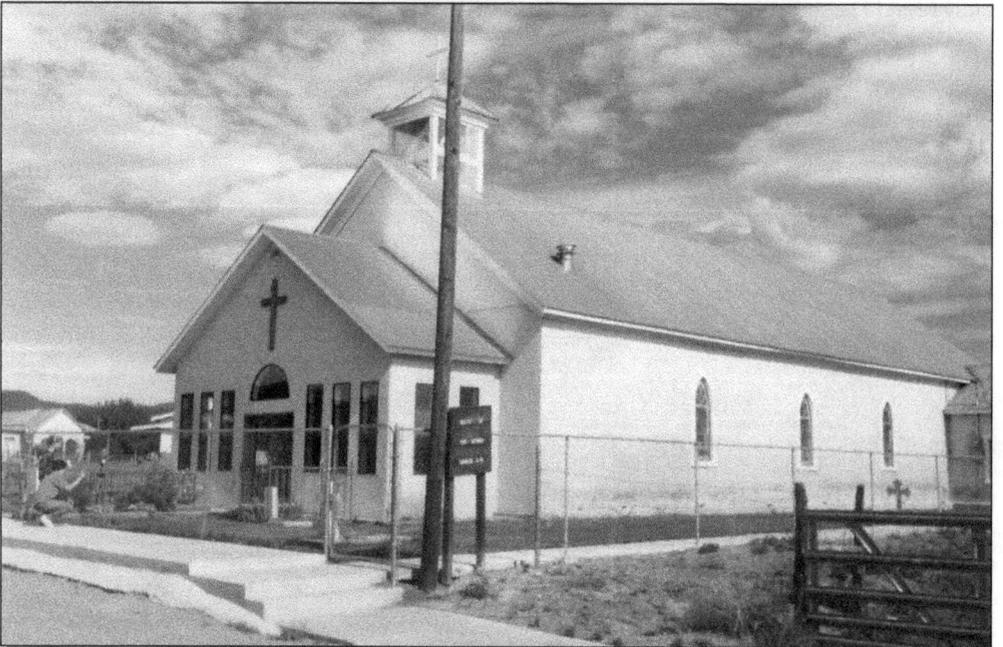

Torreón, named for the fortified tower built at Manzano, was settled in the early 1840s and was served from Tomé until 1857. The present chapel at Torreón dates to 1912 and is dedicated to St. Anthony and the Holy Family. It remained a mission of Manzano until 1973.

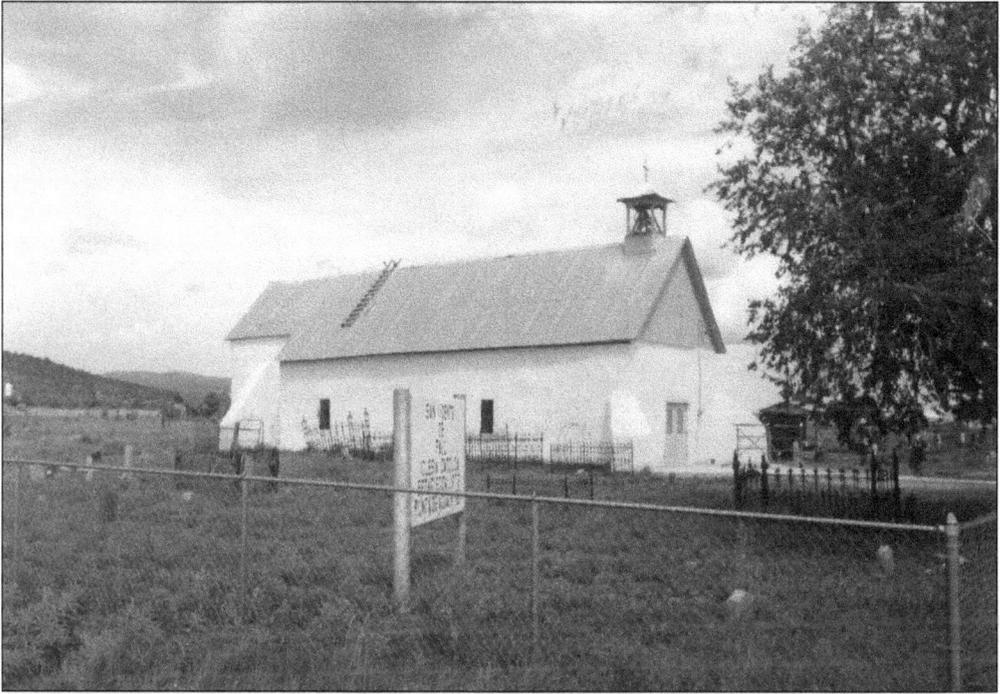

Punta de Agua was settled late in the 19th century. A church is noted in 1859 as a mission of Manzano. The mission dates from 1874 and is served from St. Alice in Mountainair. It is dedicated to St. Vincent de Paul, said to have been Archbishop Lamy's favorite saint.

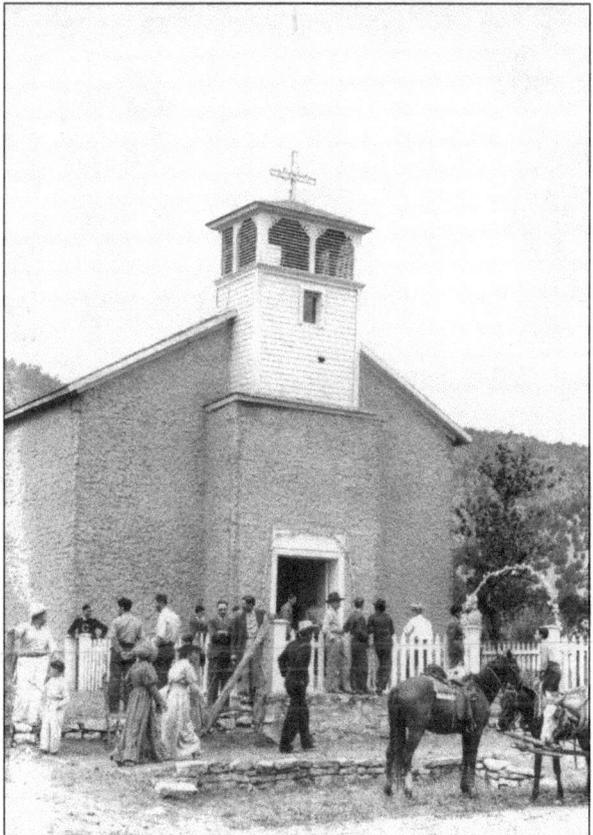

From 1867 to 1869, priests from Manzano traveled to the village now known as Lincoln, which had been settled in the 1850s by families from Manzano. The church of San Juan Bautista and other Lincoln County missions were served from Manzano again in 1893 and 1894. The church is now a mission of St. Eleanor Parish in Ruidoso. (Museum of New Mexico, 52075.)

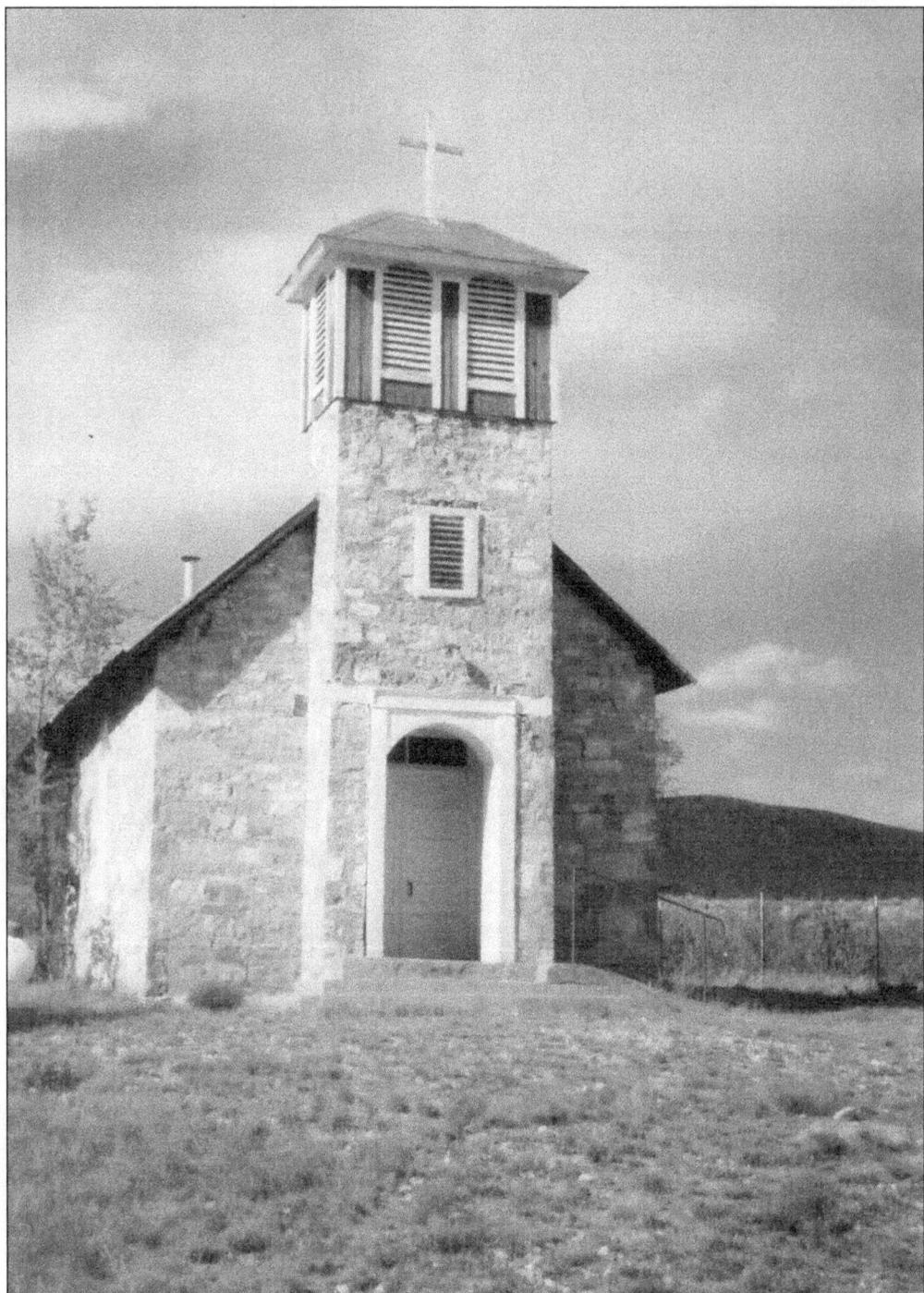

Priests from Manzano traveled over 200 miles south to serve a number of Lincoln County missions from 1893 to 1894. These included Picacho (seen here), Picacho Abajo, Ruidoso, and San Patricio. In addition, there were stations at La Gallina, Las Palas, Las Tablas, White Oaks, Nogal, and Bonito City. This suite of missions and stations was reassigned to San Juan Bautista in Lincoln in 1895.

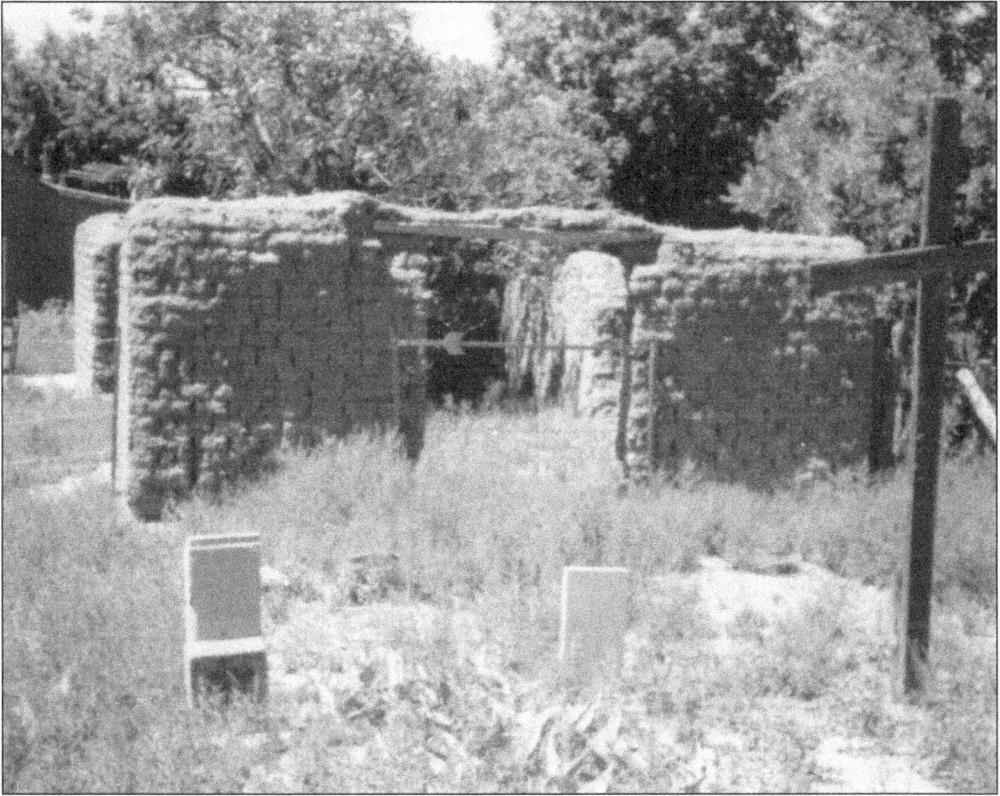

In addition to the missions previously, there was a mission at Rancho Torres (shown above in ruins). Manzano also served a mission in Pinos Wells dedicated to San Isidro and served from Manzano from 1893 through 1913. Pinos Wells was located on the north-south route from White Oaks to Santa Fe. It had two wells and two pine trees, so these features were combined to give the village its name. José Franciso Chávez, a prominent New Mexico politician from Valencia County, was assassinated while dining at his home near Pinos Wells on the evening of November 26, 1904. His murder was never solved. (Above, Felipe Mirabal; right, Museum of New Mexico, 27132.)

Cañada Alamosa (Spanish for "canyon of the cottonwoods"), settled in 1856, was renamed Monticello for the postmaster's hometown in New York. The original church of San Ignacio in Cañada Alamosa was completed early in 1869, and Mass is still celebrated in a chapel that dates to 1908, located at the site of the original structure. From its founding to 1962, San Ignacio was variously served from Socorro, San Marcial, Paraje, and Hot Springs/Truth or Consequences. For a time near the end of the 19th century and again in the early 20th century, it was the mother church for many of the local missions. In 1962, Our Lady of Perpetual Help in Truth or Consequences became the mother church of the parish, with San Ignacio as one of its principal missions. The parish was shifted from the Archdiocese of Santa Fe to the Diocese of Las Cruces when the latter was created in 1982. (Our Lady of Perpetual Help Parish.)

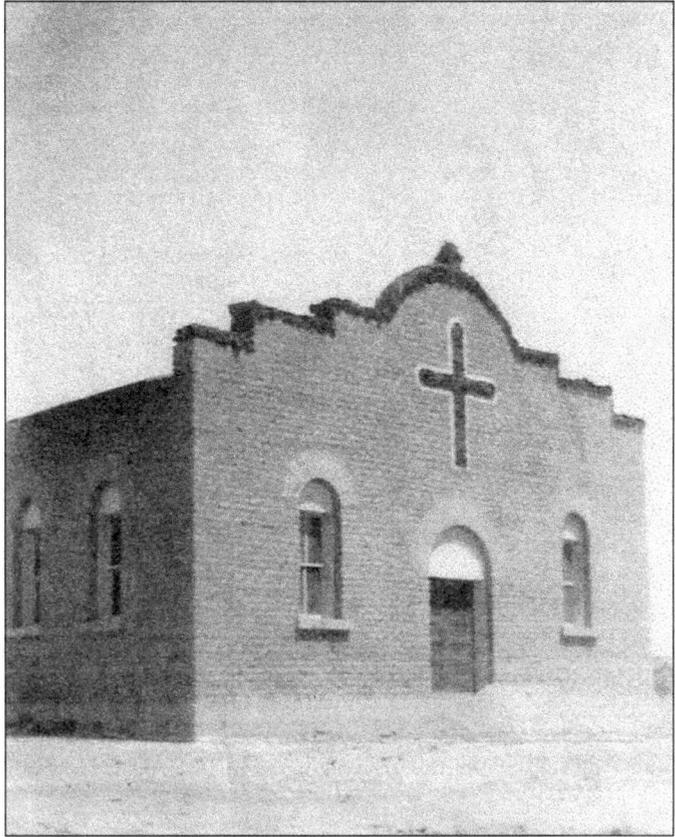

The village of Hot Springs was called Alamocitos (Spanish for "little cottonwoods") and Ojo de Zoquete (Spanish for "mud springs") by early Spanish travelers. It was settled between 1911 and 1916 by people who worked on the construction of Elephant Butte Dam. In 1950, it was renamed Truth or Consequences after the popular radio show hosted by Ralph Edwards. Mass was first said for residents of Hot Springs in 1916 at the local high school. Construction of the first church, Our Lady of Perpetual Help (right), began in 1921. This original structure is now the parish hall. The present church (below) was built in 1949. (Right, Columba Reid; below, Our Lady of Perpetual Help Parish.)

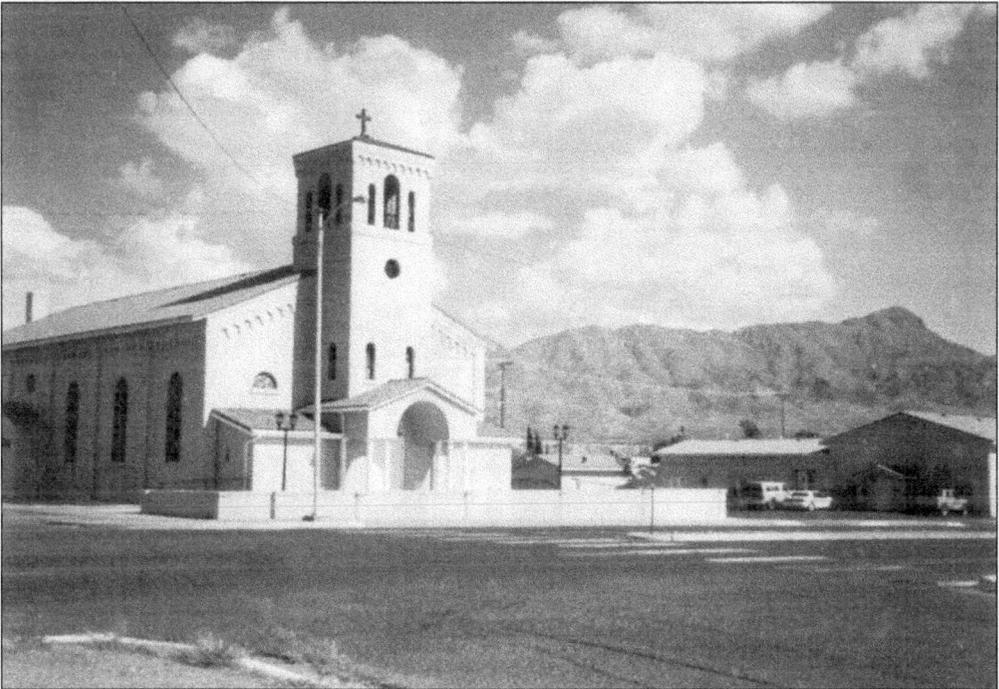

Cuchillo Negro ("Black Knife," the name of an Apache chief), was settled around 1850 and later served as a stage stop between the railhead at Engle and the Black Range mining towns. The first two chapels in Cuchillo, both dedicated to St. Joseph, were destroyed by floods. The current structure, rebuilt on higher ground, was completed in 1907. (Our Lady of Perpetual Help Parish.)

San Miguel was a small farming and ranching community in the Palomas Valley. The church, built in the form of a coffin to remind parishioners of the inevitability of death, was built around 1910. Most residents have now relocated, and Mass is celebrated once a year on the Feast of St. Michael the Archangel. (Viola Armijo.)

106

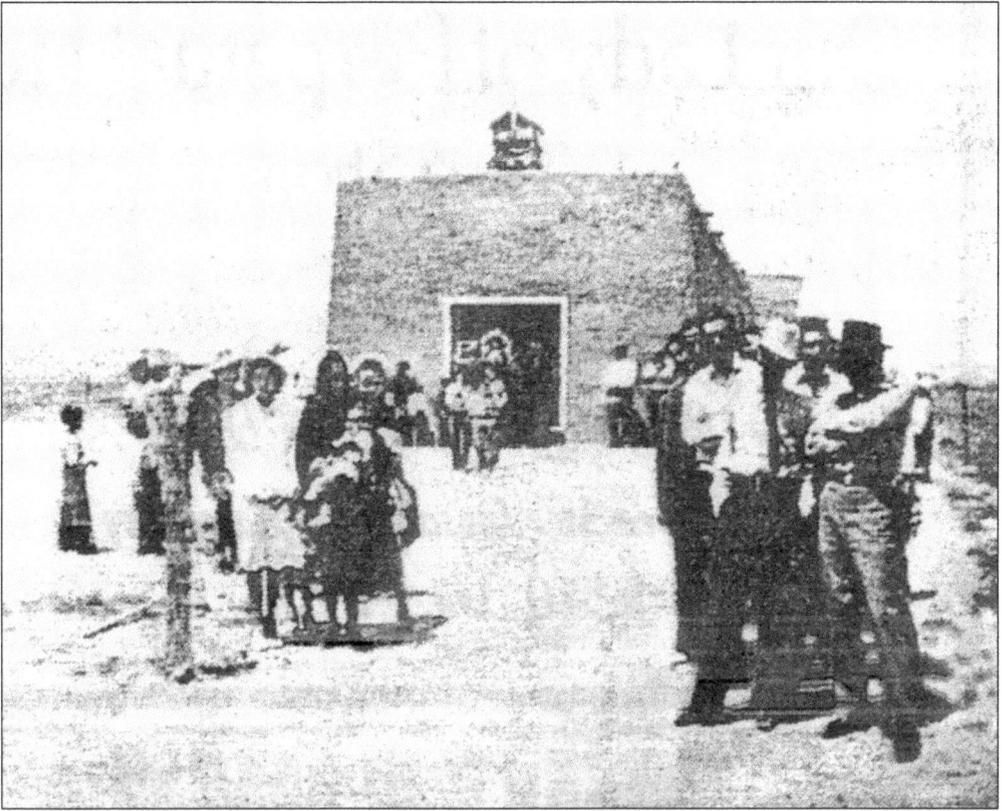

Las Palomas (Spanish for "the doves") was settled on Las Palomas Creek in the late 1850s. The area was particularly attractive because of the local hot springs and Las Palomas Gap, a passage through the nearby Caballo Mountains that served as an important east-west trade route in south-central New Mexico. The first church in Las Palomas (above) was built in the 1860s as a visita, and then mission of Cañada Alamosa, dedicated to San Isidro. It was a mission of San Marcial from 1871 to 1873, a mission of Paraje from 1873 to 1879, and has been a mission of Cañada Alamosa/ Monticello/Hot Springs/Truth or Consequences from 1879 to the present (right). (Both, Our Lady of Perpetual Help.)

The original church in Las Palomas lasted until the rising waters of the government-sponsored Caballo reservoir undermined the walls in 1942. Using reimbursement funding from the government, residents of Las Palomas reconstructed their church on higher ground in 1945. The chapel has always been dedicated to San Isidro, in recognition of the farmers and ranchers who settled and continue to work the land around Las Palomas. (Viola Armijo.)

Las Placitas was settled in 1856 and Mass was first celebrated by priests from Monticello in local homes or the village school starting in about 1905. The church of San Lorenzo in Las Placitas began in 1916 and was completed in 1926. (Our Lady of Perpetual Help.)

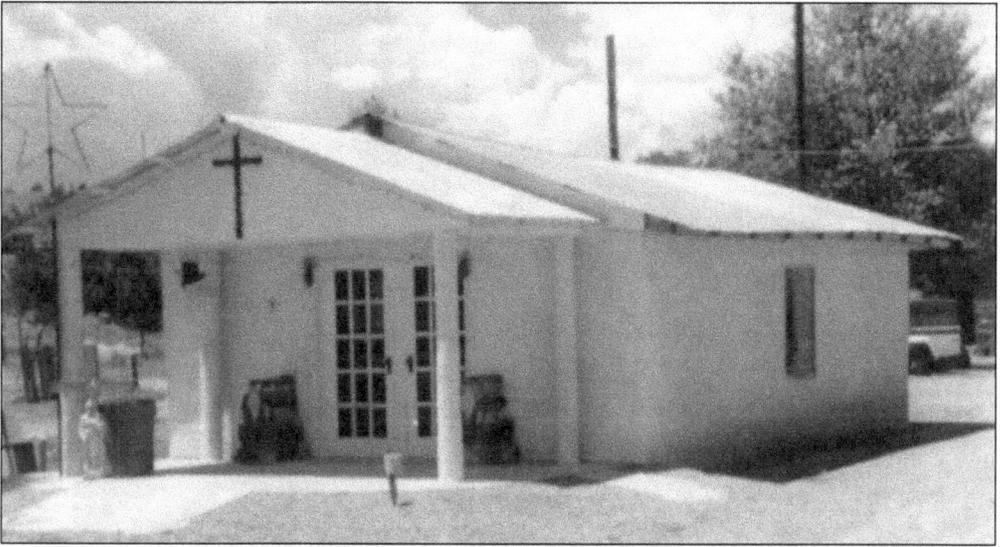

Fairview, first known as Buena Vista, was founded in 1881 and renamed Winston in 1930 in honor of a longtime resident. In 1939, priests from Hot Springs began saying Mass at the school while a private home was remodeled to serve as the mission. The building was dedicated to St. Jude Thaddeus at the request of a parishioner who donated a statue of the patron. (Our Lady of Perpetual Help.)

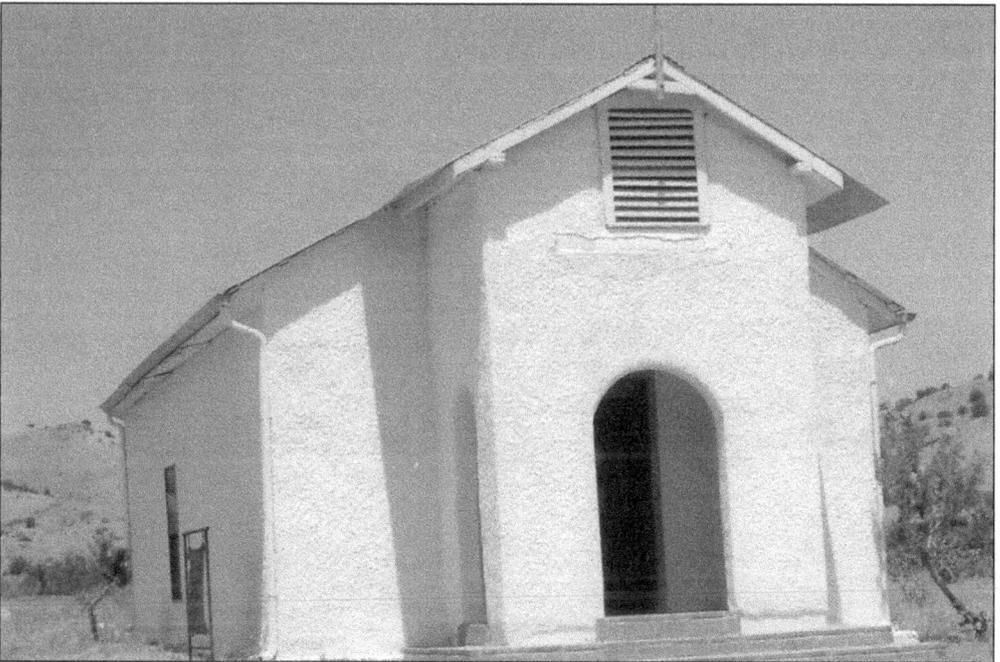

Chis, a diminutive of Cochise, is named for the famed Chiricahua chief. Priests from Monticello began saying Mass there around 1912. The present church, built between 1919 and 1922, is dedicated to St. Gregory VII, because the first rain after a long drought fell on May 25, 1923, the feast day of St. Gregory VII. (Viola Armijo.)

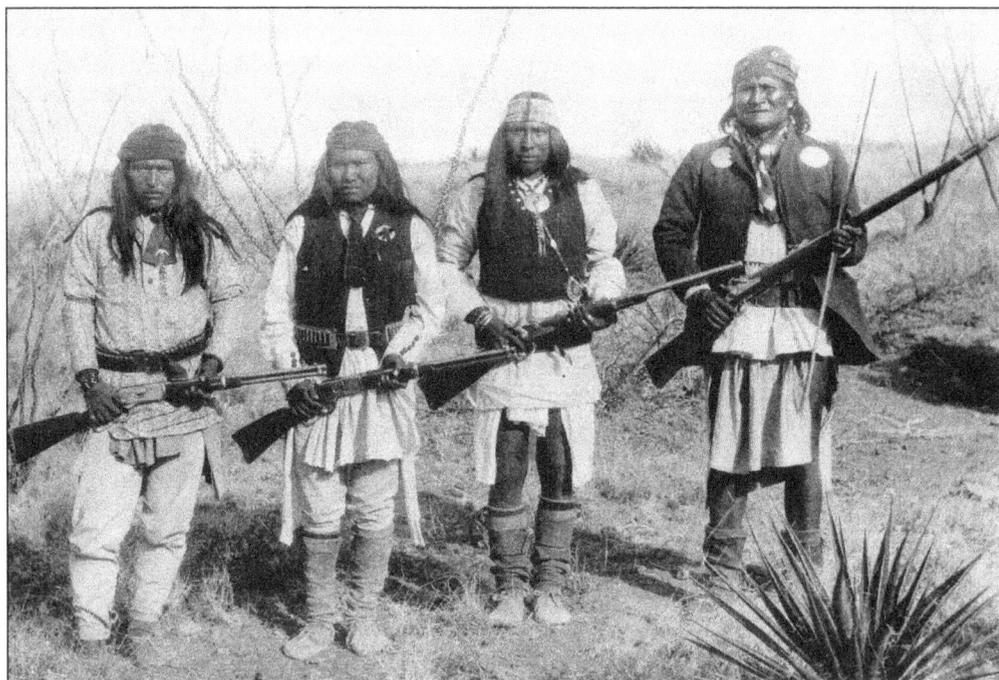

The mountain parishes bore the brunt of Native American raiders. Apache war chiefs including Victorio, Mangas Coloradas, Cochise, and Geronimo (shown on the far right) led their warriors against the miners and farmers of the area in a relentless attempt to hold onto their ancestral homelands and drive out the invaders. (Arizona State Library, Archives and Public Records, History and Archives Division, 97-2652.)

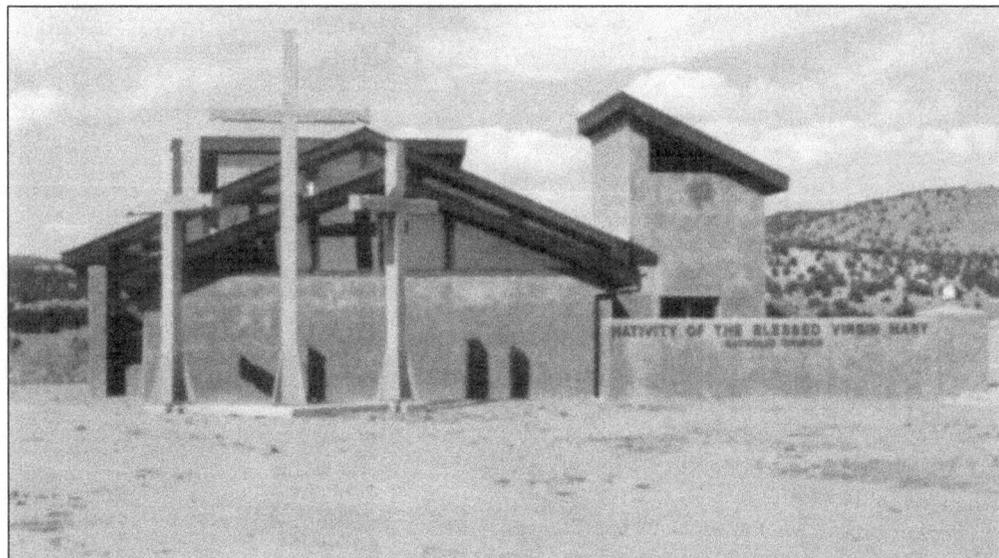

Datil (Spanish for "date") was named by Spanish explorers who probably thought that the seedpods of some desert plants resembled dates. The U.S. Cavalry used Datil as a forward location for its western Native American operations. The first church, dedicated to Buen Pastor (Good Shepherd) and affiliated with Monticello, was built in the 1920s. The new church (seen above), completed in 1987, was rededicated to the Nativity of the Blessed Virgin Mary. (Diocese of Gallup.)

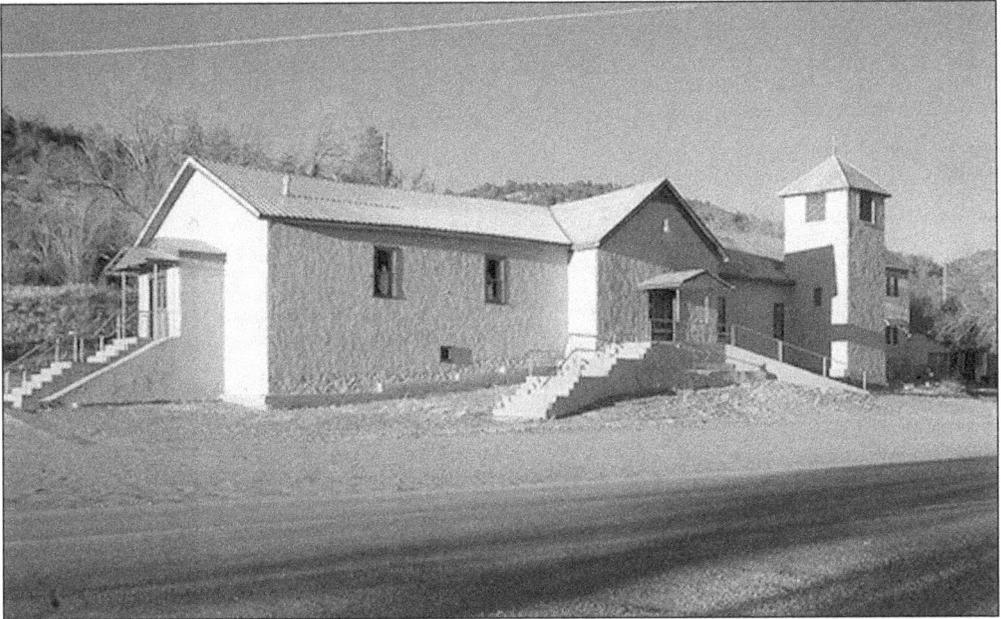

In 1872, the army established Fort Tularosa, renamed Aragón in the late 19th century, at the Warm Springs Apache Reservation agency. A chapel affiliated with Monticello and dedicated to Santo Niño (Holy Child) was established at the original fort. Aragón became a parish in 1939 and continues to this day as part of the combined parish of Aragón, Reserve, and Datil. (Diocese of Gallup.)

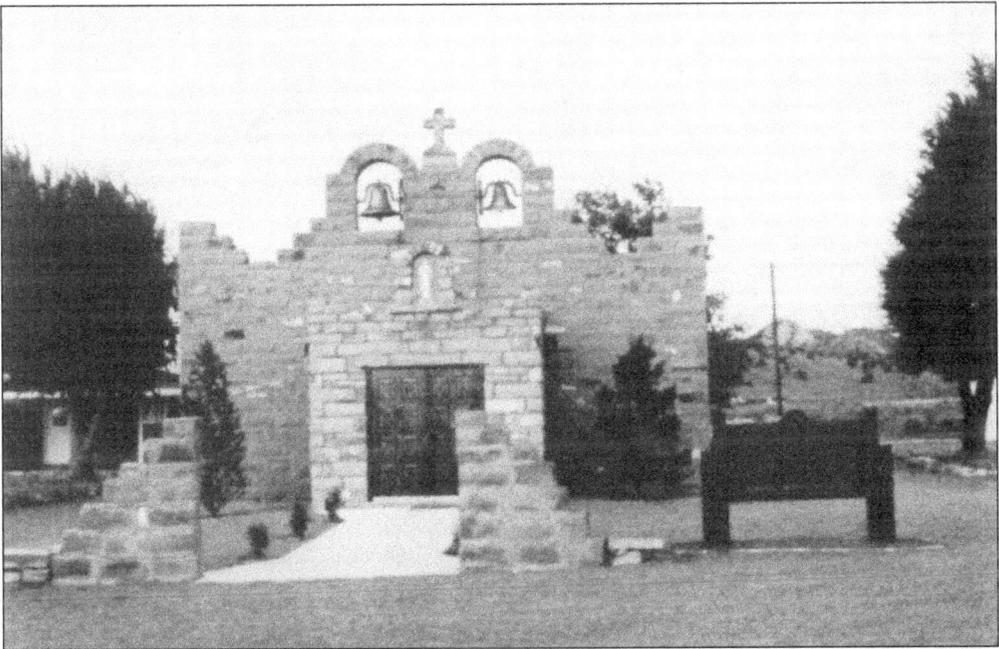

Quemado (Spanish for "burned"), probably named for an area set ablaze by Native Americans, was established in 1918. A mission dedicated to the Sacred Heart was completed in 1913. It remained a mission of San Ignacio in Monticello until it shifted to Our Lady in Mogollón in 1937, then again to Santo Niño in Aragón in 1939. The current stone church dates to 1950. (Diocese of Gallup.)

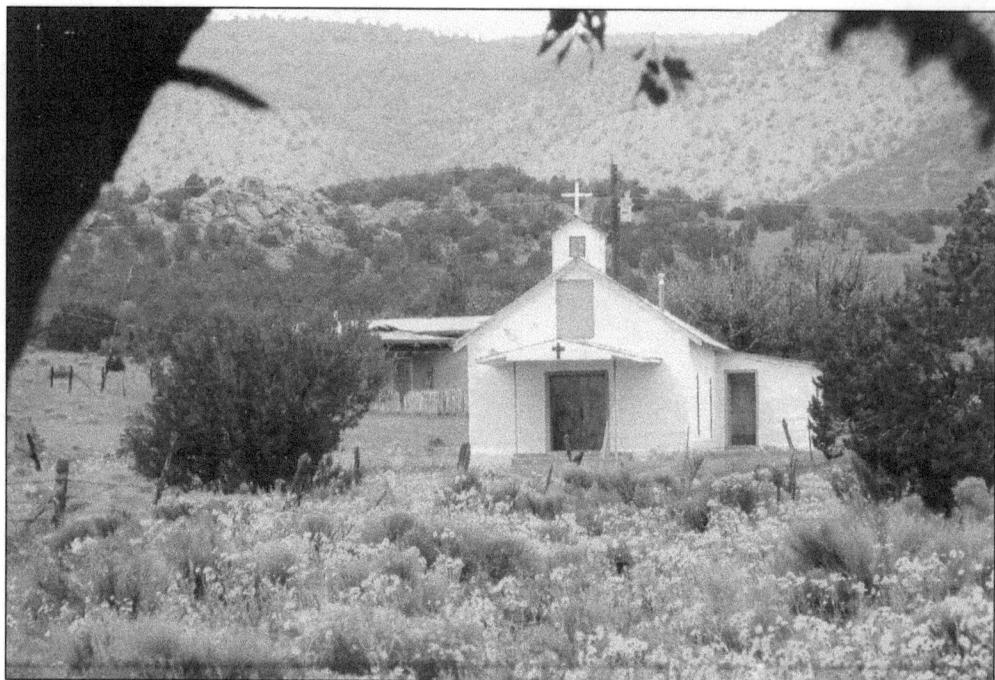

Horse Springs, named by soldiers who found a lost horse nearby, was settled in the early 1880s. A mission of Monticello dedicated to St. Ann has been in the village since 1934. The mission was served from Monticello from 1934 to 1938, before it was reassigned to Aragón. (Anita Saiz.)

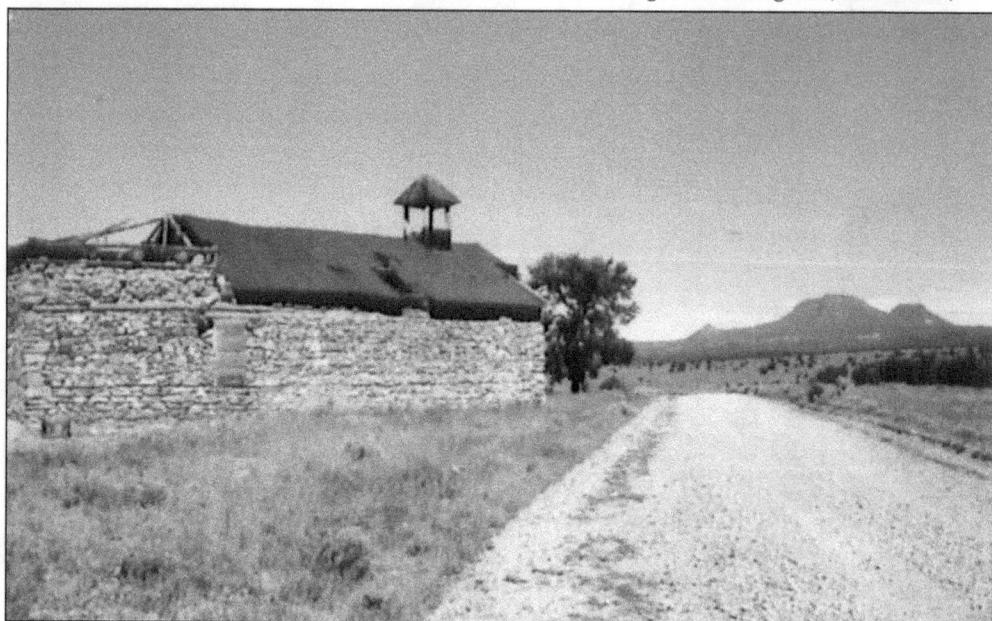

Mangas was named for the Warm Springs Apache chief Mangas Coloradas (Spanish for "red sleeves"). Originally known as Pinoville after one of the first settlers, it was established sometime before 1905. A mission of Monticello dedicated to San Pablo (St. Paul) is listed from 1920 through 1937, before briefly shifting to Mogollón. In 1939, ecclesiastical oversight was shifted to Aragón. (Anita Saiz.)

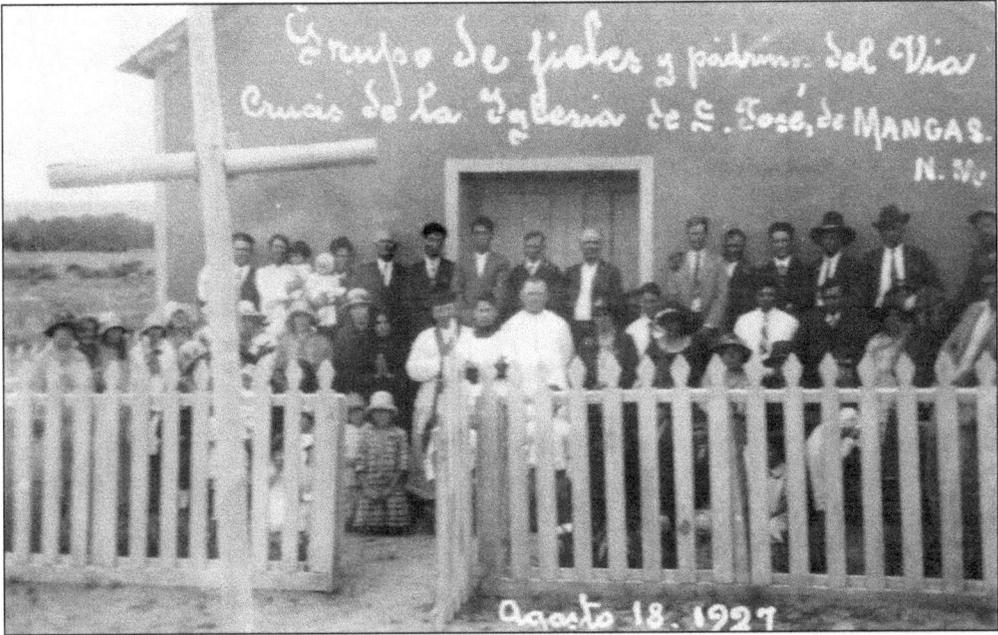

Grupo de fieles y padrinos del Via Crucis de la Iglesia de S. José, de MANGAS. N. M.

Agosto 18. 1927

San José is a rather common mission and village name throughout New Mexico. The mission of San José associated with Cañada Alamosa/Monticello was located near San José Springs, about 2.5 miles south of Mangas. This simple pitched roof chapel was used from 1880 to about 1927. (Anita Saiz.)

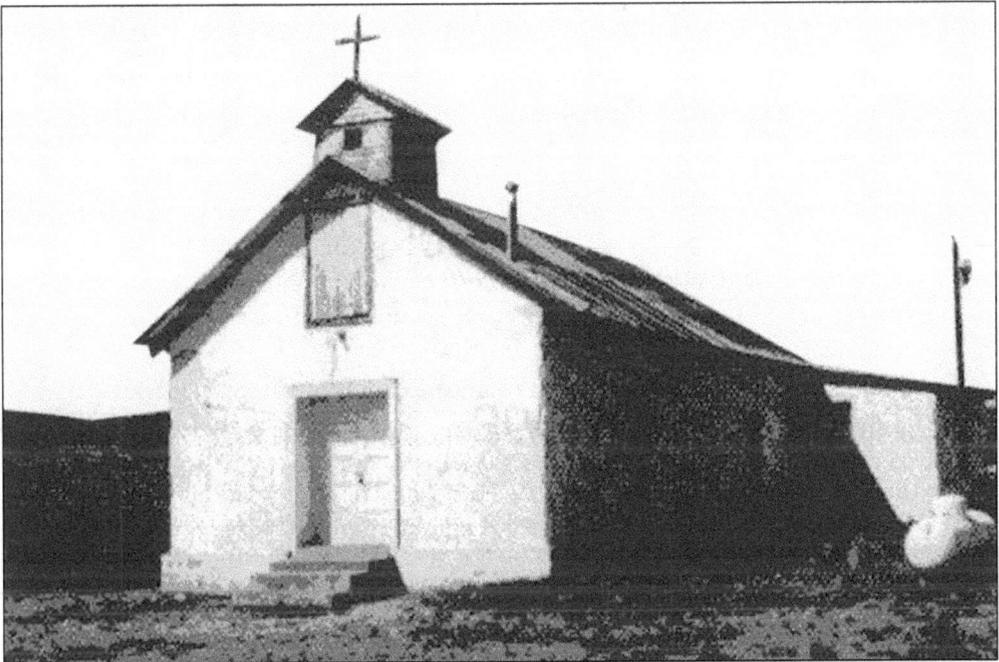

The area along the San Francisco River, settled during the 1880s and 1890s, was always subject to fierce raiding by the Apaches. One or more missions or stations associated with Monticello existed in the valley from 1928 to 1938 when they were transferred to the newly established parish of Santo Niño in Aragón. St. Isidore in Lower Frisco is seen here. (Diocese of Gallup.)

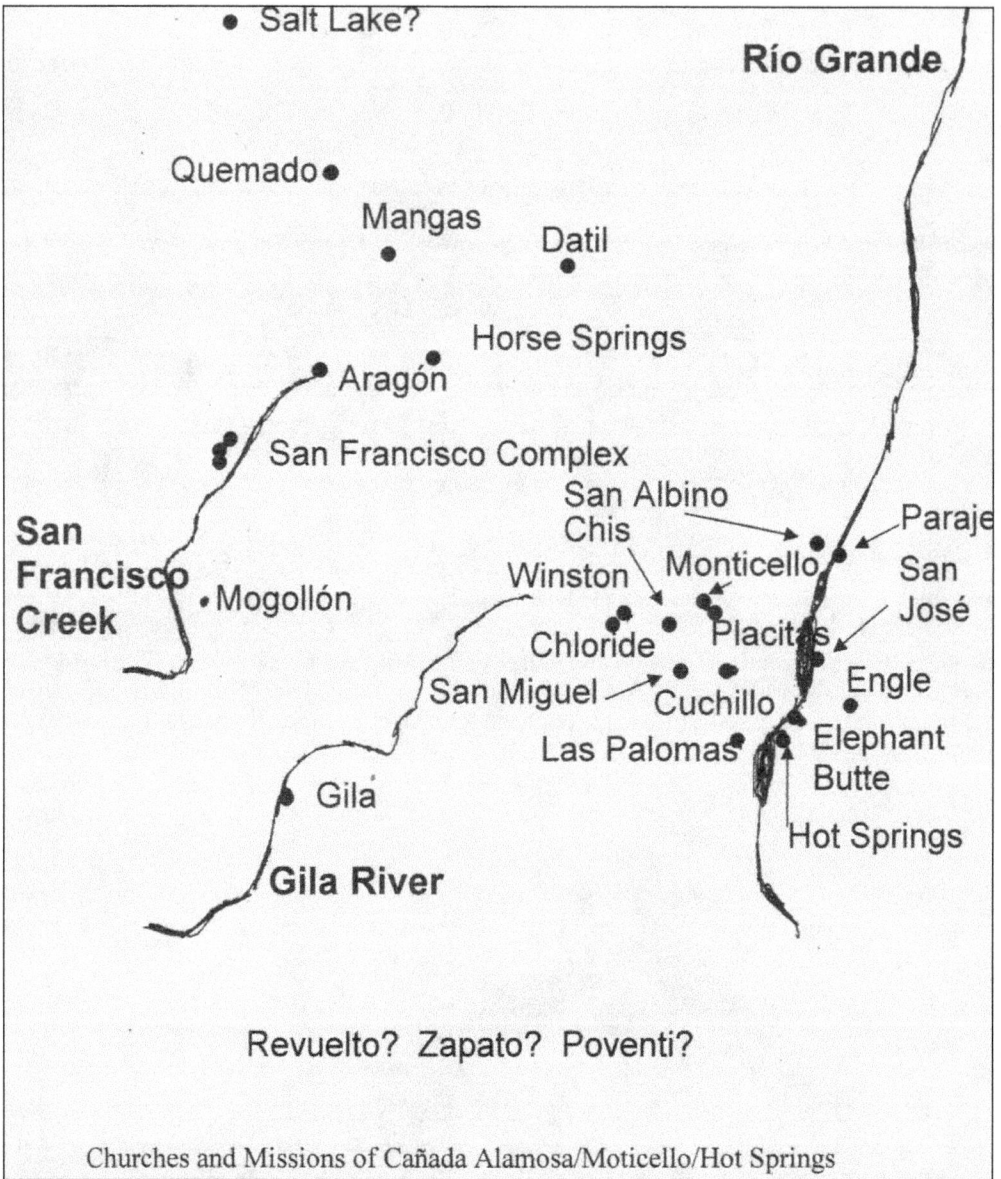

Churches and Missions of Cañada Alamosa/Moticello/Hot Springs

Pope Pius XII had become concerned that the western portions of the Archdiocese of Santa Fe and the northern portions of the Diocese of Tucson were not receiving the dedicated pastoral care required for their unique and heavily Native American populations. Accordingly, he erected the Diocese of Gallup in 1939, and most of the western parishes and missions were assigned to the new diocese. The last connection between the mountain and valley parishes was broken with the establishment of the Diocese of Las Cruces in 1982. Despite the reassignment of the diocese, they remain a crucial part of the history of Catholicism in Central New Mexico and have lasting ties to the Río Abajo. The struggles and perseverance of the priests and parishioners serving these far-flung and isolated parishes speak volumes about the dedication of New Mexico Catholics in the 19th and early 20th centuries.

Nine

THE LOST PARISHES

The area about 30 miles south of Socorro on the east side of the river was settled in 1854 as La Mesa de San Martial, in honor of Martial of Limoges, a canonized third-century French bishop. Farmers from La Mesa provided nearby Fort Conrad (and later Fort Craig) with hay and wood until 1866, when a devastating flood wiped out the village. The residents resettled on the west bank, taking their saint with them and establishing the village of San Marcial.

San Marcial varied in status from parish to mission beginning in 1870 until it was dropped from the archdiocesan rolls in 1939. The missions of San Marcial that are not documented in the images include Carthage, Tokay, Cantericio, El Contadero, Bosque Bonito, San Albino, San José, Jerónimo, Elizario, and Pueblitos.

Paraje de Fray Cristóbal (paraje means "stopping place" or "campground") is located on the east bank of the river south of Black Mesa. It was used during Spanish colonial times as a jumping off point for the dangerous trek south across the Jornada del Muerto. It was condemned as a part of the Elephant Butte project in 1915, and the site is now under water in the northern reaches of that reservoir. The church of San Cristóbal in Paraje was noted as being served from Socorro between 1867 and 1869, when it became a mission of San Marcial. It varied between parish and mission status until being stricken from the records in 1921.

The map of San Marcial with various labels including: NORTH, THE CIVIL WAR BETWEEN THE NORTH AND THE SOUTH WAS FOUGHT HERE IN FEB 1862 – VALVERDE BATTLEFIELD, VALVERDE, RANCHOS DE LOS OLGUINES, LA JORNADA DEL MUERTO, PEDRO ARMANDAREZ LAND GRANT, EL POPE, LAVA, CATTLE CO, LA MESA FARM LANDS AND COMMUNITY, RINCON, VALVERDE FARMS, GUADALAJARA, ORCHARD, RIO GRANDE, LA MESA DEL CONTADERO, BOSQUE COTTON WOOD TREES, AT & SF RAILROAD, SANTA FE STATION, STOCK PENS, CANT ADERO CEMETERY, NORTH TO TIFFANY, Santa Fe Rail Road Worker's Two Story Housing Units, RIO GRANDE SOUTH ON THE RIO GRAND:, COTTON WOOD TREES, LA PLAZA NUEVA (NEW TOWN), CONTADERO, CANTARECIO, EL VERDE (FT. CRAIG), PARAJE, SAN ALBINO, FRA CRISTOBAL MTS., SAN JOSE, BOSQUE BONITO, EL PASO DEL NORTE, YSLETA DEL SUR, SOCORRO DEL SUR, EMILIANO TRUJILLO GROCERY, SAN MARCIAL, PLACITA DE ENMEDIO, LAKE, EL CORIDO DE SAN MARCIAL BY RAMON LUNA, OLD ACEQUIA MADRE, FARM LANDS, FELIX BARRERAS, S. MC. CHURCH, LA PLAZA VIEJA (OLD TOWN), RIO GRANDE DANCE HALL, SAN ALIZARO, Present day Hunter place SAN GERONIMO, EL CAMINO REAL, OLD SAN MARCIAL LOS CHAVEZ CEMETARY, LOMA ARENOSA, CHURCH, ISMAEL ORTEGA BAR, CEMETARY, BASE BALL FIELD, MIGUEL GONZALES CEMETARY, THIS MINI MAP WAS DRAFTED BY MIGUEL R. CHAVES & AMALIA DIAZ DE CHAVEZ BOTH BORN & RAISED IN SAN MARCIAL – AUG 12, 1995 – REVISED BY BENNIE BARRERAS. DIGITIZED ON COMPUTER BY FELIX TORRES JR – AUG 23, 1995. DEVELOPED FOR THE SAN MARCIAL REUNION – AUG 26, 1995 – SOCORRO. (NOT DRAWN TO SCALE)

The parish of San Marcial is first mentioned in archdiocesan records in 1870, when it was noted as a new parish with missions in "Paraje, Cañada Alamosa, etc." However, it is likely that chapels or visitas served from Socorro existed in the La Mesa and San Marcial areas back into the early 1850s, when the area was first settled. San Marcial was attended from Paraje until 1880 before reassignment to Socorro. San Marcial (below) was redesignated a parish on its own in 1884. It remained on the archdiocesan parish list through 1939, although the last priest left in 1930. (Above, Begniño Barreras; below, Emilia Chávez.)

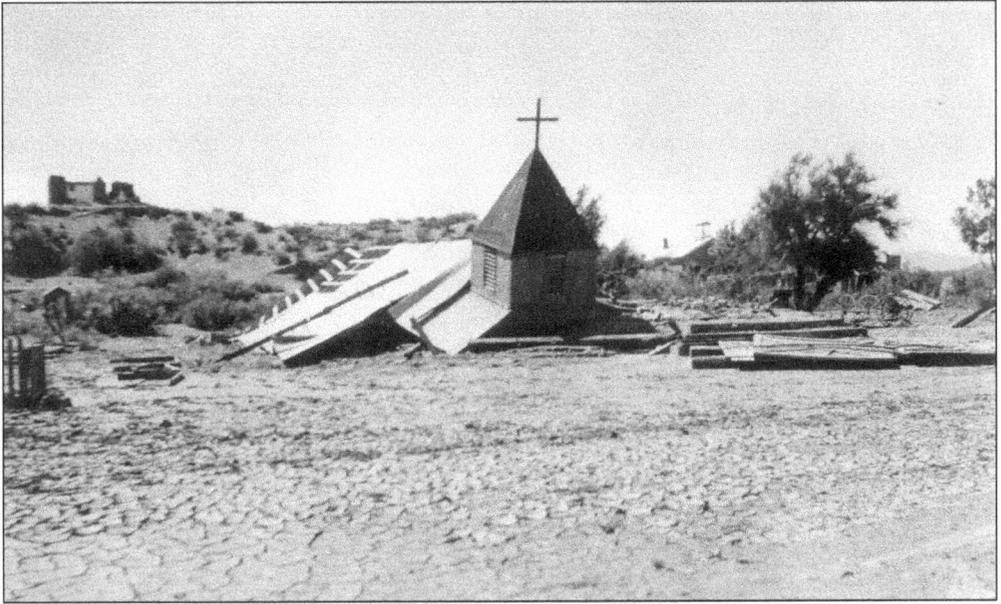

San Marcial could be the poster child for the threat posed by flooding prior to the middle of the 20th century. There had been damage from the floods of 1884 and 1904, and engineers had warned of a catastrophic flood, but most people believed that their dike would protect them. On August 13, 1929, the dreaded event happened—the dike broke and the Rio Grande reclaimed much of the village. After the water subsided, people returned and began to clean up and rebuild; however, on September 24, the river rose again and destroyed what was left from the previous event, leaving the town under as much as 10 feet of mud, water, and debris. All that is left today are some decaying ruins amongst a tangle of tamarisk bushes. (Above, New Mexico State University, 940786; below, Museum of New Mexico, 57293.)

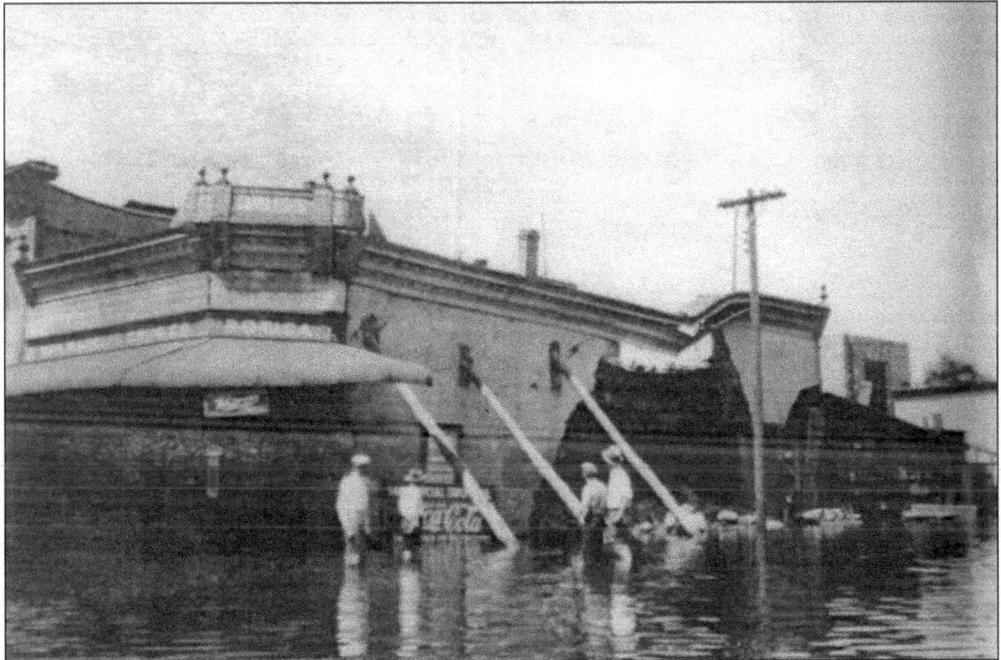

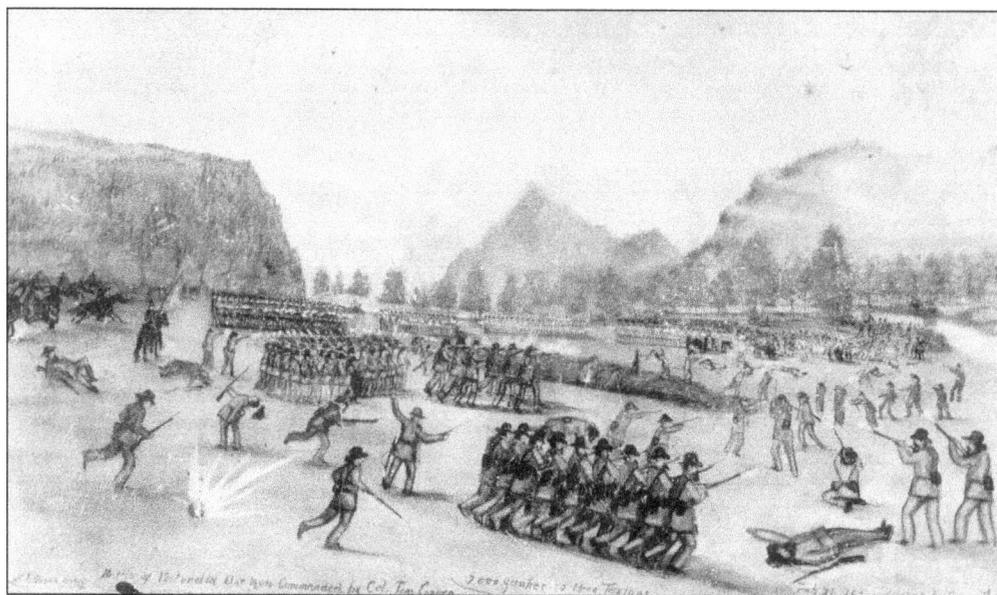

Valverde was the site of one of the two major Civil War battles in New Mexico. At the Battle of Valverde (February 21, 1862, above), the largest land battle ever fought in the West, the Confederate forces were commanded by Col. Tom Green (below right), while the Union forces were led by Col. E. R. S. Canby (below left). These men were the same two opponents who would square off at Los Pinos on April 15, 1862 (see chapter six). Valverde was founded in 1803 but was abandoned about a year later due to Navajo raids. Valverde was a thriving farming village on the east side of the river at the time the railroad reached San Marcial in 1881. The first bridge between the two villages was constructed in 1910. Although Valverde was wiped out in the floods of 1929 that also destroyed San Marcial, the railhead at the abandoned village was used to support the first nuclear weapon test at the nearby Trinity Site on July 16, 1945. (Above, Texas State Archives; below, both, Library of Congress.)

The church of San Antonio in Valverde, first noted in Catholic archives in 1821, was attended from Socorro from 1857 to 1884, when it became a mission of San Marcial. Valverde remained a mission of San Marcial until the floods of 1929. The ruins of the old Valverde church were still visible in 1982, and this 1847 woodcut probably illustrated the walls of the old church. (Lt. James W. Abert.)

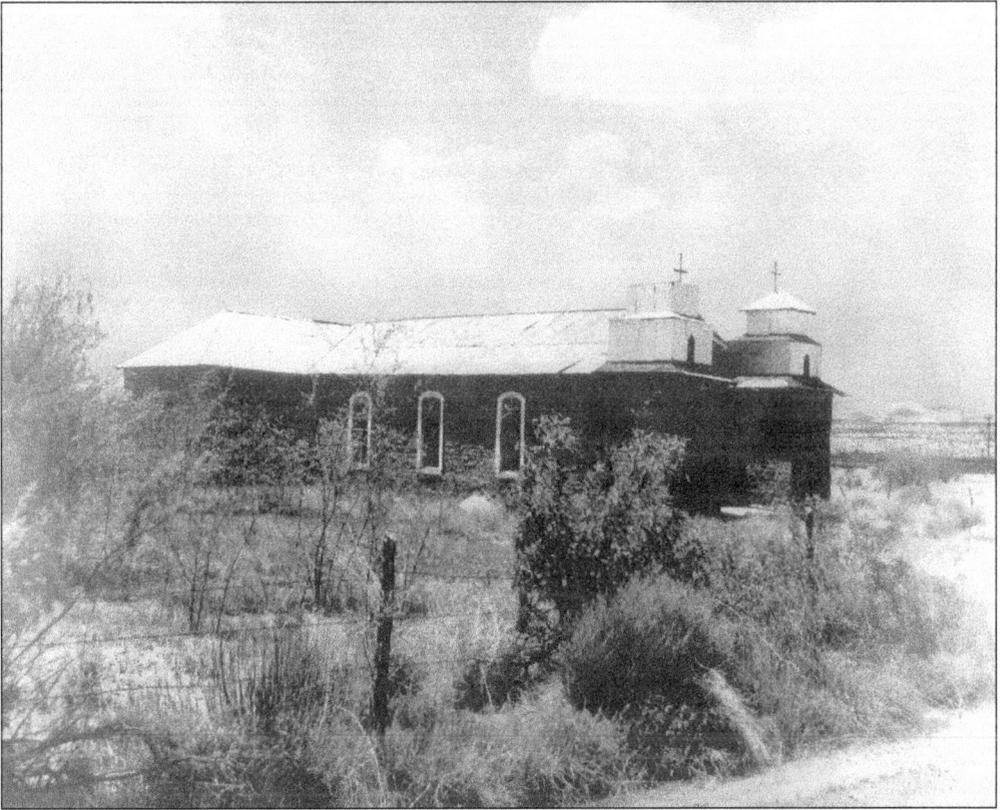

About a mile south of the present-day village of San Antonio is the site of San Antonito, the pre-1880 location of San Antonio. A small church, dedicated to the Immaculate Conception and served from San Marcial and Socorro, existed in the area from 1918 through 1941. The building has been deconsecrated, and the property is now a private residence. (Margene Harris.)

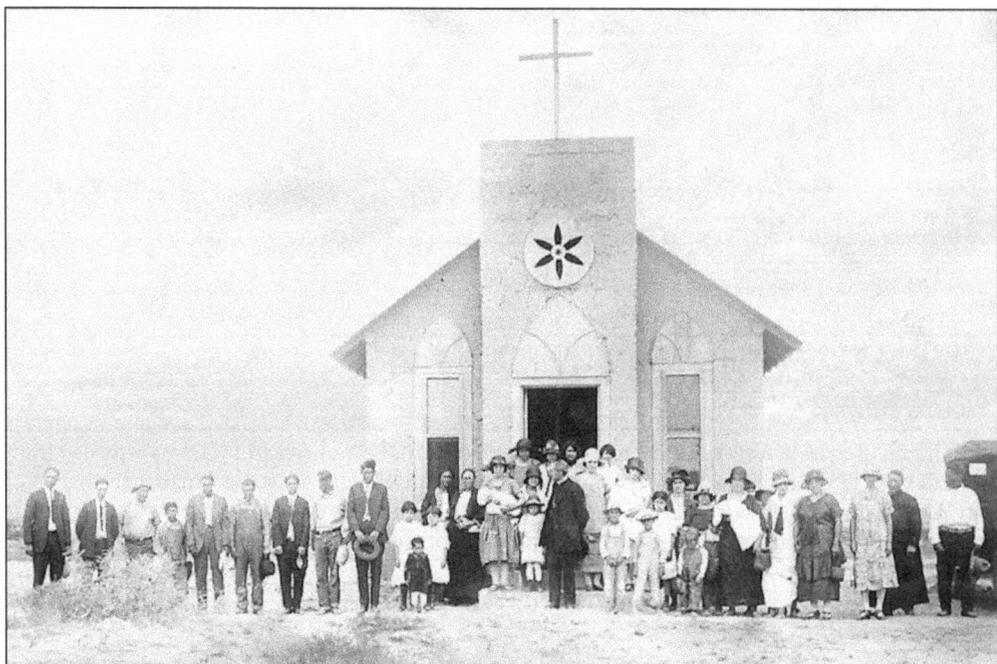

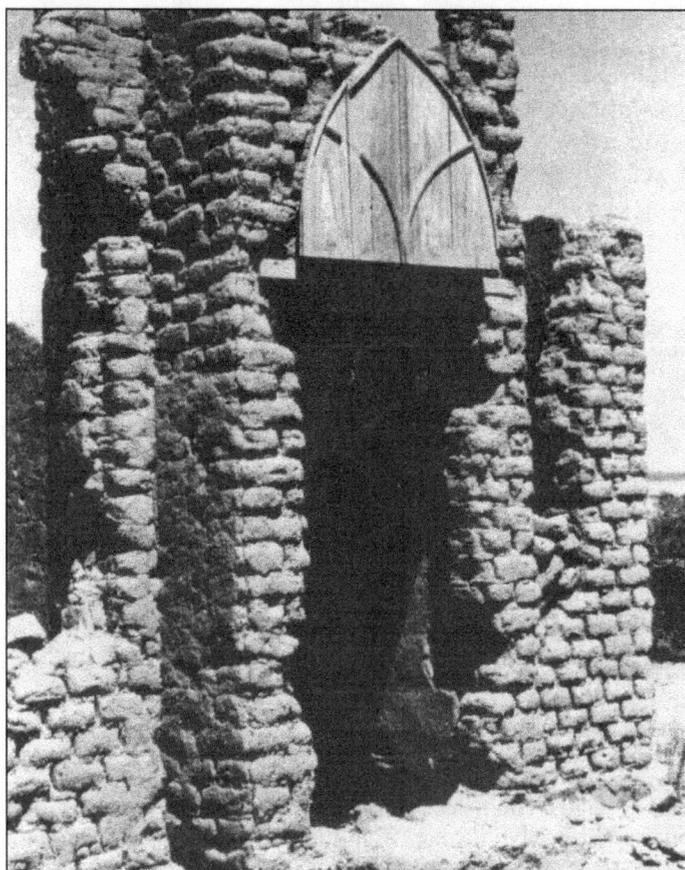

Engle was first known as Rogers Ranch and was built in 1879 as a station on the Atchison, Topeka, and Santa Fe Railroad. It was named for R. L. Engle, a railroad construction engineer. The chapel of St. James at Engle was finished in the spring of 1926 and listed as a mission of San Marcial from 1922 to 1940. (Columba Reid.)

Engle was served by priests from Socorro from 1931 until 1939. In 1940, it formally became a mission of Socorro, and it became a station served by Monticello/Hot Springs in 1941. Although it is still carried on the parish rolls as a station of Our Lady of Perpetual Help, the original building is now in ruins. (Columba Reid.)

The village of Bosquecito (Spanish for "little wooded area") lies north of San Antonio on the east bank of the river. Bosquecito had a mission of Socorro dedicated to San Gabriel from 1892 through 1915, when responsibility shifted to San Marcial. Today nothing remains except a cemetery that is still cared for by local residents. The photograph shows the location of the church and demonstrates how quickly and completely nature reclaims its own. (Paul Harden.)

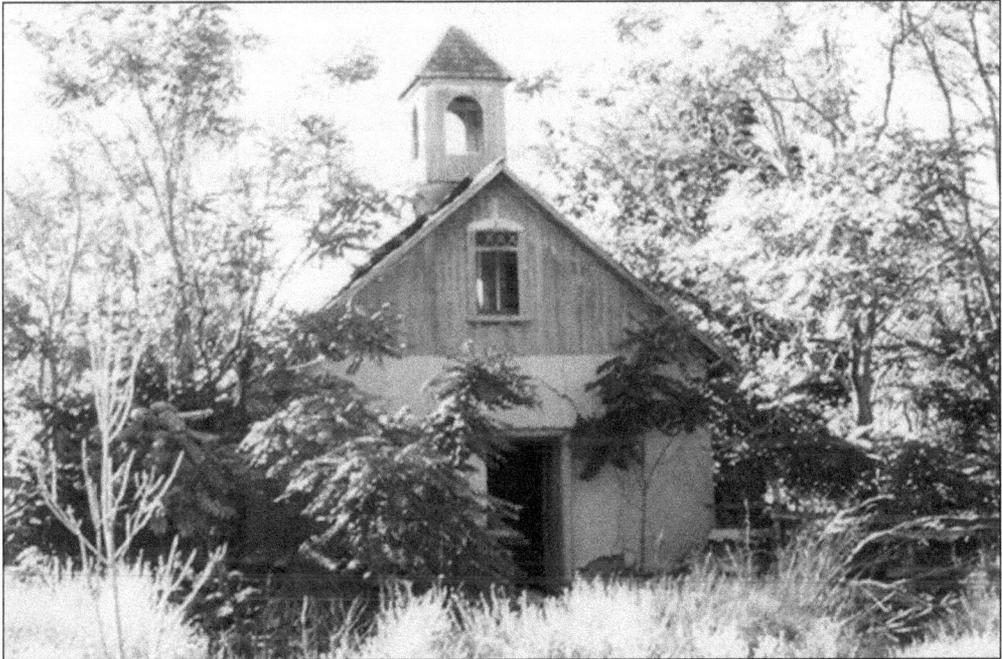

About a mile east of San Antonio lie the ruins of San Pedro, named for the Benedictine priest Peter Celestinus. This village, famous in the 19th century for its vineyards, was founded in the 1840s. The mission was served from Socorro and San Marcial until it dropped from the Socorro list in 1957. (Jane Farmer and Dado Lucena.)

Fort Craig was constructed in 1854 to take the place of Fort Conrad, which was in a swampy river bottom location. Fort Craig, one of the principal military installations in New Mexico, was assigned a critical role in supporting the army's attempts to control the Apache Indians in the southern and central parts of the territory. In addition, it was one of the main objectives of the Confederate invasion during the Civil War. From 1884 to 1891, priests from San Marcial journeyed south to Fort Craig to hold catechism classes for the soldiers and their families. (National Archives.)

Ten

RETROSPECTIVE

The timeline of Catholic ministry in the central Rio Grande Valley begins with Isleta and the other pre-Pueblo Revolt Franciscan missions in Tajique, Quarai, Abo, Socorro, Alamillo, La Joya, and Senecú. The missions east of the Manzanos were abandoned in the 1670s, and the rest were desecrated and destroyed during the tumultuous Pueblo Revolt. In the years following the reconquest of the 1690s, Catholicism returned to the colony.

Following the Mexican-American War, Jean-Baptiste Lamy, an energetic French bishop, set about evangelizing the area, approving the construction of churches, erecting parishes, and confronting the Protestant influences that had also begun to appear in the area by the 1850s.

Over the years, some parishes disappeared or were absorbed into others. San Marcial was washed away. Magdalena emerged from Socorro and then was reabsorbed. Cebolleta and Mogollón became a part of the new Diocese of Gallup, while Truth or Consequences became a part of the Diocese of Las Cruces. Tomé gave birth to Peralta, and Isleta released San Clemente. These birthings were not without their controversy. Dedications changed, missions and stations were swapped between parishes, and the designation of mother churches in parishes like Sabinal/La Joya and Monticello/Hot Springs were swapped amongst missions within parish boundaries, all with angst for those whose traditions and power bases were being uprooted.

Through it all, from Native American depredations to floods to droughts to American and Confederate invasions and counterinvasions, the strong Catholic traditions in the Río Abajo prevailed. Today the Archdiocese of Santa Fe is responsible for seven parishes with 20 missions serving the populations of Valencia and Socorro Counties, which still thrive along the now-pacified Rio Grande. The fact that these parishes continue to flourish as they bring faith to the area is a tribute to the priests and parishioners who have persevered through the first 400 years of Catholicism in the Río Abajo.

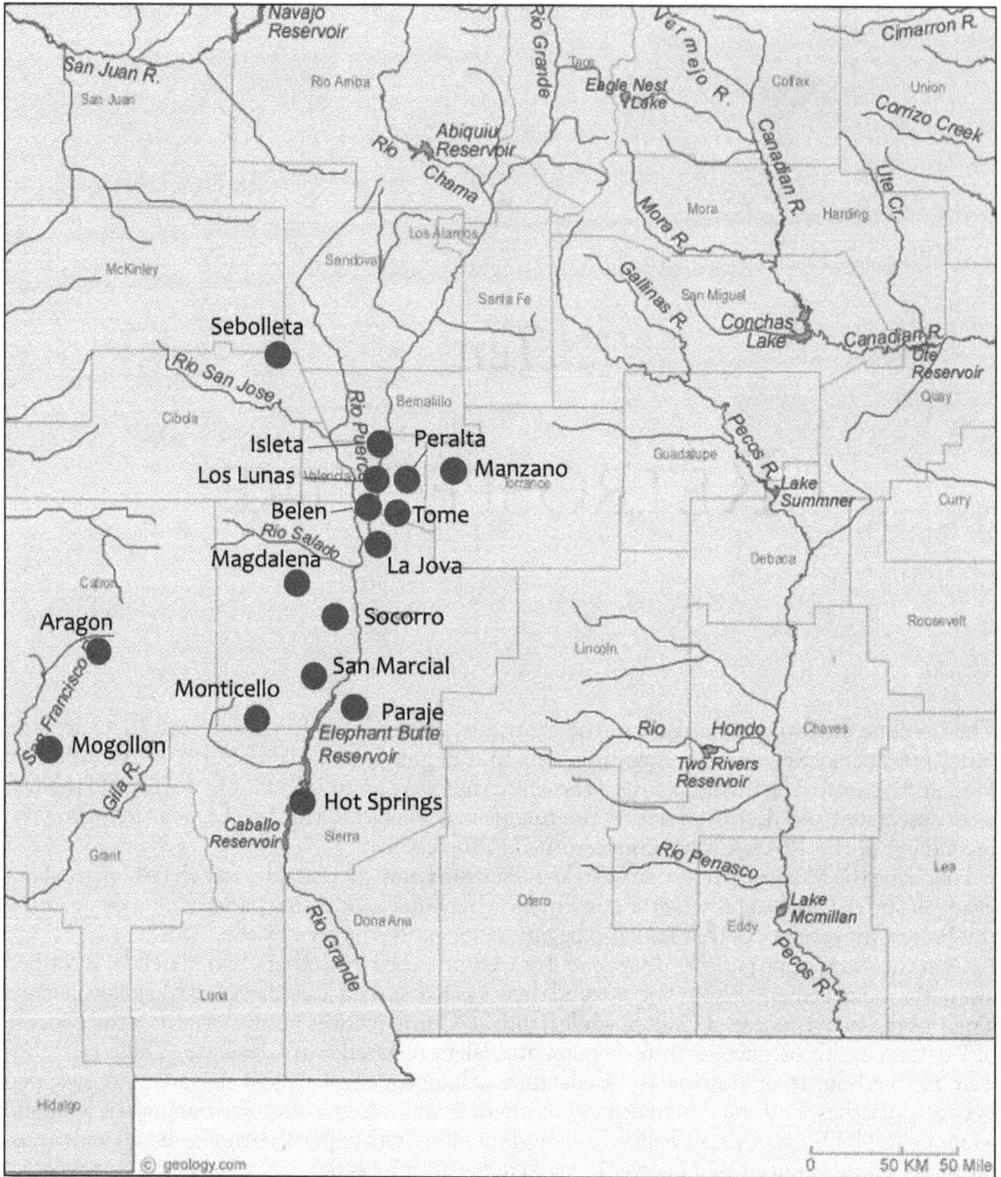

This map summarizes the parishes and missions visited in this book's journey through time along the Río Abajo. When Lamy first inventoried the Río Abajo parishes and missions in 1852, he found four active parishes and 19 missions. When he died in 1888, there were seven parishes serving more than 30 missions and visitas, stretching from Isleta's mission in Pajarito on the north to the Las Palomas mission on the south. Between Lamy's arrival in 1850 and the present, there are or have been 16 parishes with at least 134 churches, missions, visitas, oratorios, and stations constructed to serve the Catholic populations of the area. In addition, the vast region established by Lamy has spawned two new dioceses—Gallup in 1939 and Las Cruces in 1982.

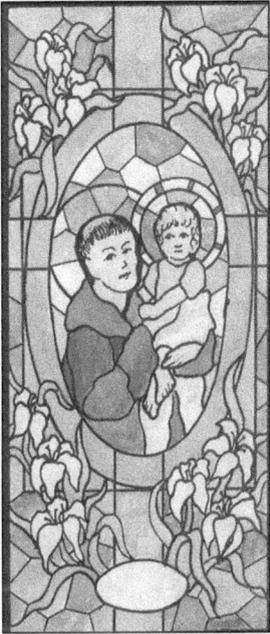

The most popular dedications among the churches and missions of the Río Abajo are San Antonio, a patron of the Franciscans (above left), San José, the patron of New Spain (above right), San Isidro, the patron of farmers (below left), and various dedication to the Virgin Mary (below right). Some dedications can be explained. Others survive in legend. Some can be traced to previously named parishes or missions. However, questions remain. Why did the residents of La Mesa dedicate their mission to Saint Martial, an obscure third-century French bishop? How did Polvadera come to be dedicated to Saint Lawrence? There will probably never be definitive answers, although it may be entertaining to speculate. (Above left and below right, Cathy Gore; above right, John Taylor; below left, B. G. Burr.)

This image shows the tabernacle carving by Carlos Otero that is in the center of the retablo carved by him during the 2004–2005 renovation of Our Lady of Guadalupe in Peralta. Tabernacles in churches and missions contain the consecrated host, a centerpiece of Catholic liturgical life. This carving symbolizes the perseverance and endurance of Catholicism along the Rio Grande. (Gil Duncan.)

BIBLIOGRAPHY

Catholic Directories for the Archdiocese of Santa Fe. Various versions 1852–present. Sadlier, Kennedy, and Metropolitan Publishers.

Chávez, Fray Angélico. Archives of the Archdiocese of Santa Fe. Lamy Memorial, Centenary of the Archdiocese of Santa Fe. Archdiocese of Santa Fe, 1950.

Gregg, Andrew K. *New Mexico in the 19th Century: A Pictorial History*. Albuquerque: University of New Mexico Press, 1968.

Julyan, Robert. *The Place Names of New Mexico*. Albuquerque: University of New Mexico Press, 1996.

Kelley, Elizabeth. *Diocese of Gallup: Golden Jubilee 1939–1989*. Gallup, NM: Diocese of Gallup, 1989.

Marshall, Michael P., and Henry J. Walt. *Río Abajo: Prehistory and History of a Rio Grande Province*. Santa Fe: New Mexico State Historic Preservation Division, 1984.

Montoya, Joe L. *Isleta Pueblo and the Church of St. Augustine*. Isleta Pueblo, NM: St. Augustine Church, 1978.

150th Anniversary of the Founding of the Parish of Our Lady of Belén. Belen, NM: Our Lady of Belén Parish. 1943.

Our Lady of Perpetual Help: 50th Anniversary of the New Church. Truth or Consequences: Our Lady of Perpetual Help Parish, 1999.

Commemorating the Solemn Rededication of Old San Miguel Mission. Socorro, NM: San Miguel Parish, 1974.

Steele, Thomas J., Paul Rhetts, and Barbe Awalt, eds. *Seeds of Struggle, Harvest of Faith*. Albuquerque: LPD Press, 1998.

Taylor, John M. *Dejad a los Niños Venir a Mi: A History of the Parish of Our Lady of Guadalupe in Peralta*. Albuquerque: LPD Press, 2005.

Río Abajo Heritage. Belen, NM: Valencia County Historical Society, 1981.

Visit us at
arcadiapublishing.com

······································